THE SITES OF ANCIENT GREECE

THE
SITES
OF
ANCIENT
GREECE

GEORG
GERSTER

With an introduction by Paul Cartledge

page 6
The Fourni islands
The Fourni archipelago, twelve
small islands between Samos
and Ikaria, was once feared for its
pirates. The island group could be
interpreted as mirroring the entire
Aegean archipelago: this aerial view
helps explain the so-called Greek
Migration, when the ancient Greeks
moved from the mainland to the
shores of Asia Minor, around 1100 BC.
They would secure and colonize an
island but immediately succumb to
the lure of another one in sight, and
so hopped from one beguiling island
to the next ...

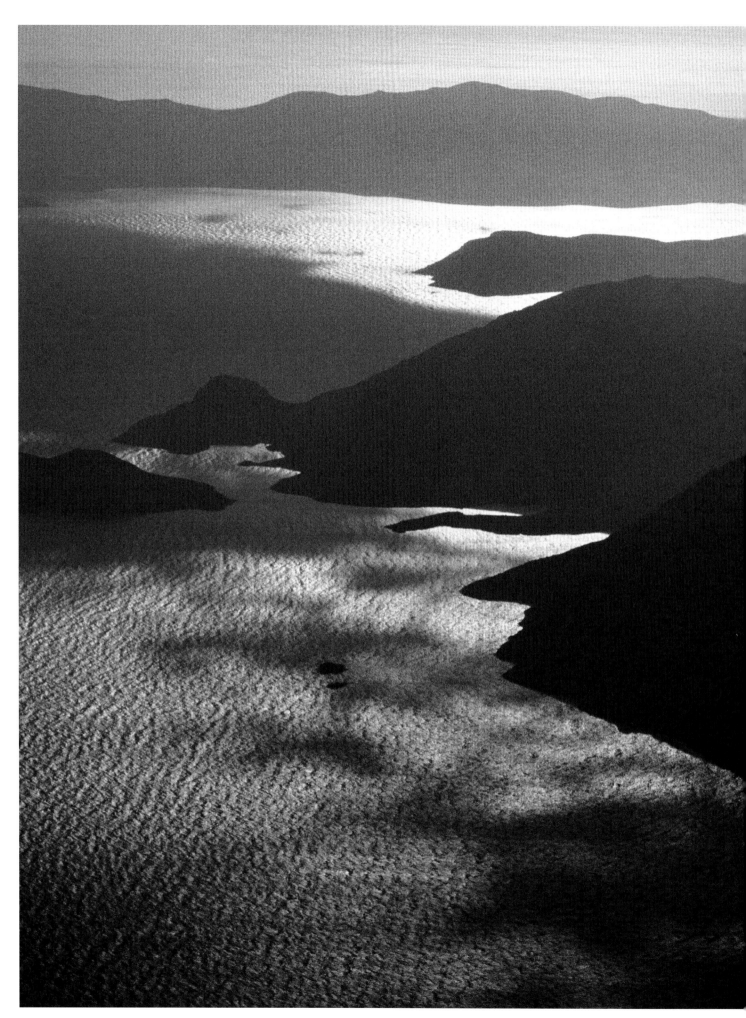

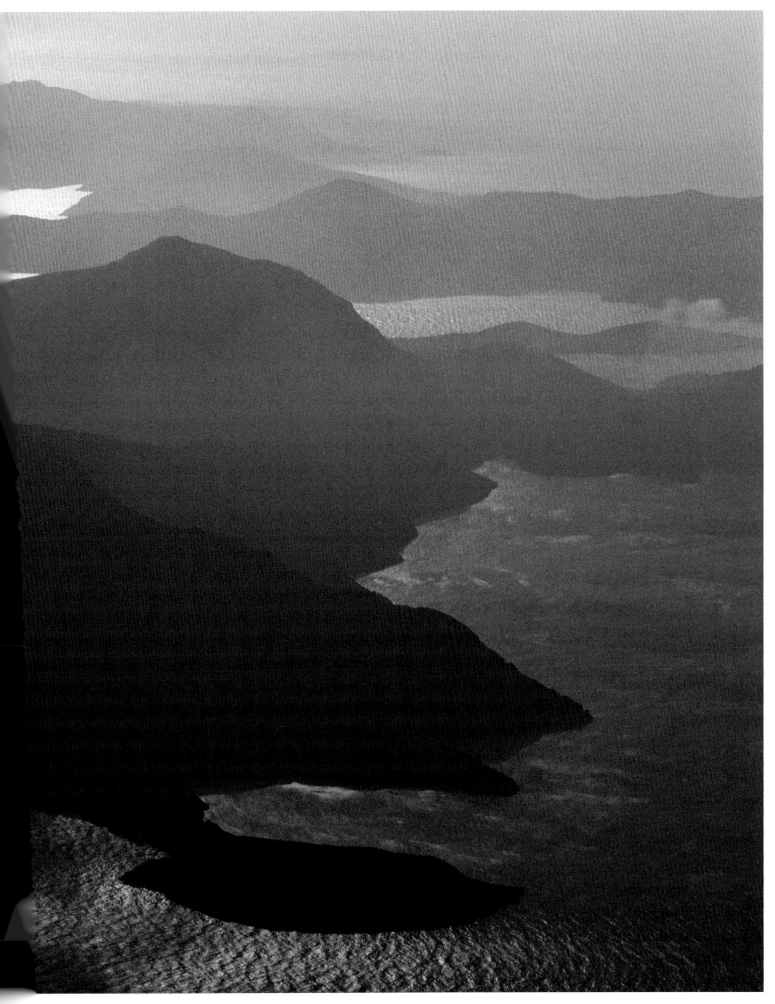

FOREWORD

This aerial overview of Greece, as seen 'through the eyes of the gods', was produced between 1996 and 2006 from more than 100 photo flights, involving a total of 248 flying hours. These photo expeditions were carried out in Cessna 172s or 182s, small, single-engine aircraft. Flying out over the open sea in such a tiny airplane can be a little disconcerting, to say the least, even if one has every confidence in the plane and its pilot. Even on the most glorious of days there is always a risk of sudden gusts or turbulence. There is also one particular island in the Aegean archipelago which can easily produce a feeling of apprehension – its very name, Ikaria, is a reminder of the world's earliest known flying disaster, when Icarus fell to his death in the seas off this island after his wings, fashioned from feathers and wax, melted in the sun.

Thousands of years old, the myth of Icarus' escape from Crete and the Labyrinth of the Minotaur with the aid of a pair of wings made by his father Daedalus, who had warned his son not to fly too close to the sun, mirrors man's age-old dream of being able to fly. The Greek philosopher Plato (428/427–348/347 BC) confessed to harbouring an 'overwhelming desire for wings', although in his case the desire stemmed from more than a simple yearning to take to the air. Flying held the promise of the acquisition of knowledge. A flight over modern-day Attica brings to mind the passage from Plato's work *Critias* lamenting the deforestation and erosion of the Athenian landscape. This remarkably topical ecological review contained in one of his late Dialogues suggests a survey somehow conducted from the air. Although Socrates (c.470–399 BC) realized that the 'true Earth' would only be revealed to one who could fly like a bird, he nevertheless describes it from the perspective of an astronaut, so to speak: 'This earth, seen from on high, would resemble a ball sewn from twelve pieces of leather … in bright colours' (*Phaedo* 110b). The term 'overview effect' was coined by present-day astronauts to describe the euphoric experience of viewing the earth from such an all-embracing perspective.

At school, I was one of the 'Greeks': that is to say, ancient Greek was one of my main subjects. This may partly explain why these flights over Greece's cultural heritage sites and varied landscapes had me delving back into my classical education. However, these beautiful sights did not always inspire visions of glory and nobility. The ancient Greeks, including their philosophers, were down-to-earth people, struggling to cope with the demands of everyday life. The sprawling olive plantations occasionally made me think of Thales of Miletus (c.624–c.546 BC), who is regarded as the father of philosophy and renowned as one of the Seven Wise Men of antiquity. A mathematician and astronomer, Thales successfully foretold a solar eclipse. On another occasion, he concluded that the next olive harvest would be exceptionally good. Was his prediction based on an altruistic desire to benefit everyone? Not in the least! He secretly rented all the available olive presses in the region at an extremely low price. When the harvest did indeed prove to be a bumper one, the olive growers were obliged to hire the presses at an extortionate rate from this wily, egotistical entrepreneur. In the financial world, a manipulative action of this sort is known as cornering and considered disreputable, or even downright illegal. The story of Thales' coup is told by the philosopher Aristotle, Plato's most gifted pupil (384–322 BC) in his work *Politics*. Aristotle's report is devoid of any vestige of disapproval – Thales merely intended to demonstrate that even philosophers could become rich if they wanted to.

It was pearls of knowledge such as these, remembered from my school days, which inspired and encouraged me to undertake this project; I have my former teachers to thank in this respect. After so many years of aerial exploration, the accumulated debt of gratitude is so great that, while greatly appreciated, it is almost impossible to mention all the individuals concerned. My thanks go to the civil authorities for granting the necessary permits and to the airport staff for opening up the airports early in the morning or keeping them open beyond the usual hours of operation. I am indebted to the military authorities for allowing us to use their runways and allowing a photographer into air space above sensitive frontier zones for a short period. First and foremost, however, my heartfelt thanks go to my friend and pilot, Jürgen Perteck. He spends his professional life flying much larger birds of the Boeing variety for Hapag Lloyd, but donated his free time to fly small Cessnas for our project. His masterly skills were always very much in evidence whenever the plane was rocked by turbulence or buffeted by strong side-winds during landings: he remained unflappable at all times. With Jürgen in the pilot's seat, I even managed to overcome my disquiet at flying towards Ikaria, with its fateful associations. But then the Cessna's wings are, after all, not held together with wax.

As for the aerial photographs, suffice it to say they were taken with Nikon 35-mm cameras using Kodachrome or Fuji Velvia film.

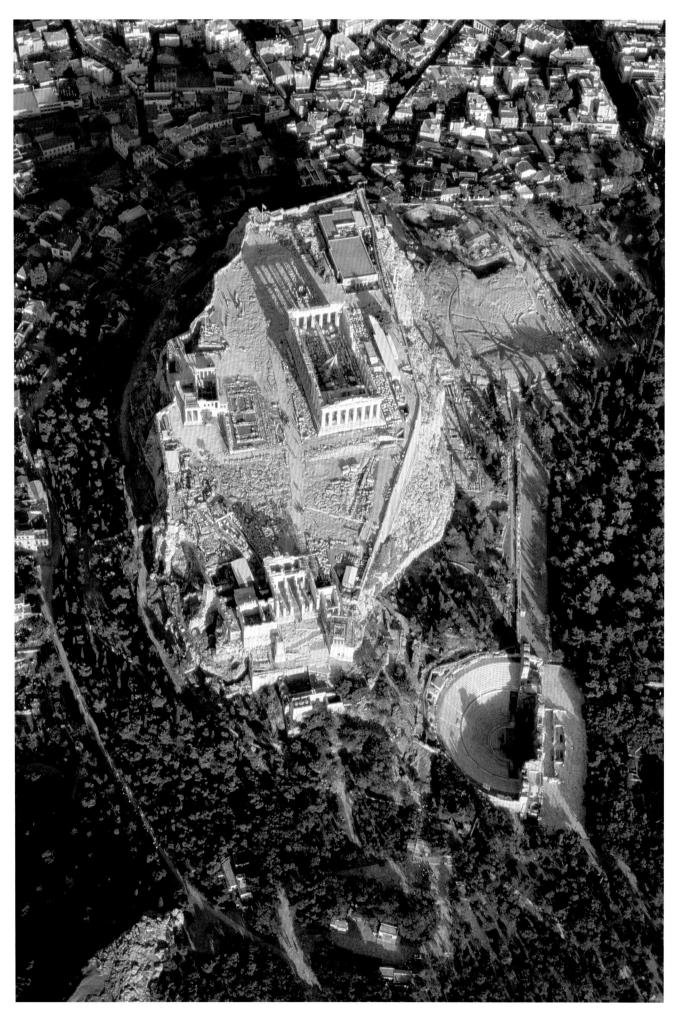

The Acropolis of Athens, Attica

THE TREASURES OF ANCIENT GREECE

In 414 BC the birds took over the world. Setting up a new city in the sky, midway between heaven and earth, they cut off the gods and mortals from each other the better to rule both. In his fantasy comedy *Birds*, performed for the first time in the Theatre of Dionysus at Athens in that year, Aristophanes gave us the wonderfully useful word 'Cloudcuckooland'. Georg Gerster knows all about taking to the air, and taking over the air, by means of photography or light-writing, another word of Greek derivation. But his sphere is far from being a mere Cloudcuckooland, let alone pie in the sky. He studied ancient Greek from an early age and has never lost his passion for that realm of magic realism made flesh. I too share that passion, and it is an immense privilege to introduce this book of Georg Gerster's images of Greek lands and places – ancient, medieval and modern.

Greece – both the real and the imaginary – is a space of often quite startling contrasts and oppositions. We have encountered already that between gods and mortals. In ancient myth, mighty but not almighty Zeus, 'father of gods and men' as Homer calls him, but also Zeus the great 'cloud-gatherer', presided somewhat uneasily over a ménage of male and female immortals. Their home was imagined as being located on the top of Greece's highest mountain, Olympus (2919 metres or 9577 feet) – in actuality often shrouded in cloud and mist. Many other Greek mountains, peaks or ranges are featured in what follows. It is perhaps only local patriotism (I am an honorary citizen of modern Sparta) that makes me single out for special mention Taygetos (2404 metres or 7887 feet), the 'masculine' mountain as it is sometimes nicknamed, which casts its broad shadow over Sparta long before the sun sets and frames even this relatively architecturally deprived setting with a suggestion of grandeur. Thucydides, the Athenian historian of the later fifth century BC, presciently observed that future visitors to the ruins of Sparta and Athens would respectively under- and overrate those mighty cities' actual strength and power.

Which reminds us that against the myth of Homer and other poetical fabulists the ancient Greeks counterposed sober history, beginning with Herodotus' memorable tale of the clash of Greeks and Persians in the later sixth and early fifth centuries BC and

continued on page 16

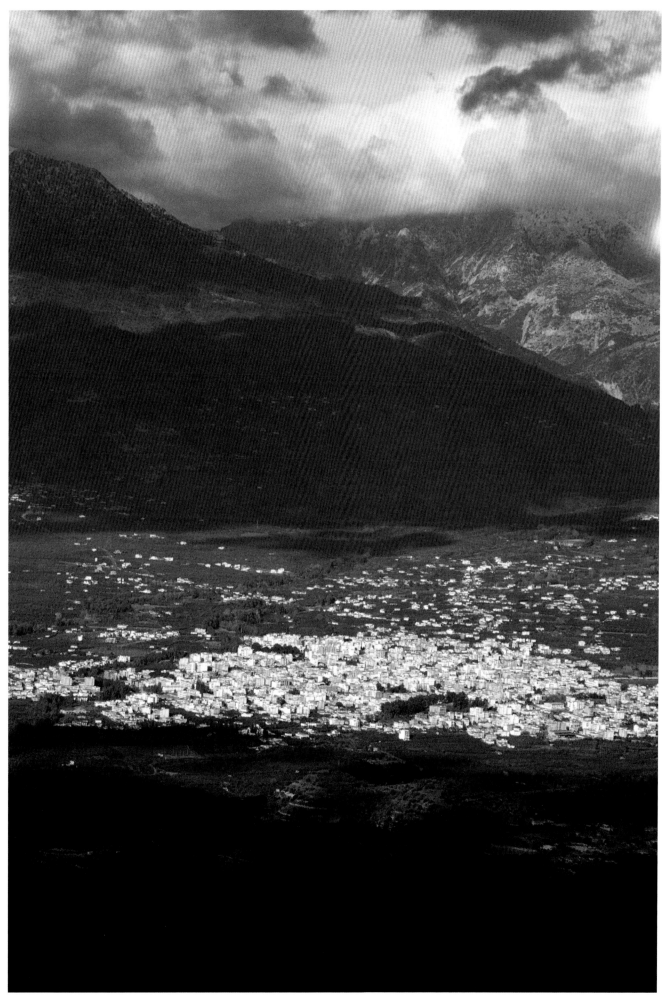

Sparti, capital of Laconia

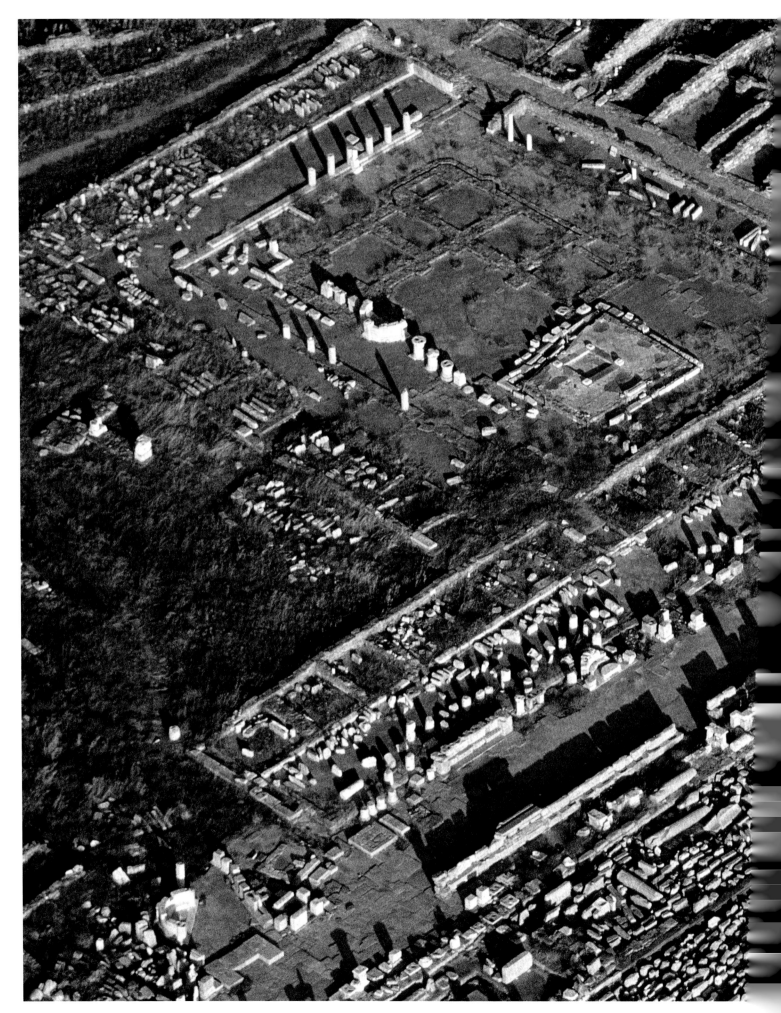

The Agora of the Delians on the Sacred Way, Delos, Cyclades

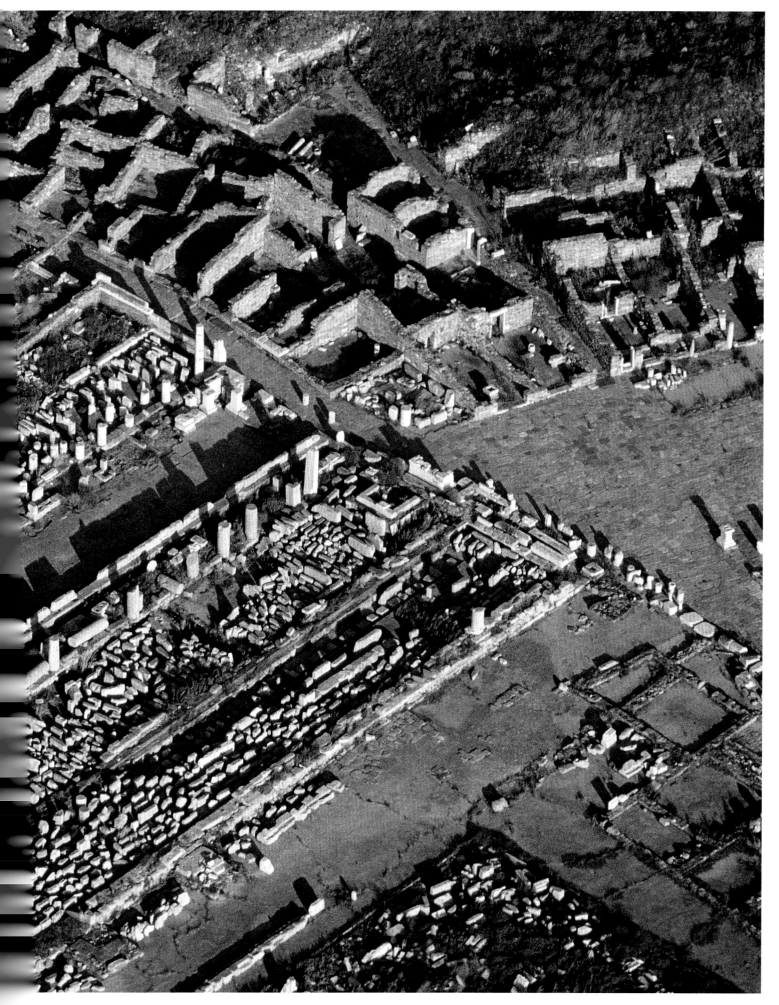

continuing with Thucydides' anti-epic of Greek pitted against Greek (Athens versus Sparta and their respective allies) in an unholy and prolonged civil war. Herodotus' conflict was decided both by land (the battles of Marathon, Thermopylae and Plataea) and by sea (Salamis), those two elements for once acting in cooperation, though more often they were seen as opposed, as mountain (Olympus) was to plain – for instance, the plain of Boeotia in central Greece, which earned itself the nickname 'the cockpit of Ares' (the god of war), so many were the battles fought out there (including Plataea). His conflict was moreover decided relatively quickly, in a matter of a couple of campaigning seasons, in 480 BC and 479 BC. Thucydides' Peloponnesian War by contrast lasted a whole generation, from 431 BC until 404 BC. But both wars affected ancient Greece – and so ultimately us – decisively, though the former more for the good, the latter much more for the worse.

In historical succession Sparta's early dominance of the mainland Greek world was surpassed by the maritime empire of Athens, which yielded the superlative architectural monuments of the massive Athenian acropolis. Athens however rode for the fall it took in the Peloponnesian War, whereupon Sparta – only with massive Persian financial aid, ironically – enjoyed a brief and illusory imperial renascence. Sparta in its turn was brought low by central Greek Thebes, another city with a richly and controversially mythical past (the saga of the house of Oedipus) but also a briefly incandescent present, as it produced a practical and philosophical genius of the calibre of Epaminondas. Truly does he deserve his sobriquet of 'the Liberator', as he set free and politically enfranchised tens of thousands of Helots, Greek men and women who had for generations, indeed centuries, toiled as the internal semi-slave underclass of the heroic but oppressive Spartans.

Epaminondas died in a moment of victory over Athens and Sparta combined, on the field of battle at Mantineia in Arcadia in 362 BC. Just a few years later, there arose a new power in the land, the ancient but until recently deeply divided kingdom of Macedon, with its original capital at Aegae (modern Vergina) and its more modern one at Pella. Here in 356 BC was born Alexander, the future 'the Great', son to Philip II and his northwestern Greek queen Olympias. Pella in due course received the regal trappings due to what became, under Alexander, the far-western capital of a new, monumental Eurasian empire – stretching from the Adriatic and the Danube to Afghanistan and the Indus. Alexander, who reigned from 336 BC to 323 BC, in just over a decade took Greek arms and, not less important, Greek learning, culture and aesthetic sensibilities to conquer a Middle East that had for two centuries known nothing but rule from Persia – the Iran of Georg Gerster's previous book, *Paradise Lost: Persia from Above*.

The epoch that succeeded Alexander's premature demise in Babylon is known rather clumsily as the 'Hellenistic' – basically Hellenic, but with a strong admixture of the orient, it covers roughly the last three centuries BC. Perhaps the translation of the Hebrew Bible into Greek at Alexander's new Egyptian foundation of Alexandria may stand as a symbol of this innovative cultural-political fusion. It is ultimately to the scholarship of the Library and Museum of Alexandria that – by way of the Romans – our legacy from the ancient world is owed. It was during this Hellenistic epoch too that Rhodes flourished as never before or since, producing in the eponymous Colossus one of the seven ancient Wonders of the World, and then that another island far to the north, Samothrace, was graced by the statue of a winged Nike (Victory), fashioned in about 200 BC, which today pulls in very different crowds of worshippers, at the Louvre in Paris.

By the turn of the modern era Greece had come very far indeed from its distant origins in prehistorical Crete, attested by such early sites as Fourni and Palaikastro, and yet more splendidly by Knossos of fabled Minoan and Minotaurian legend. It was to proceed on a very different path with the dawning of the Christian era, where it played a starring role in the Acts of the Apostles and in the destinations of various canonical Pauline epistles – such as Corinth at the hinge between southern and central Greece and Philippi up in the Macedonian north. Yet there was an awful lot of dying left still in pagan Greece; the old, resolutely plural Olympian gods and goddesses, such as Hera of Argos, refused to relinquish their station to the upstart God (singular) without a prolonged rearguard action, as the Panhellenic (all-Greek) religious centres of Delphi and Olympia fervently attest. It took an official decree, issued in AD 395 in Constantinople by a Greek but orthodox Christian emperor who also called himself a 'Roman', Theodosius I, 'the Great', to shut them up and their cult-places down, for good. And it took many more centuries before the Christian redoubts of Meteora and Athos soared into the aerial prominence they have not yet relinquished.

I end this very brief introductory overview with the small rather than great, the little Cycladic island of Melos. Here was set a so-called dialogue that took place in 416/5 BC between representatives of mighty, democratic Athens and of relatively powerless, oligarchically run Melos – the opposition of democracy and oligarchy being yet another of those binary polarities that seem to characterize or beset the Greek scene. Thucydides immortalized it as a philosophical meditation on the fatal necessities of overweening inter-state power exercised incontinently. 'Nothing too much', wisely proclaimed one of the three maxims inscribed on the temple of Apollo at Delphi, the 'navel of the cosmos' as the ancient Greeks saw that numinous site. But Melos had another day in the sun, in 1820, when a representative of the Ottoman sultan contested the ownership of another iconic statue with the French ambassador to the Sublime Porte – a contest the French won, which explains why the armless but far from charmless Venus (Latin) de Milo (Venetian) is an ornament not of Constantinople-Istanbul but – like the earlier Samothrace Victory – of the Louvre. The statue, fashioned of top-grade marble from the nearby island of Paros, represents an Aphrodite, and a pun: the ancient Greek for apple (or quince) was very close to 'Melos', and everyone knows the story of the Judgement of Trojan prince Paris, who awarded the golden apple to Aphrodite, thereby setting in train the events leading to an earlier pretty disastrous conflict, the Trojan War, national bard Homer's chosen specialist subject.

In the *Iliad*, the gods' messenger is the female Iris, also a personification of the rainbow; in the *Odyssey*, it is the male Hermes who performs that role. Georg Gerster is both our modern Iris and our modern Hermes, mediating as he does between heaven and earth, between the world of the gods and the mundane world we poor mortals inhabit. Until the day that deep digital maps are readily available to enable us to see terrestrial patterns and information that are right now literally invisible to us, this stunningly beautiful photographic album will continue to provide us with a spectacularly artistic as well as earthily realistic vision of the space those who are fortunate enough to inhabit the land of Greece probably all too often take for granted.

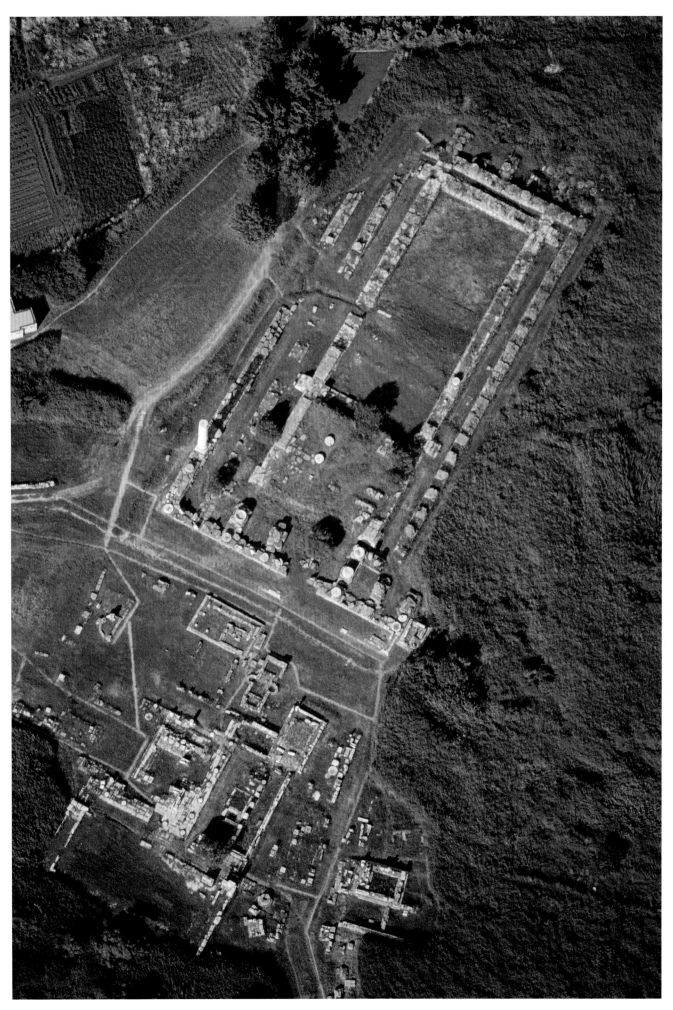

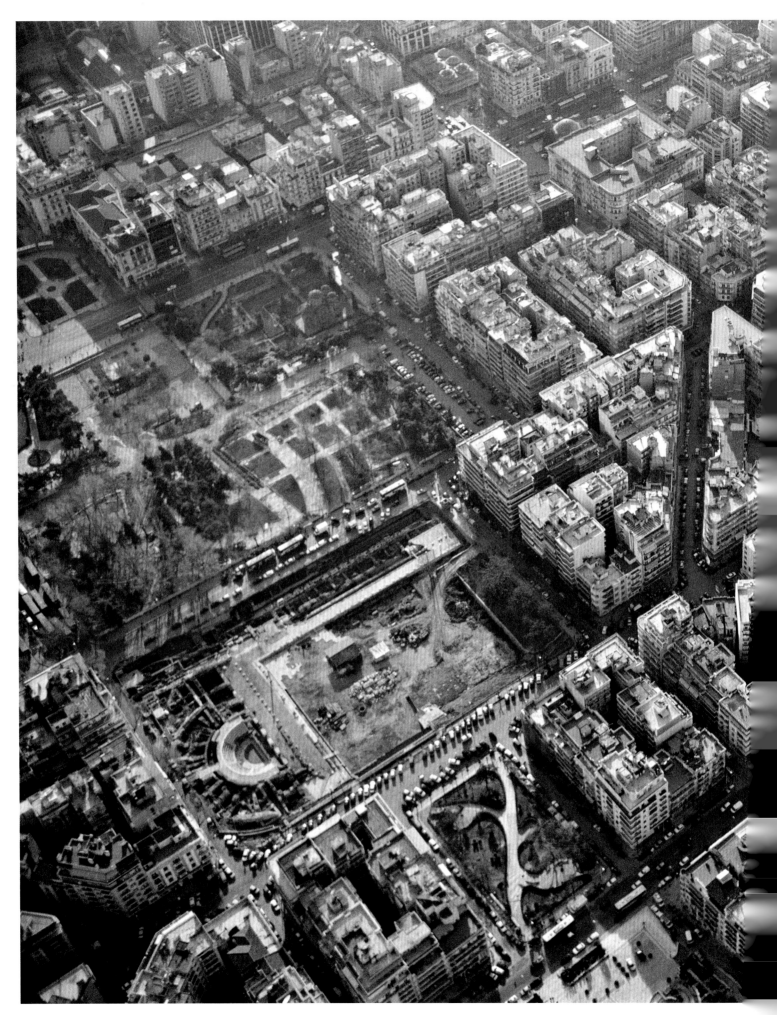

Thessaloniki, the capital of Macedonia

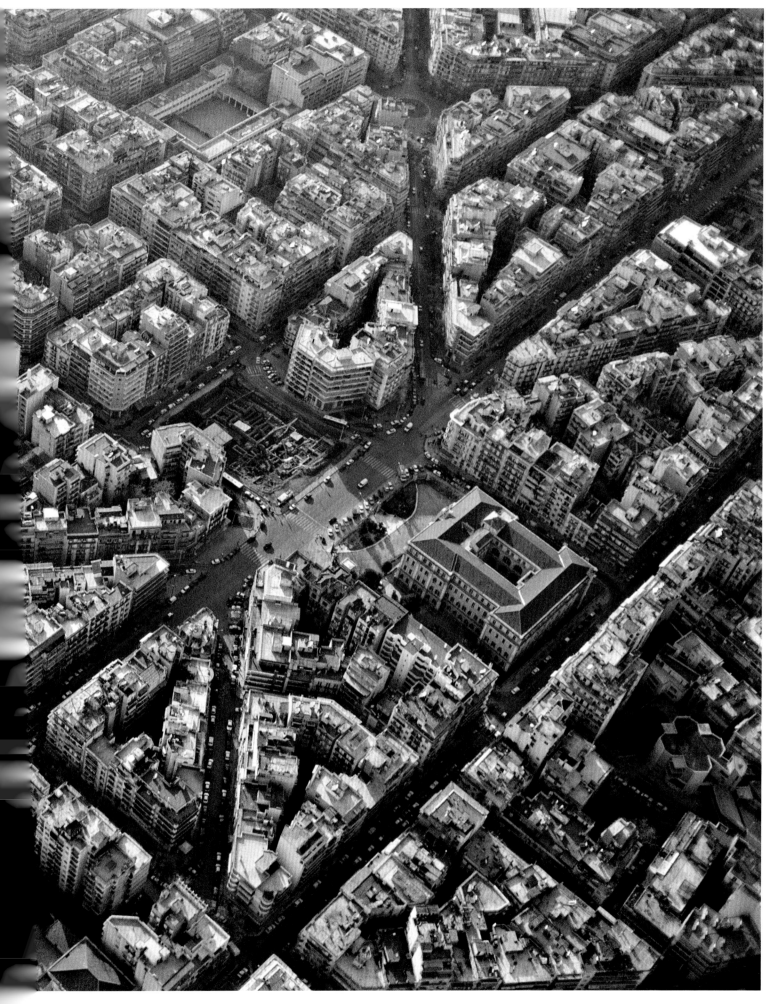

page 14
The Agora of the Delians on the Sacred Way, Delos, Cyclades
Pilgrims, chanting and adorned with flowers, reached the sanctuaries via the Sacred Way, a broad processional road. It was lined with votive offerings, and there were columned halls (stoas) and gathering places (agoras) along the route. Unfortunately there is no description of Delos by ancient writers; therefore archaeologists often find themselves at a loss as to a building's function or purpose. The square in this photograph is known as the Agora of the Delians, but it may well have served as a market rather than a place for meetings.

page 17
Temple to Hera on the island of Samos, Eastern Aegean
Samos was considered to be the birthplace of Hera, wife of Zeus. When in about 535 BC Polycrates, tyrant of Samos, started rebuilding an earlier sanctuary to Hera that had been destroyed by fire or an earthquake, his plans were grandiose: to build the biggest temple ever. After three centuries of construction, however, the shrine was still unfinished. It was deliberately left open to the sky, without a roof. The mathematician Pythagoras was a native of Samos. Both the town named for him, Pythagorio, and the Heraion are UNESCO World Heritage sites.

page 18
Thessaloniki, the capital of Macedonia
Vibrant, bustling Thessaloniki is the second city of Greece, but prides itself on being first for culture. It dates back to shortly after the time of Alexander the Great, and archaeologists have uncovered a Greek agora (right of the centre in the photograph) and a Roman forum with an adjacent odeum (lower left corner). As a port city and a hub of trade routes, Thessaloniki once rivalled Byzantium, and churches from the Byzantine period have earned the modern city the status of a UNESCO World Heritage site.

page 21
The sanctuary at Eleusis, Attica
No other shrine in antiquity equalled the sanctuary dedicated to the great goddess Demeter and her daughter Persephone in Eleusis, its ruins now encroached upon by industry and suburban Athens. Pilgrims from all over Greece flocked to this site for the Eleusinian Festival, seeking initiation through the Eleusinian Mysteries into the cult of Demeter and Persephone, which celebrated fertility and its annual rebirth in spring. The shrine was conceived as a fortress and the initiated were sworn to secrecy – revealing the sacred rites was punishable by death. Death also awaited any uninitiated intruder. The ceremonies remained secret for the nearly 1500 years the sanctuary was active.

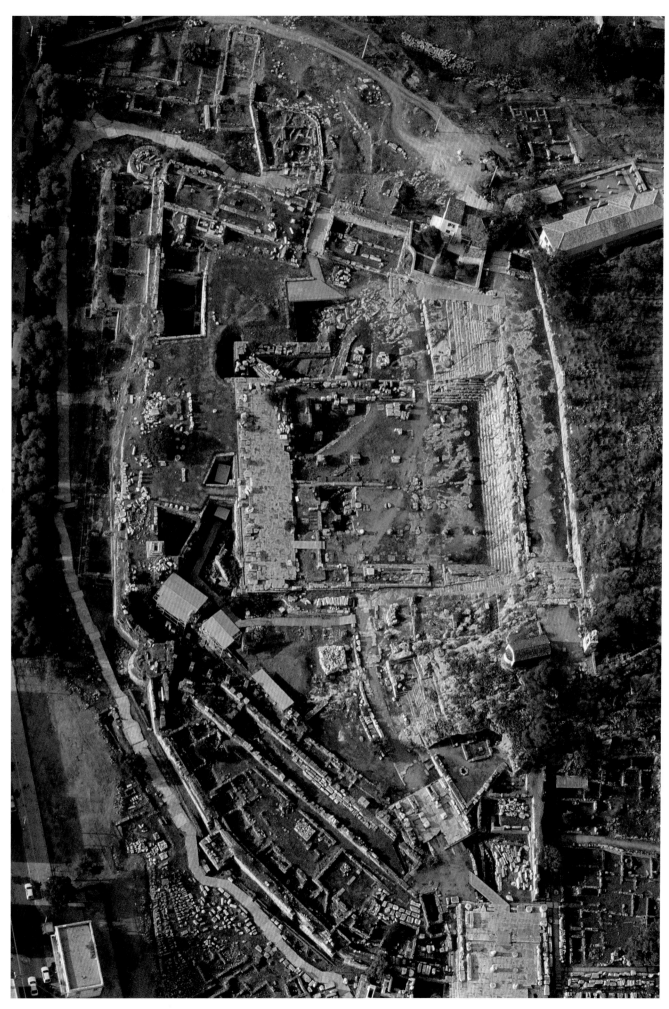

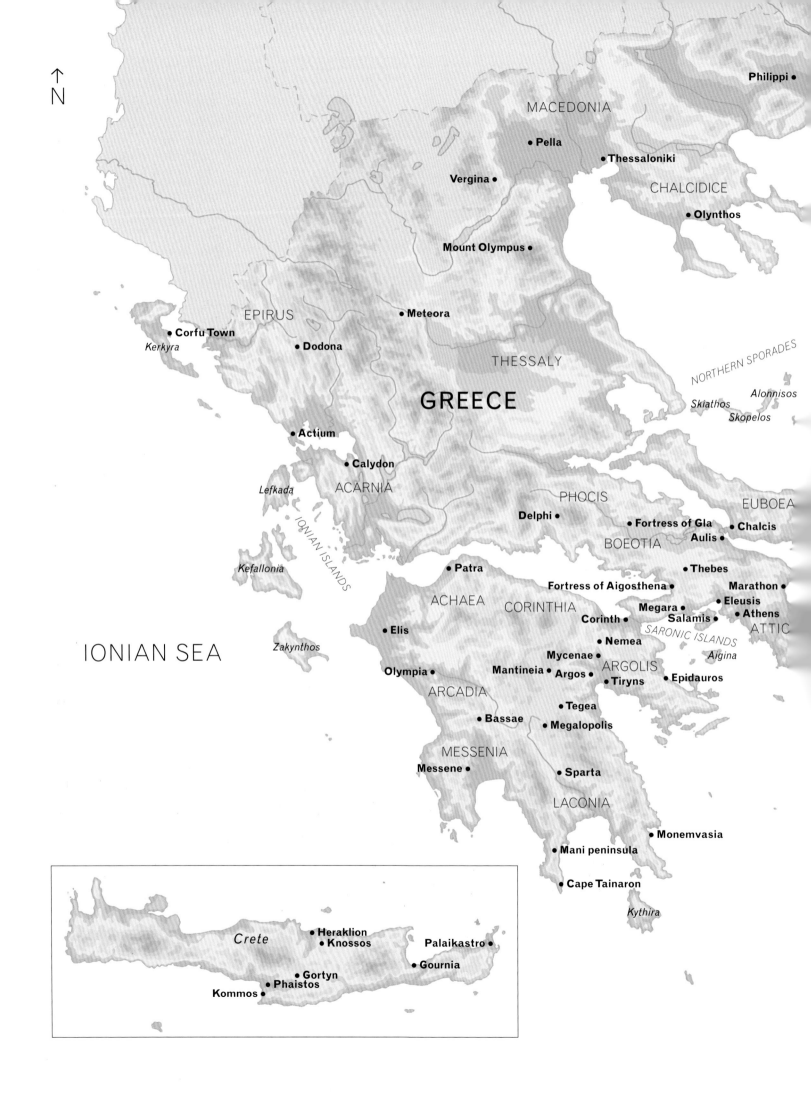

N↑

MACEDONIA

• Philippi

• Pella

• Thessaloniki

Vergina •

CHALCIDICE

• Olynthos

Mount Olympus •

EPIRUS

• Corfu Town

Kerkyra

• Dodona

• Meteora

THESSALY

GREECE

NORTHERN SPORADES

Alonnisos

Skiathos

Skopelos

• Actium

• Calydon

ACARNIA

Lefkada

PHOCIS

EUBOEA

Delphi •

• Fortress of Gla

• Chalcis

Aulis •

BOEOTIA

IONIAN ISLANDS

Kefallonia

• Patra

• Thebes

Marathon •

Fortress of Aigosthena •

ACHAEA

CORINTHIA

Megara •

• Eleusis

Salamis •

• Athens

Corinth •

SARONIC ISLANDS

ATTIC

Zakynthos

• Elis

• Nemea

Mycenae •

ARGOLIS

Aigina

IONIAN SEA

Olympia •

Mantineia •

Argos •

• Tiryns

• Epidauros

ARCADIA

• Tegea

• Bassae

• Megalopolis

MESSENIA

Messene •

• Sparta

LACONIA

• Monemvasia

• Mani peninsula

• Cape Tainaron

Kythira

Crete

• Heraklion

• Knossos

Palaikastro •

• Gournia

• Gortyn

• Phaistos

Kommos •

THRACE

• **Byzantium**

• **Kavala**

Thasos

Samothrace

Mount Athos

TURKEY

• **Troy**

Lemnos • **Hephaestia**

MYSIA

Agios Efstratios

Lesbos

Mytilene • • **Pergamum**

AEGEAN SEA

LYDIA

Skyros

Psara

Chios

• **Ephesus**

Andros *Samos* CARIA

• **Cape Zagora** *Ikaria* *Fourni islands*

ounion *Tinos*
ea
Mykonos *Patmos*
Ermopouli • *Delos*
thnos *Syros* *Rheneia*

CYCLADES DODECANESE

Serifos *Kos*

Paros • **Naxos Town**

Sifnos *Naxos*

Amorgos

• **Panagia Chozoviotissa**
 monastery

Ios *Astypalaia*

Melos *Sikinos* *Tilos* • **Rhodes Town**
Folegandros
 • **Kamiros**
Thera • *Anafi*
 Thera *Rhodes*
 • **Lindos**

Karpathos

0 km 25 km 50 km 75 km 100 km 150 km

Kasos

THE SITES OF ANCIENT GREECE

The sites, cities and landscapes of Greece depicted in this book cover a period of well over three millennia. 'Greece' is an ambiguous term – the current nation-state of that name embraces far less than did ancient Hellas, which extended from southeast Spain to Georgia and beyond. For present purposes, 'Greece' here focuses on the Aegean heartland, as shown on the map on page 22.

Mount Olympus, Thessaly/Macedonia

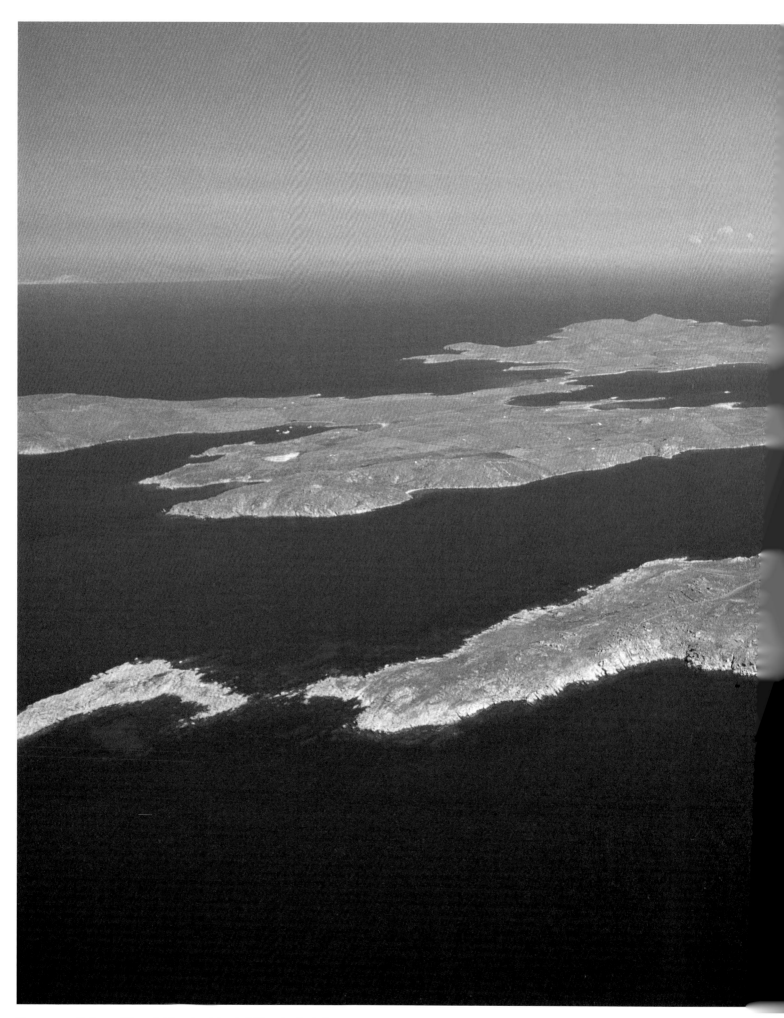

Delos and the neighbouring island of Rheneia, Cyclades

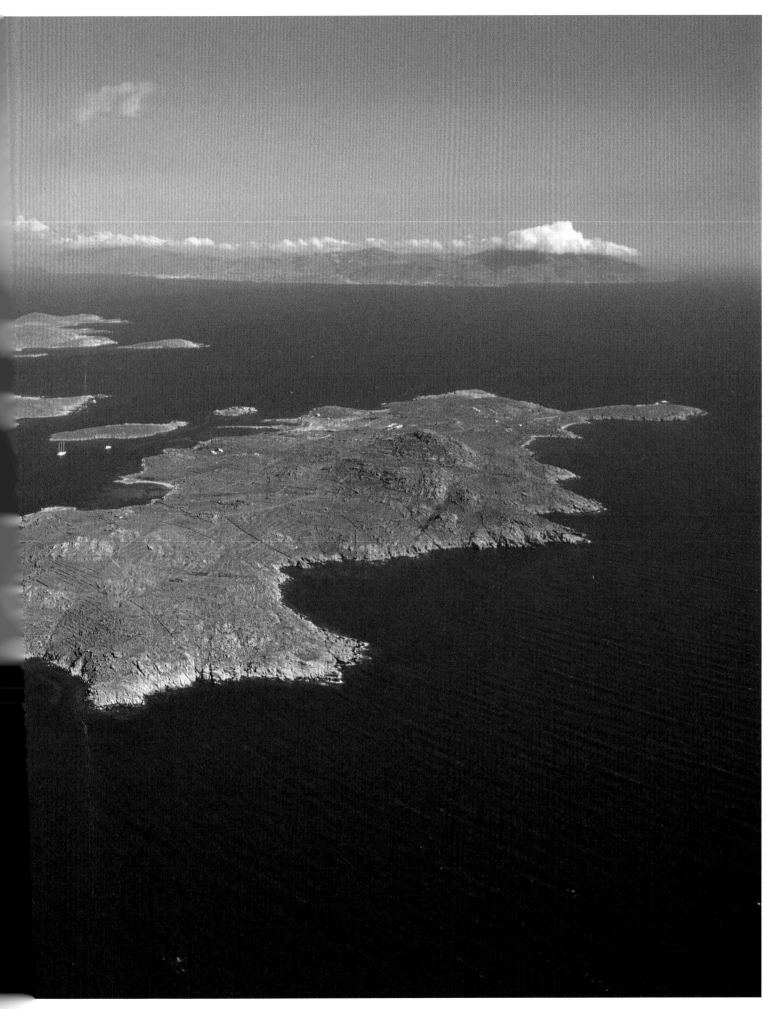

Mount Olympus, Thessaly/ Macedonia

Rising up to a height of 2919 metres (9577 feet), Mount Olympus marks the border between Thessaly and Macedonia. This is the highest mountain in Greece, and certainly the most celebrated. The ancients revered it as the home of the 12 principal gods presided over by the supreme deity, Zeus, whose throne on the summit is covered in snow for the better part of the year. As Mount Olympus is usually wreathed in clouds, Homer conferred on Zeus the epithet of 'cloud-gatherer'. Today naturalists praise the area's biodiversity, with some 1700 plant species, many of them native and rare. Mount Olympus was declared a national park in 1937.

Delos and the neighbouring island of Rheneia, Cyclades

According to myth and legend, the utterly barren small island of Delos was the birthplace of the twin gods Artemis and Apollo. During the last millennium BC, sacred Delos developed into a religious and cultural centre of ancient Greece. Most of the time Delos was a dependency of Athens, politically and administratively. Twice Athens ordered a cleansing of the island, the first purge targeting graves within sight of the sanctuaries, the second removing all dead bodies from the sacred soil. It was forbidden by law to die or give birth on Delos. The neighbouring island of Rheneia profited by establishing cemeteries and a kind of maternity home. In the fifth century BC, a pilgrim who could not face the bustle of the sacred port of Delos went ashore on Rheneia and had a floating bridge to Delos built overnight. Delos is a UNESCO World Heritage site.

The theatre district of ancient Delos, Cyclades

In 166 BC the Romans declared Delos a free port and the island's economy took off like a rocket. Merchants, bankers and shipping tycoons from the Levant, Syria, Egypt and Italy settled on Delos, preferably in the residential theatre district, and brought their divinities with them. Egyptians donated shrines to Isis, Anubis and Serapis; Jews built a synagogue. But adherence to spiritual values declined: now people were motivated by money. Delos was an important commercial centre for wine, oil and wood, and it became the primary market for grain and slaves in the eastern Mediterranean. Every day up to 10,000 slaves were traded on the once so sacred island. In 88 BC Mithridates, King of Pontus, sacked Delos, and pirates who previously had been kept in check by the island's sanctity did the rest. By 69 BC, Delos was no longer important.

The temple of Poseidon on Cape Sounion, Attica

Perhaps the most emblematic sight of Greece is that of the temple of Poseidon, the god of the sea, on Cape Sounion. Attica's southernmost headland plunges precipitously into the Aegean Sea, and the turbulent waters off the cape provided good reason to placate Poseidon with offerings. Pericles (c.495–429 BC), general of Athens during the city's 'Golden Age', ordered the temple to be built around 440 BC, at the same time as the Parthenon. Today, the gleaming white marble of the sanctuary is a comforting landmark for approaching sailors. In antiquity, however, the temple's value as a signal may have been reduced by its gaudy colouring.

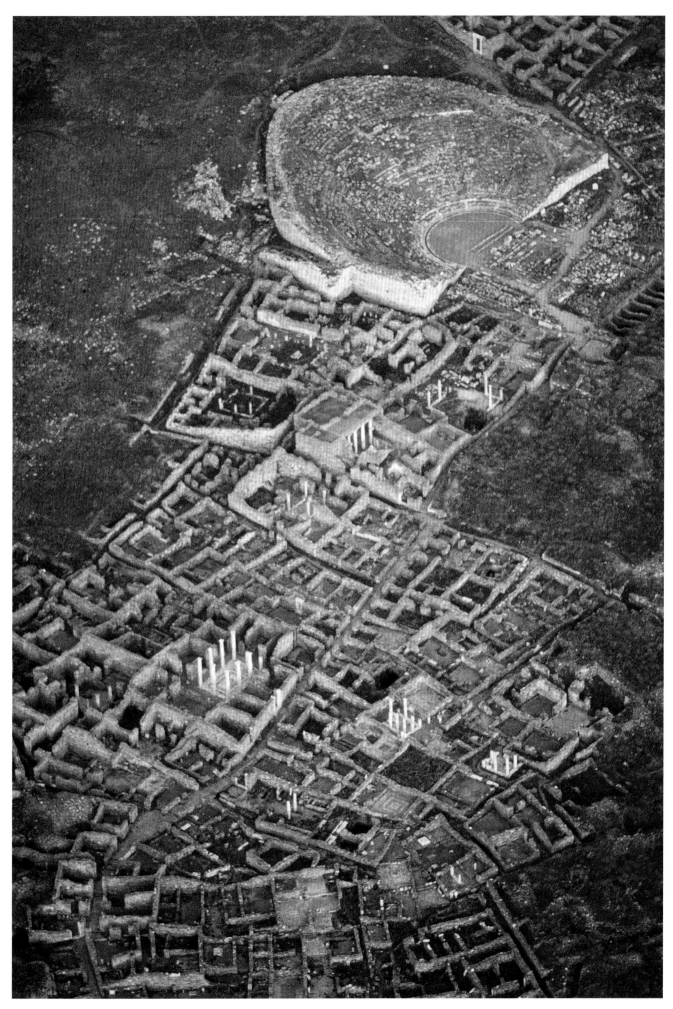

The theatre district of ancient Delos, Cyclades

The temple of Poseidon on Cape Sounion, Attica

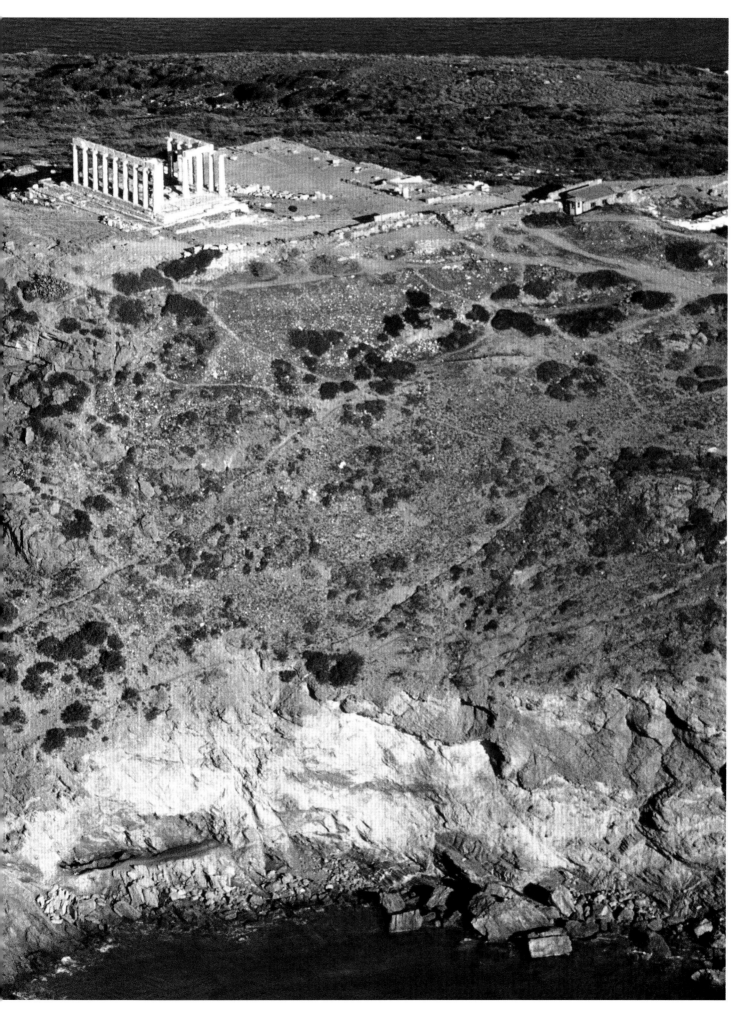

The ruins of ancient Aigina Town, Aigina, Saronic islands

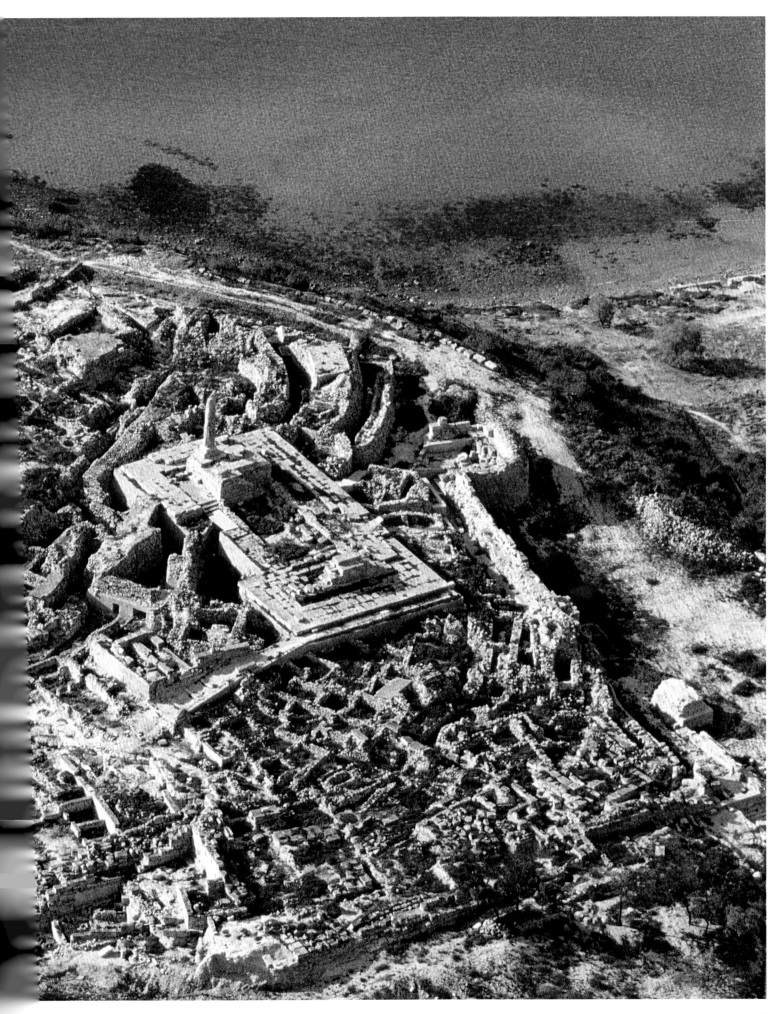

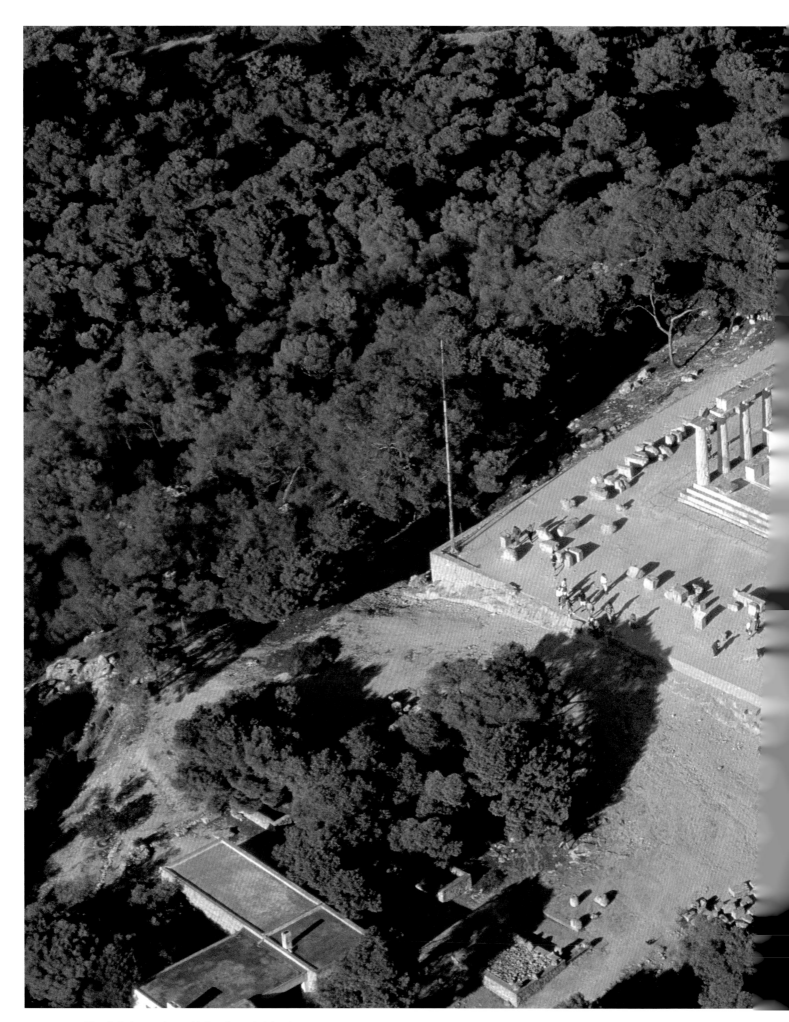

The Aphaia temple on Aigina, Saronic islands

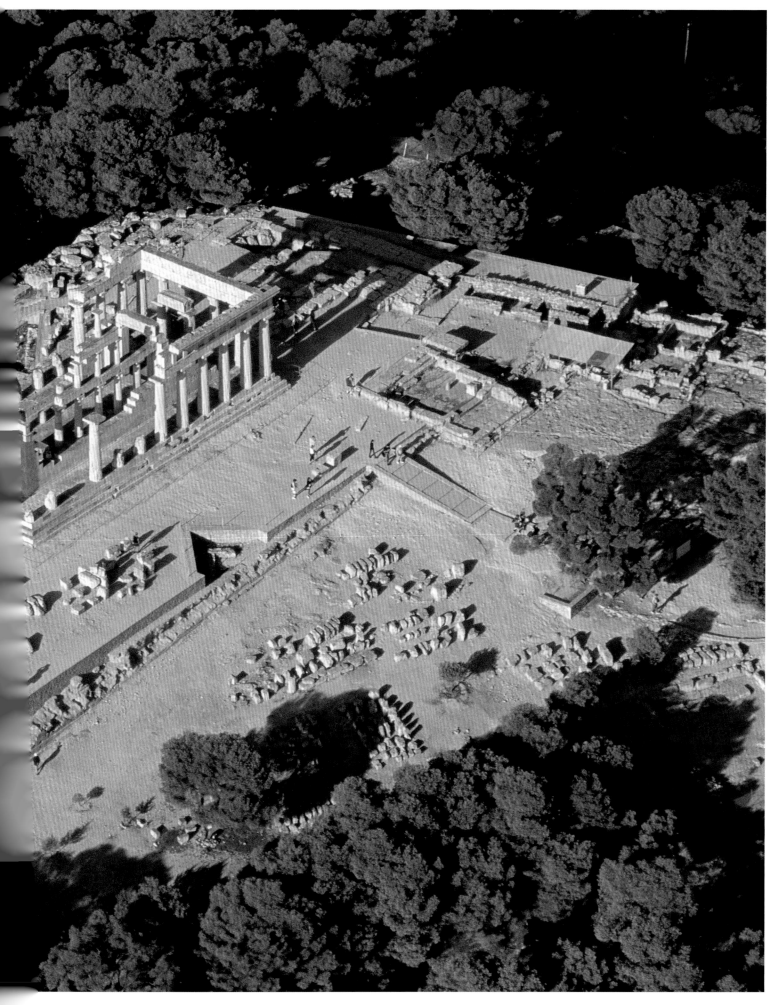

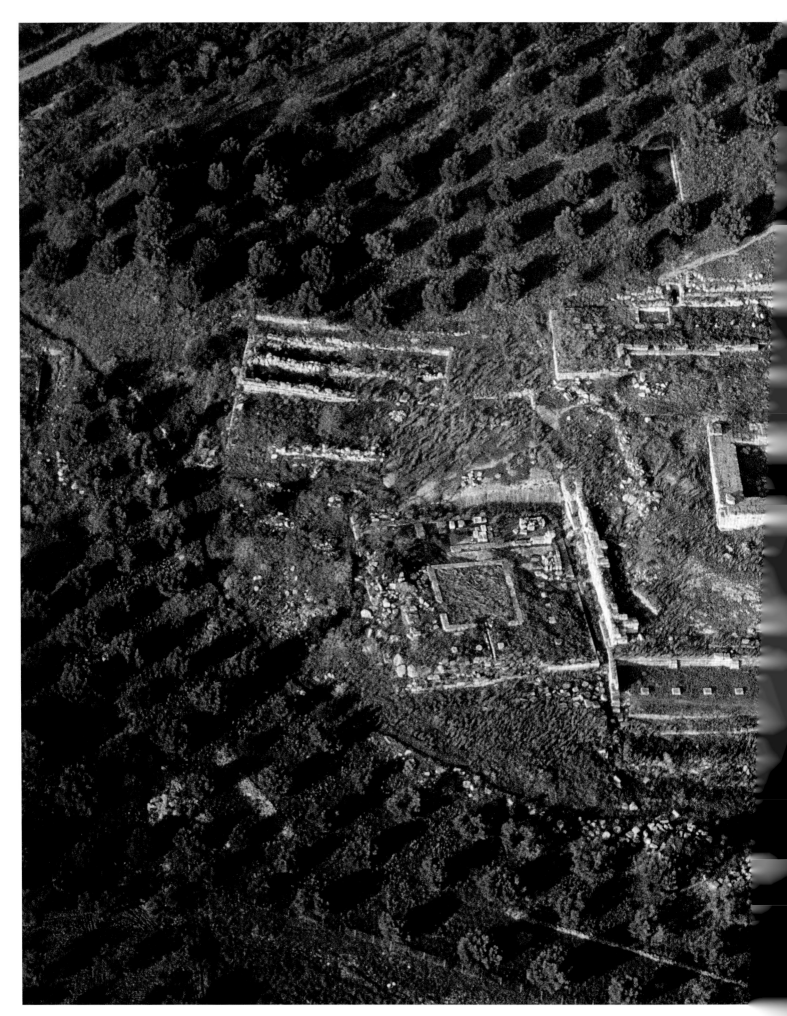

The Heraion, Argolis

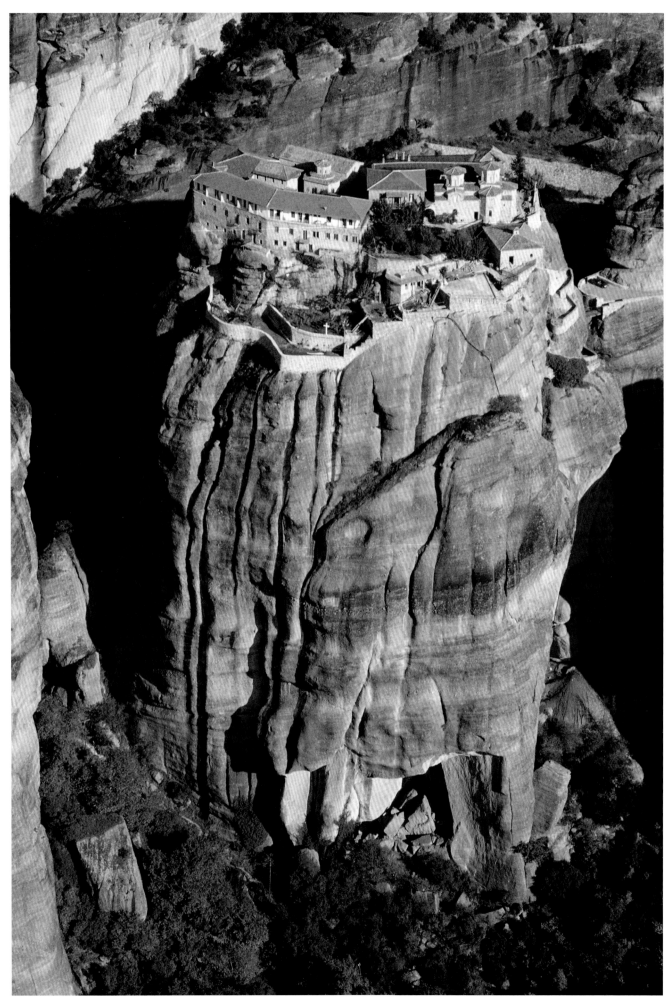

The Meteora monastery of Varlaam, Thessaly

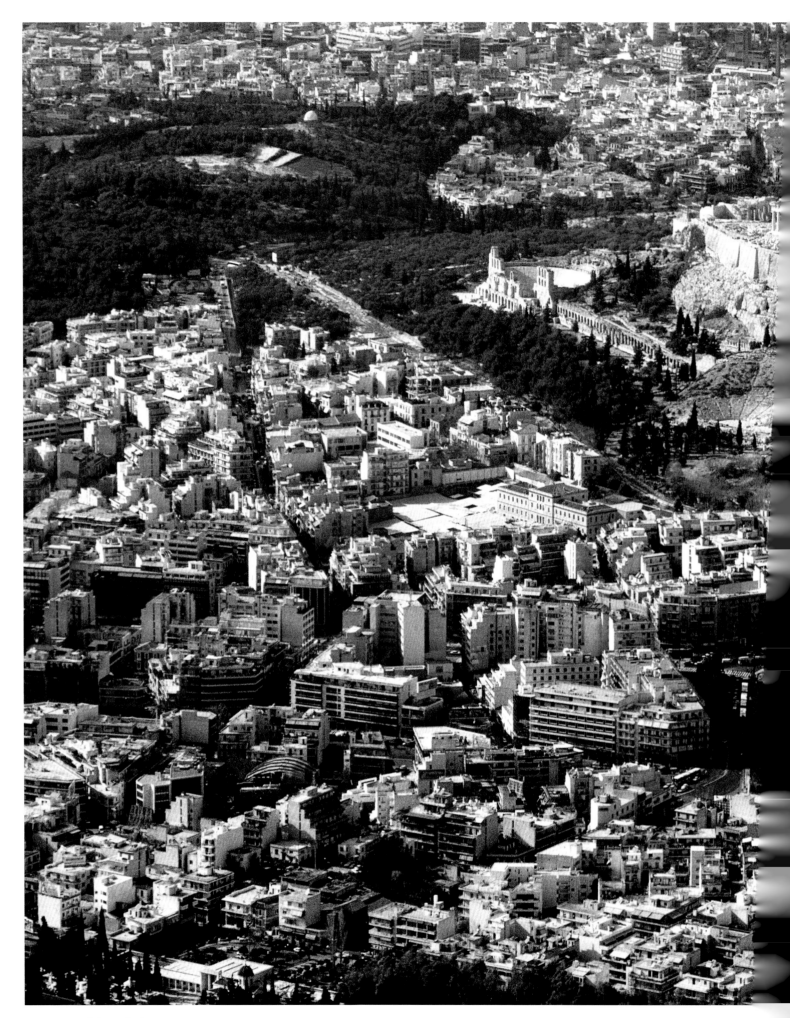

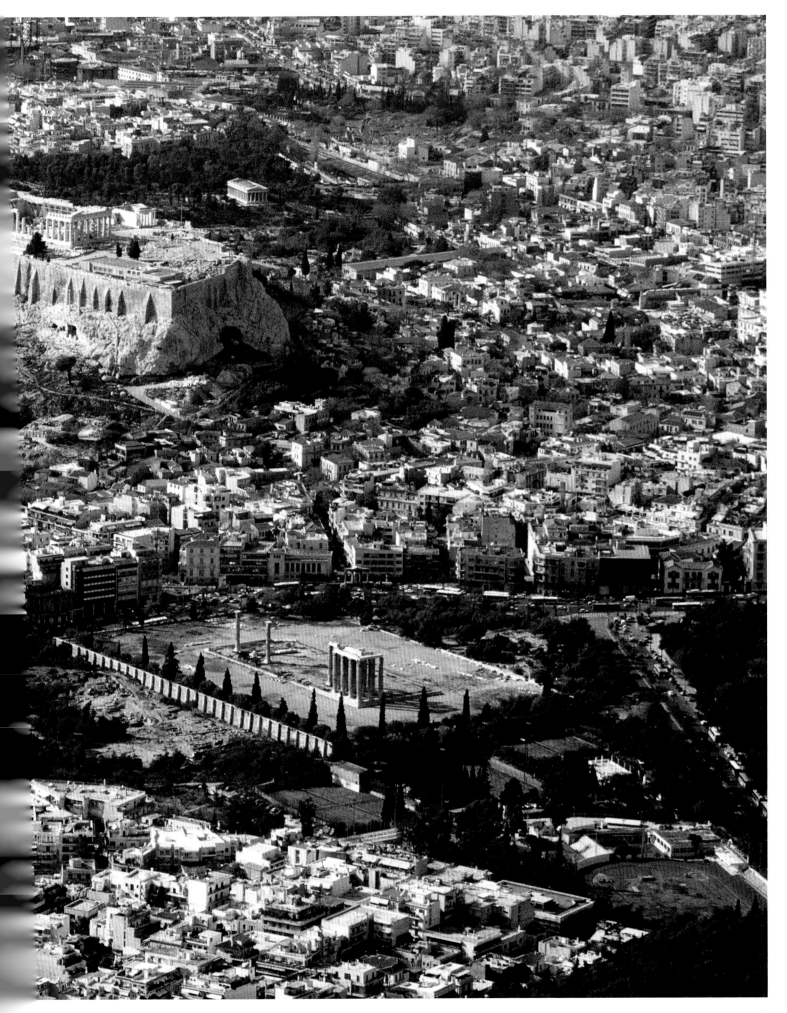

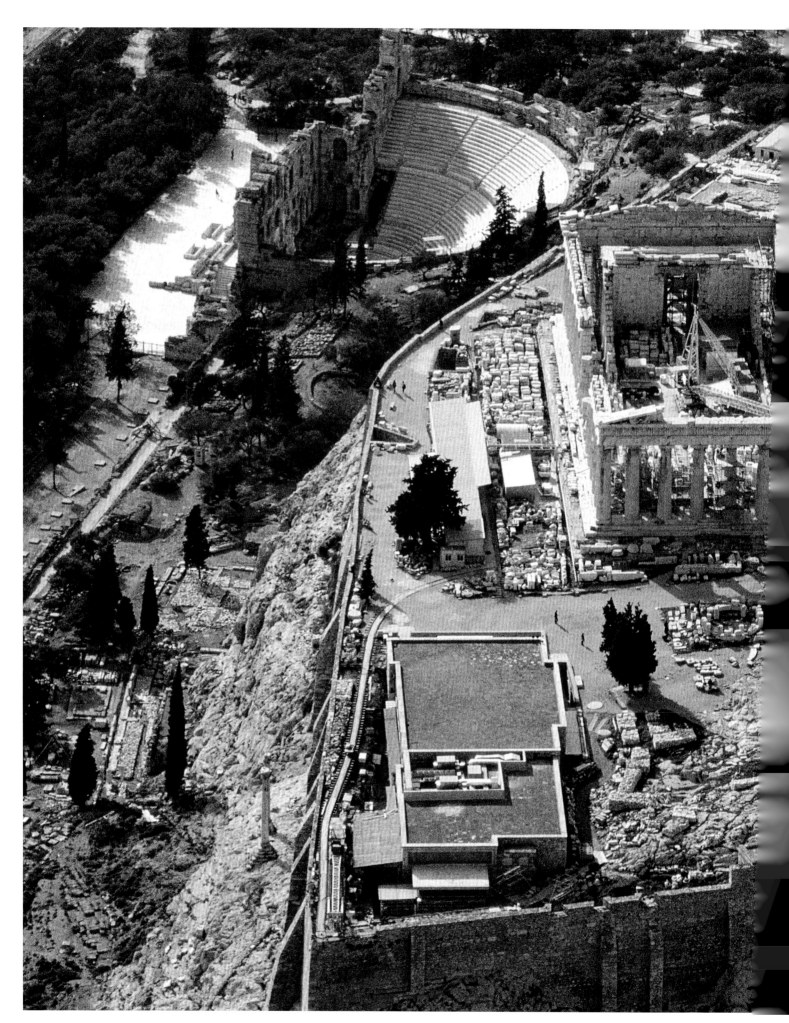

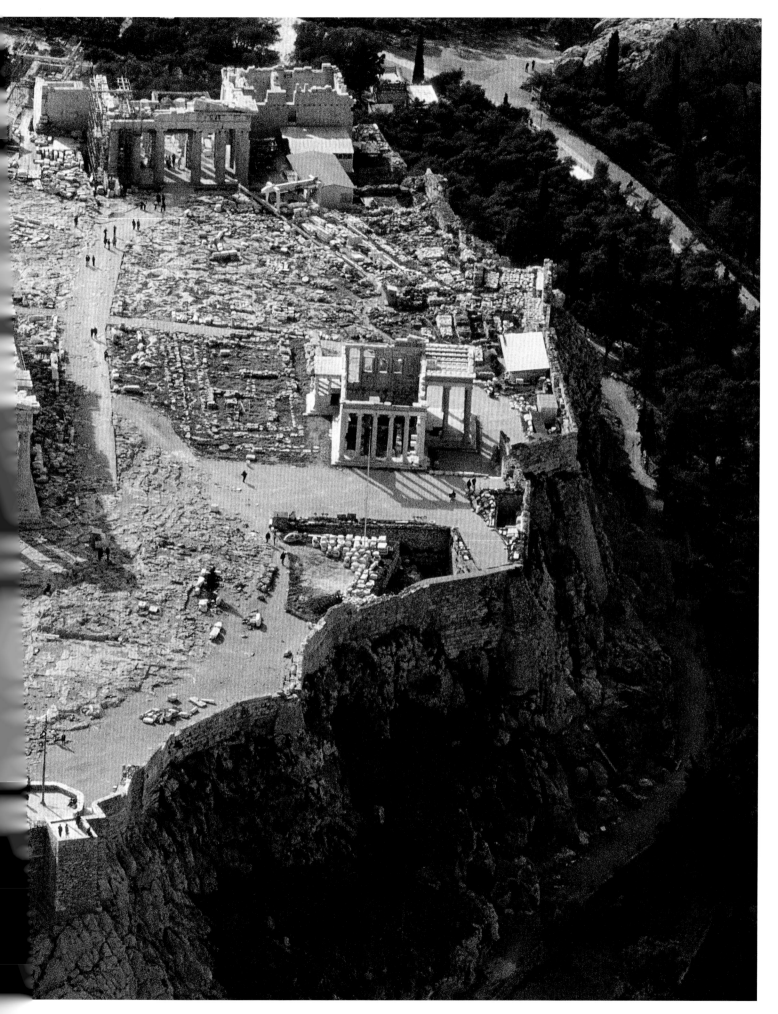

Athens, Attica

The monuments of Athens' heritage are like jewels that stud the fabric of the modern metropolis, which has more than four million inhabitants. The Acropolis stands out as the city's crowning glory, with the Odeum of Herodes Atticus and the Theatre of Dionysos on its slopes, the sites of festivals to which the famous Attic writers contributed their plays. Visible behind the Acropolis in this photograph are the Agora, the meeting place of ancient Athens and a cradle of democracy, and the Kerameikos cemetery. In the lower right stand the surviving columns of the Olympieion, a colossal temple dedicated to Zeus Olympios that was finally completed in the second century AD by the Roman Emperor Hadrian, more than 600 years after construction started.

The Acropolis of Athens, Attica

In the later fifth century BC, classical Greek architecture reached its peak in the preeminent edifice of the Acropolis, the Parthenon. A temple dedicated to Athena, it housed a monumental gold and ivory statue of the goddess by Phidias (c.490–430 BC). Conspicuous below it is a later addition: the Odeum of Herodes Atticus, built in the early second century AD. The Acropolis of Athens is a UNESCO World Heritage site.

The Marmaria in Delphi, Phocis

The Greeks of the Archaic and Classical periods (roughly from 700 BC until 330 BC) considered Delphi 'the navel of the world'. They believed that Zeus sent off an eagle from each end of the universe so that they would meet in the centre, and they met over Delphi. A stone known as an *omphalos*, meaning 'navel', was placed to mark the spot. Delphi earned its central position in the Hellenic world through its sanctuary of Apollo, which dispensed oracles – first only once a year, but later once a month. The oracle was closed in the winter, when Apollo was away. Before entering the sanctuary of Apollo, pilgrims stopped at the temple of Athena, which is now known as the Marmaria – the magnificent temple was exploited as a marble quarry. A graceful rotunda, or *tholos*, possibly a sanctuary of the earth goddess Gaea, echoes its former splendour.

The sacred precinct of Delphi, Phocis

The sanctuary of Apollo (in the centre of the photograph) was the source of the oracles. The Pythia, an ordinary woman of a certain age • who had led a blameless life, would sit on a tripod atop a fissure in the earth, uttering what the god inspired her to say; priests translated the sibylline babble into verse. The oracle of Delphi was consulted by states and cities, kings and generals, as well as by individuals from lower walks of life. Those seeking advice paid generously, and treasures piled up in Delphi (the Treasury of the Athenians is visible in the lower right corner). Delphi also had a theatre (upper left corner) and a stadium (not shown here) as part of its infrastructure for the quadrennial Pythian Games, with competitions in poetry as well as in sports. Delphi is a UNESCO World Heritage site.

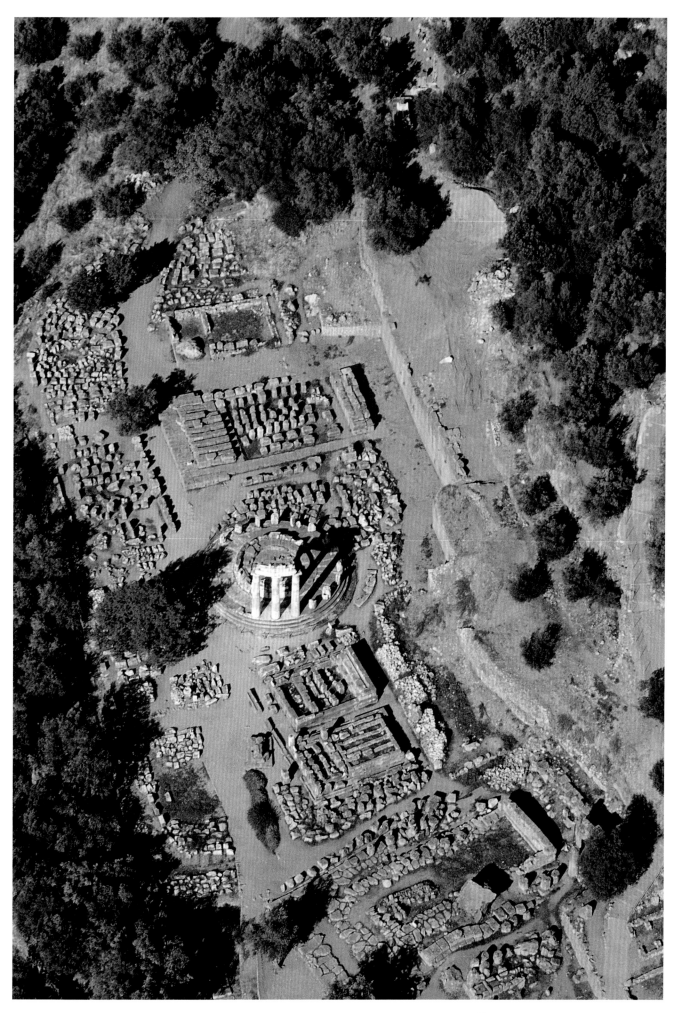

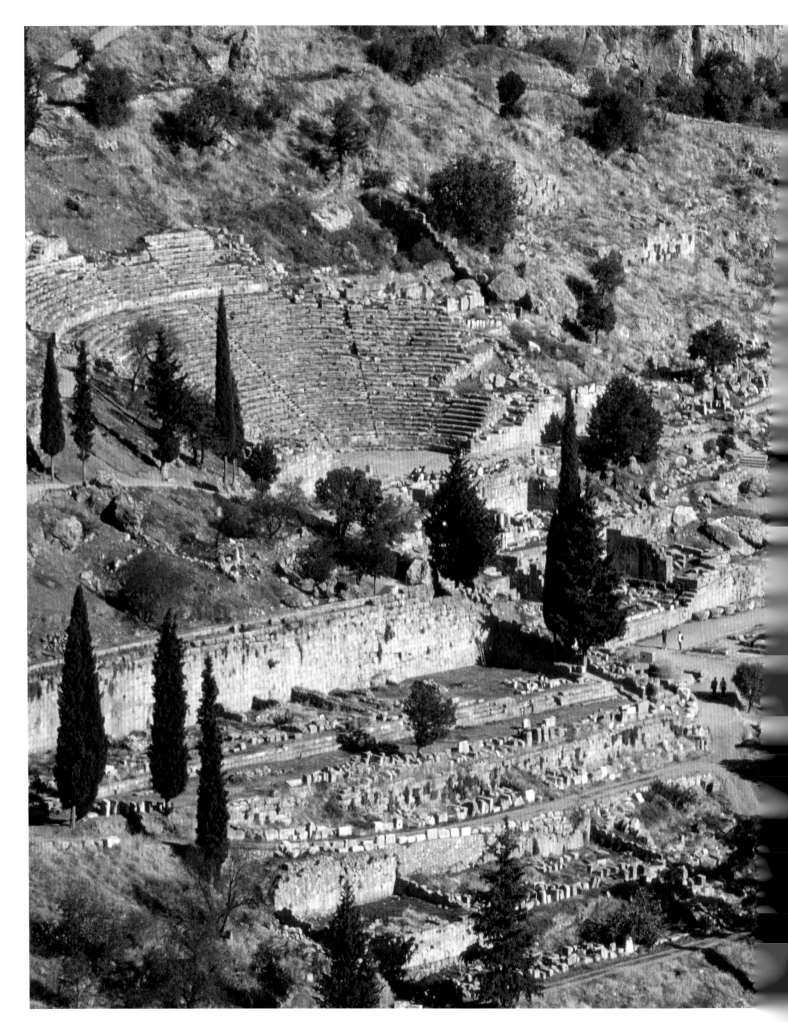

The sacred precinct of Delphi, Phocis

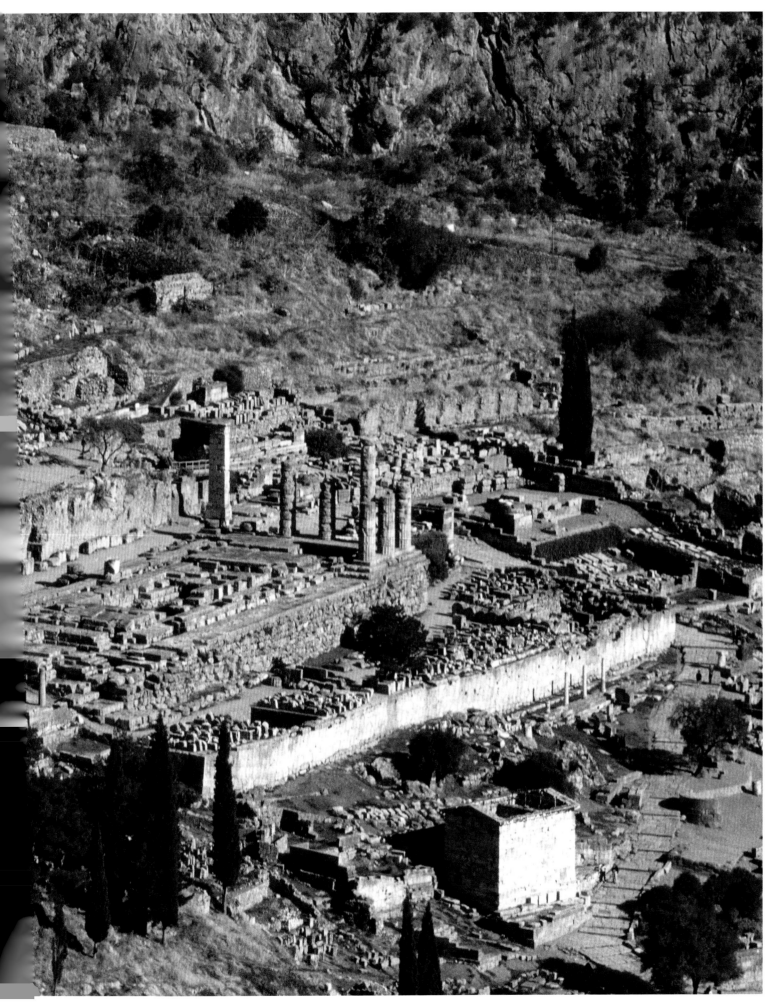

page 51
The New Town of Olynthos, Chalcidice

The regional capital of the Chalcidice peninsula, Olynthos was forced to expand in the second half of the fifth century BC due to an influx of people. The new residential areas were laid out in a grid pattern, with a hierarchy of streets from boulevards to alleys, not unlike a modern subdivision. Olynthos was destroyed in the year 348 BC and never rebuilt, rewarding today's archaeologists with a unique window on ancient town planning.

page 52
Ioulida, the capital of Kea, Cyclades

With its cubic white houses hugging the hill like rows of seats in a natural amphitheatre, modern Ioulida, the capital of Kea, probably doesn't look much different from its predecessor, the ancient town of Ioulis. Even the red-tiled roofs may have a link to the past: Ioulis exported red chalk, highly esteemed by the Athenians for coating their ships. In antiquity, the older inhabitants of this delightful, sunny town appear to have been subject to a rather sinister law: according to the geographer and historian Strabo (c.63 BC–after AD 23), citizens over the age of 60 had the right – and in times of war, when food for the young defenders of Ioulis was dwindling, the obligation – to die by drinking hemlock. The suicidal so-called 'Kean cup' became proverbial in ancient Greece.

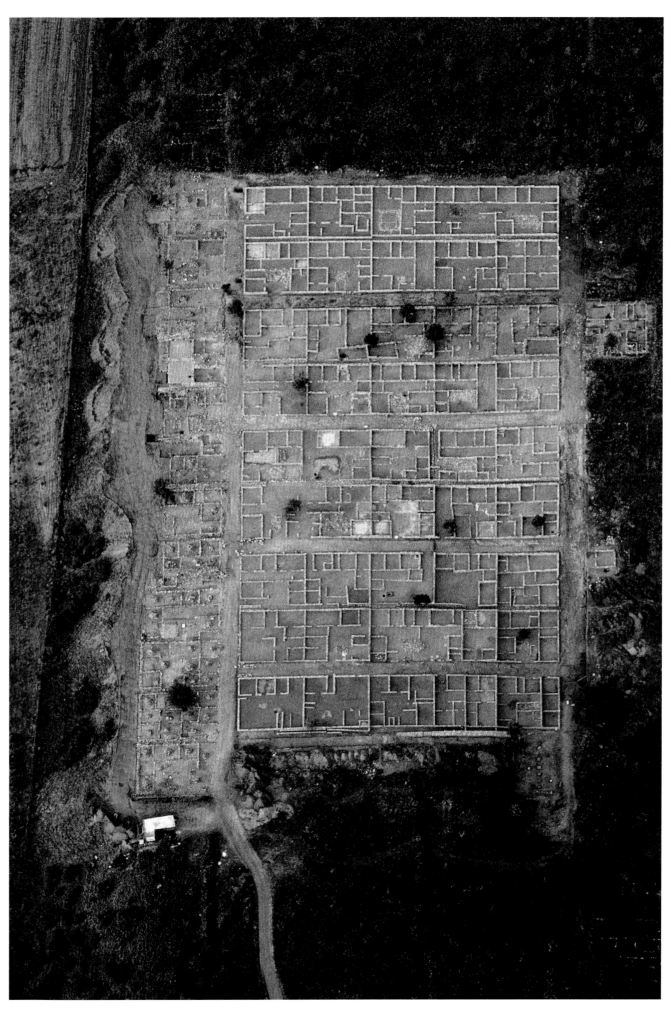

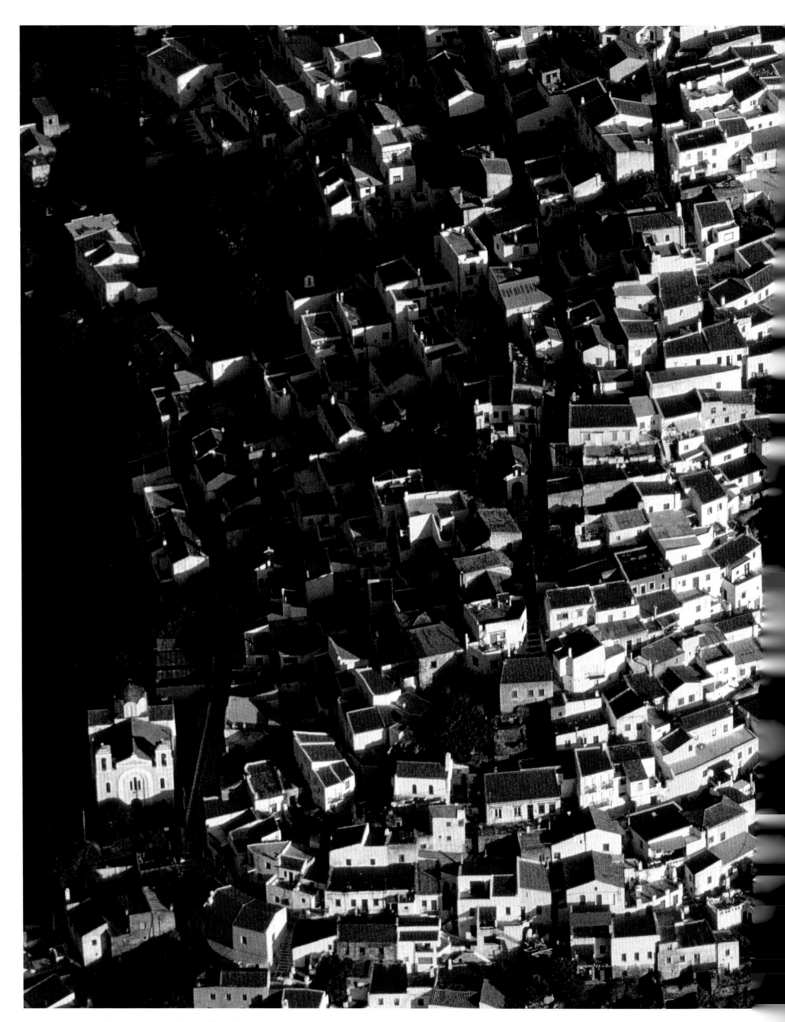

Ioulida, the capital of Kea, Cyclades

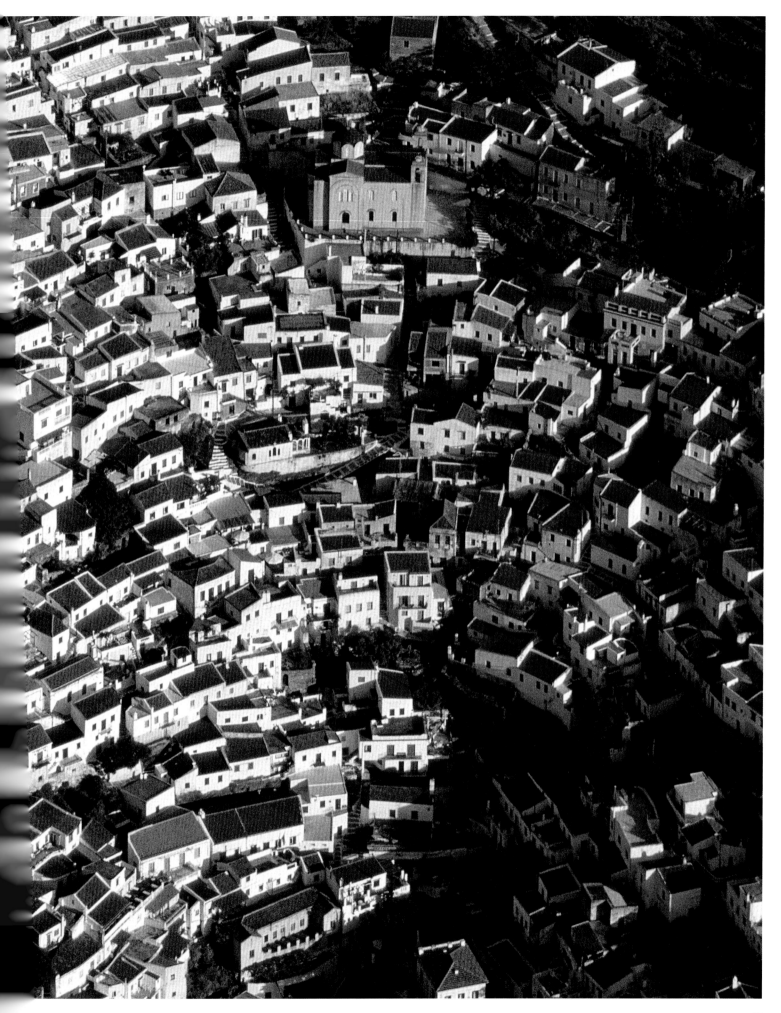

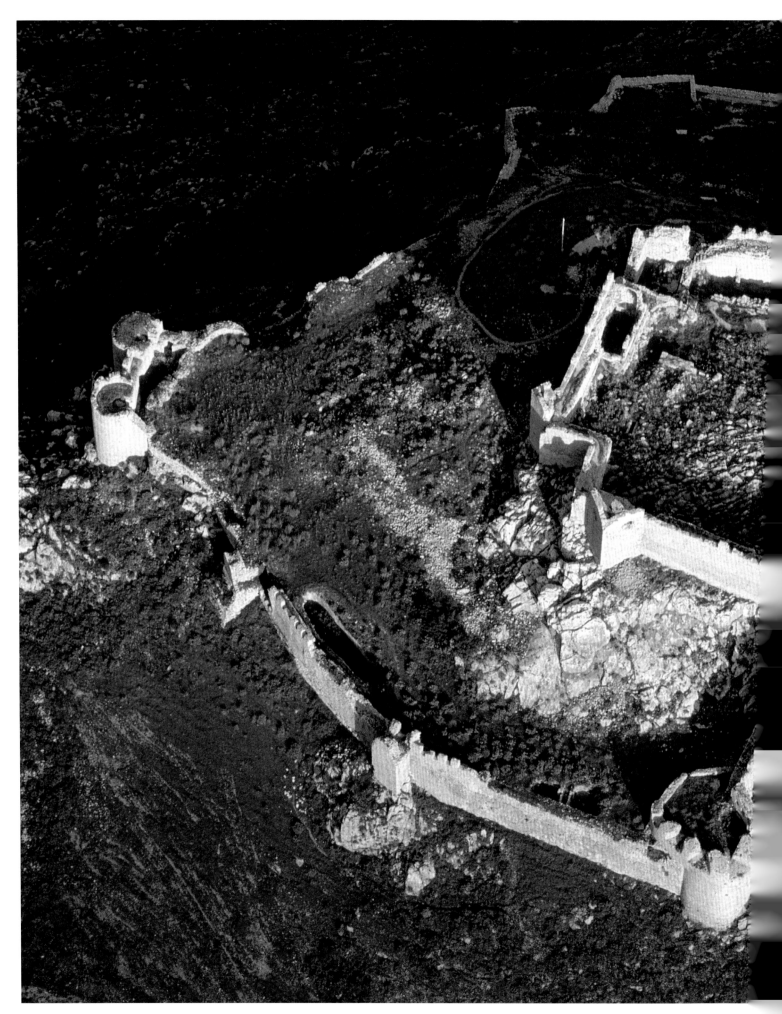

The fortress of Larissa, Argos, Argolis

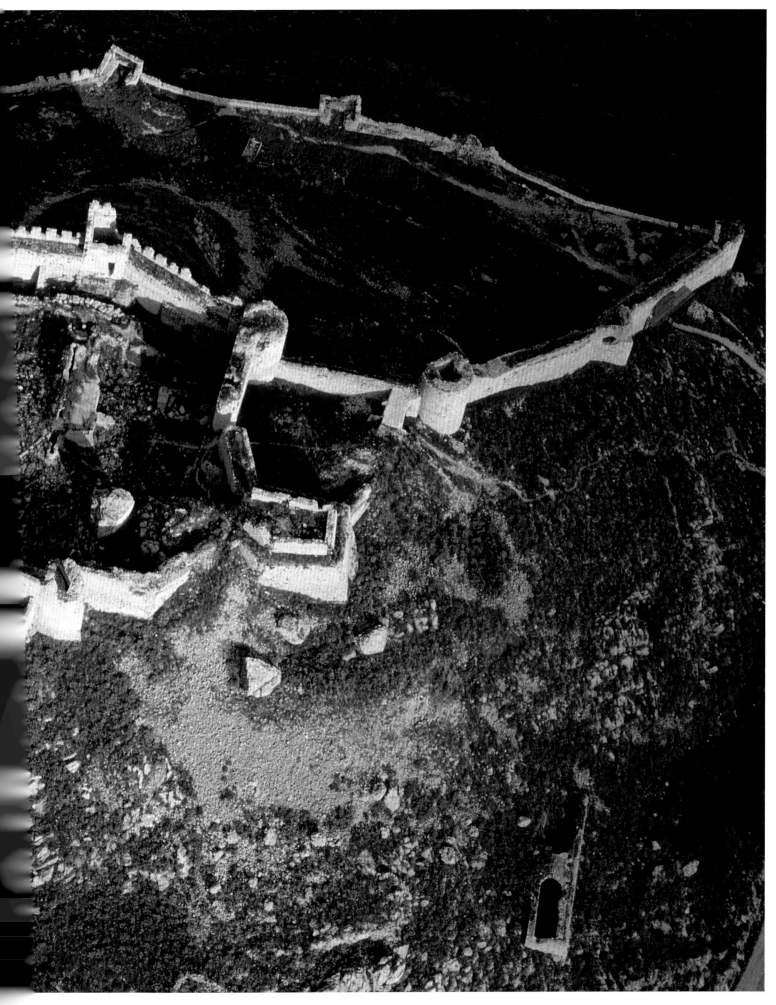

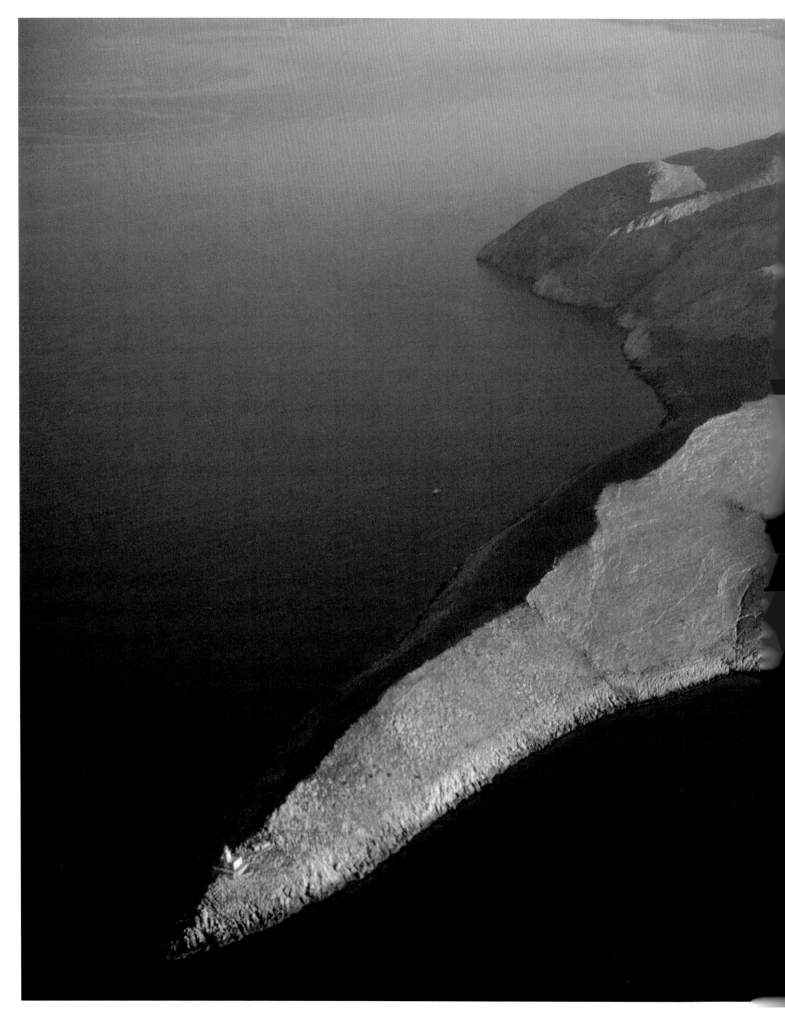

Cape Tainaron, Laconia

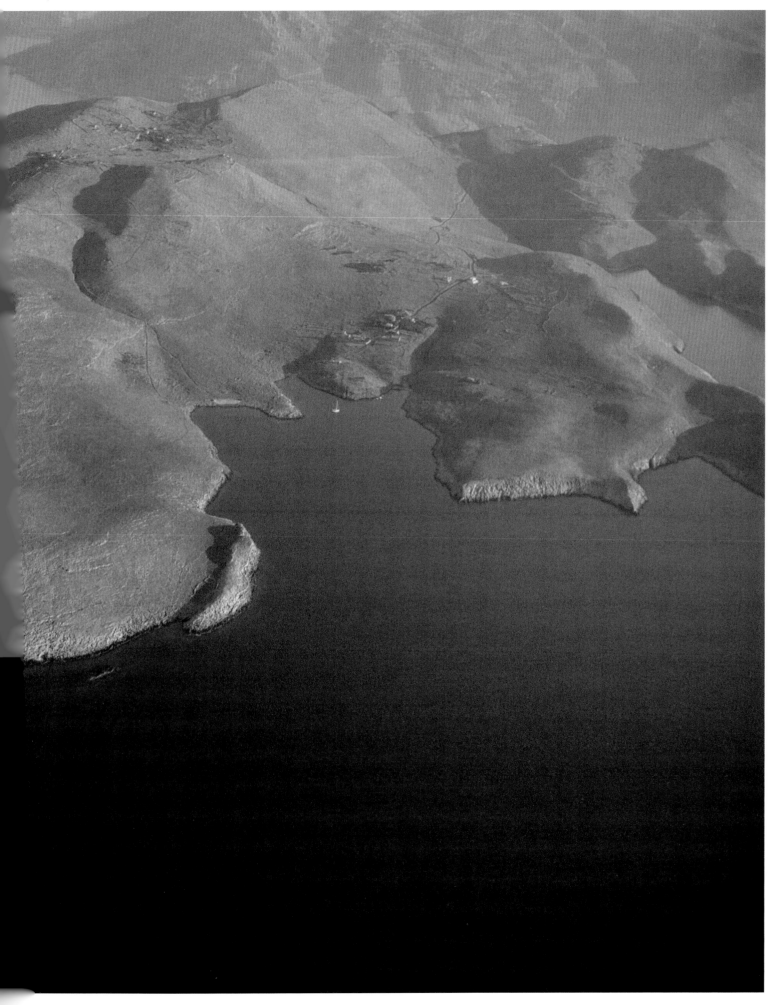

The fortress of Aigosthena, Megaris

page 54
The fortress of Larissa, Argos, Argolis

The citadel of Argos, on the summit of Larissa Hill above the theatre, has its origin in Mycenaean times. While the Byzantines added to some still-upright walls of the ancient acropolis, the structure owes its present shape to the French Knights of the Fourth Crusade (AD 1204), who took a liking to the fertile Argive Plain and upgraded the Larissa fortress, making it the foremost stronghold in the Peloponnese. Later the Venetians and the Turks took over the citadel and enlarged it further.

page 56
Cape Tainaron, Laconia

The southernmost point of the Peloponnese and continental Greece, Cape Tainaron looks as if the Mani peninsula were stabbing the sea. A visitor would be forgiven for feeling slightly out of this world here, and in fact the ancient Greeks believed an entrance to Hades to be in a nearby cave. This is therefore where Heracles, in his twelfth and final labour, entered the underworld in order to catch and drag out Cerberus, the multiple-headed beast guarding the Gate of Hades.

page 58
The fortress of Aigosthena, Megaris

This heavily fortified town may have been a border stronghold for Athens, a naval power vulnerable on land, or perhaps, conversely, it shielded Megaris from its overpowering neighbour. Whatever its purpose, the fortress of Aigosthena, built in the fourth century BC, is an outstanding example of the military architecture of classical Greece. A wall with eight artillery towers, skilfully crafted from large polygonal and square blocks of limestone, encircles the citadel. The highest tower today still rises 9 metres (30 feet) above the curtain wall.

page 61
The fortified town of Monemvasia, Laconia

A huge slab of rock off the coast, rising 300 metres (1000 feet) above the sea, now linked to the mainland by a causeway after an earthquake cut the former peninsula loose and created an island: this is Monemvasia, the 'Gibraltar of Greece' according to writer and philosopher Nikos Kazantzakis (1883–1957). The Byzantines had initially fortified the plateau of Monemvasia against the Slav invasions. Later the Lower Town, set within defensive ramparts, grew at the foot of the rock. This was an important port of call for ships en route to the Levant and Constantinople in Byzantine, Venetian and Turkish times. The old town's name lives sweetly on in one of its successful export products: a white wine called Malmsey (from the Venetian 'Malvasia').

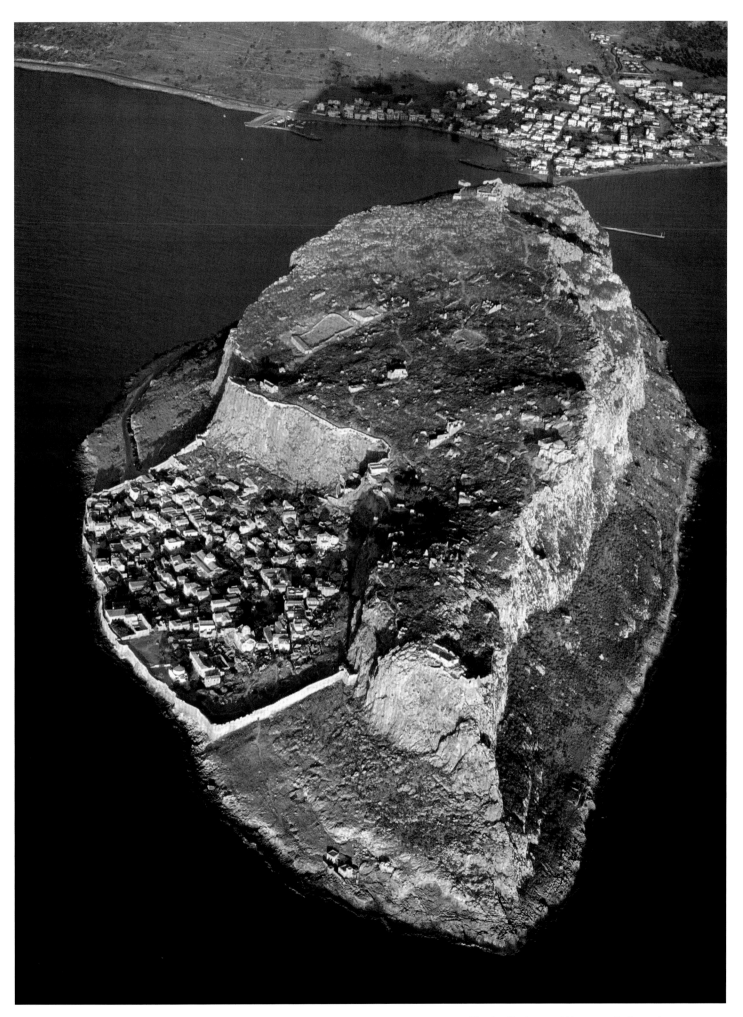

The fortified town of Monemvasia, Laconia

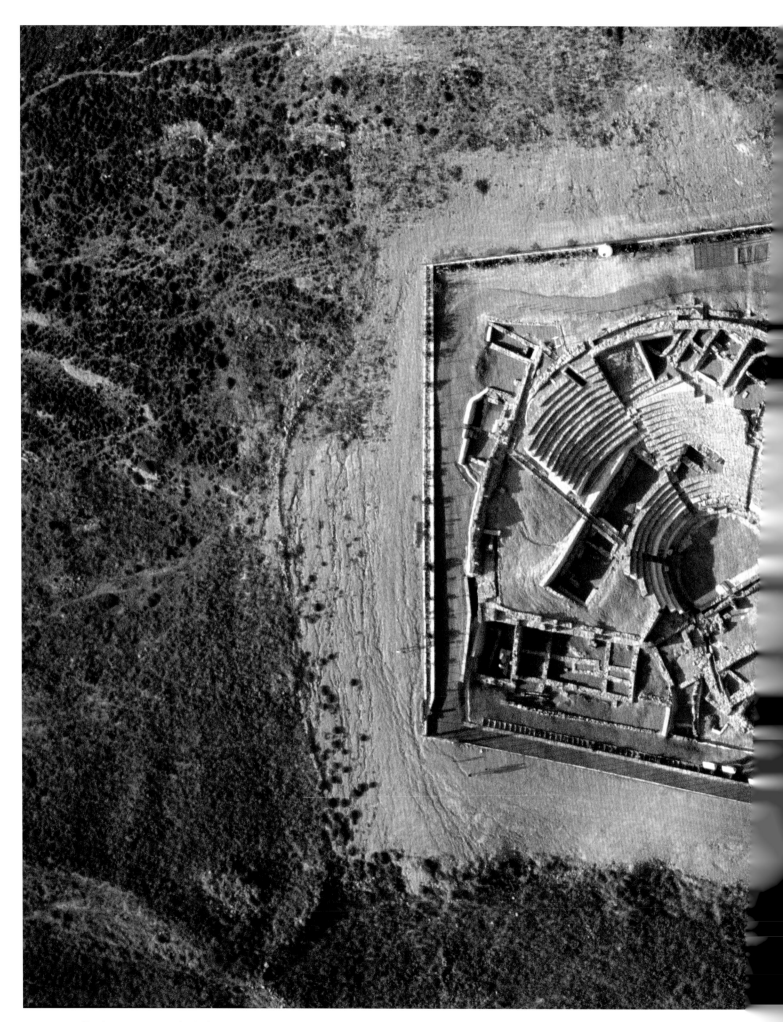

Hephaestia on the island of Lemnos

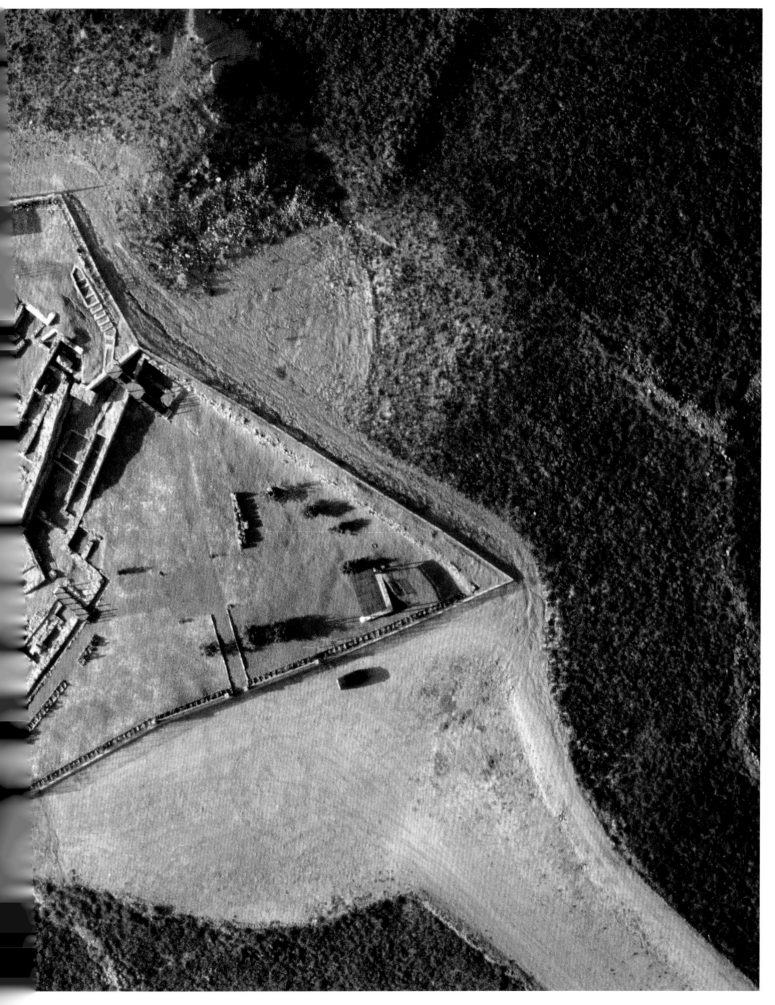

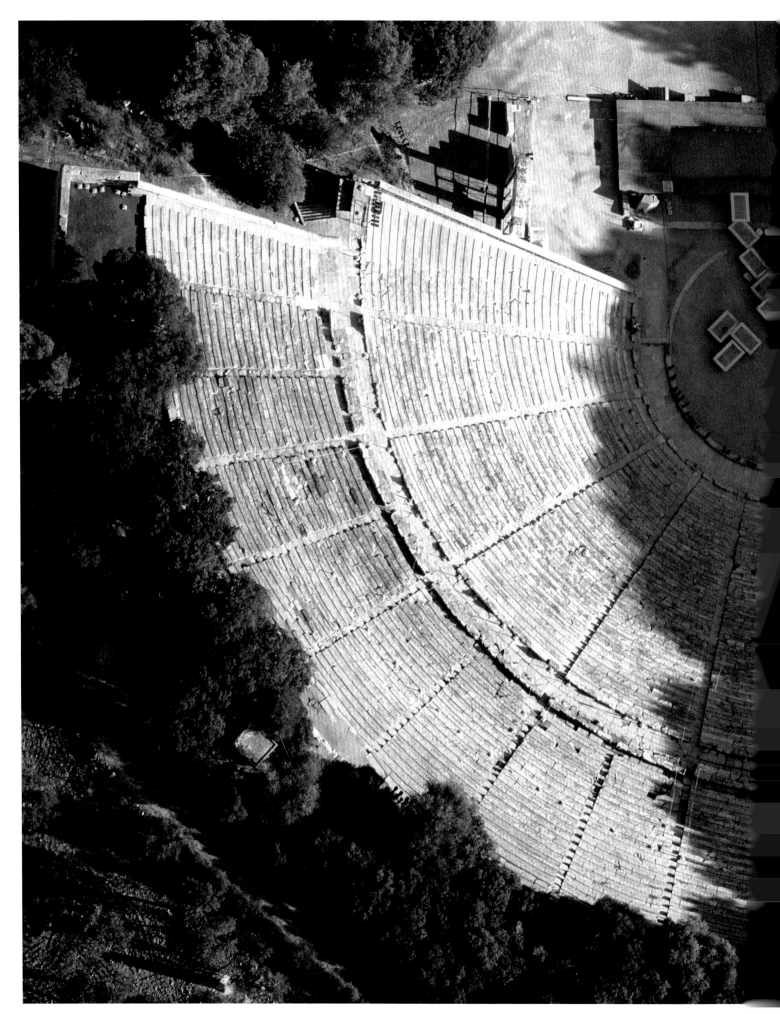

The theatre of Epidauros, Argolis

page 62
Hephaestia on the island of Lemnos

Lemnos, an isolated island in the northeastern Aegean Sea, has been inhabited since the fourth millennium BC. Archaeologists dug up what they believe to be the earliest town in Europe here – Poliochni, which dates back to 2250 BC. Lemnos is volcanic, so it is with good reason that myth made it the home of Hephaistos, the god of fire, technology and blacksmiths. Where he allegedly toiled in his forge a town developed, Hephaestia, which became the island's principal settlement. Among the town's more conspicuous remains is a small Hellenistic theatre. The Lemnians also seem to have been fiery people: it is said that at one time all the women who had been spurned killed their men, while at another time the men in turn murdered their women and children. In ancient Greece any bloody crime was therefore known as a 'Lemnian deed'.

page 64
The theatre of Epidauros, Argolis

In Epidauros, one of antiquity's most famous healing shrines, intellectual stimulus from drama and poetry was part of the recommended treatment. No wonder then that the theatre built here in the fourth century BC is one of the marvels of ancient Greece. Seating an audience of 14,000, it is elegant and superbly proportioned, and definitely a masterpiece as far as its stunning acoustics are concerned: a word whispered in the centre of the circular orchestra carries to the uppermost row of seats.

page 67
The theatre of Argos, Argolis

The city of Argos, sustained by the fecund Argive Plain, takes pride in being the oldest continuously inhabited Greek town, going back no fewer than 6000 years. Ancient Argos was legendary for breeding horses, for its heroes and military prowess. Its enormous theatre, built in the early third century BC and refurbished in Roman times, seated 20,000 spectators. The 81 rows in the centre have survived because they were cut into the cliff face. In the Greek War of Independence from Ottoman rule, the theatre also served as the meeting place for the National Assembly twice, in 1821 and 1829.

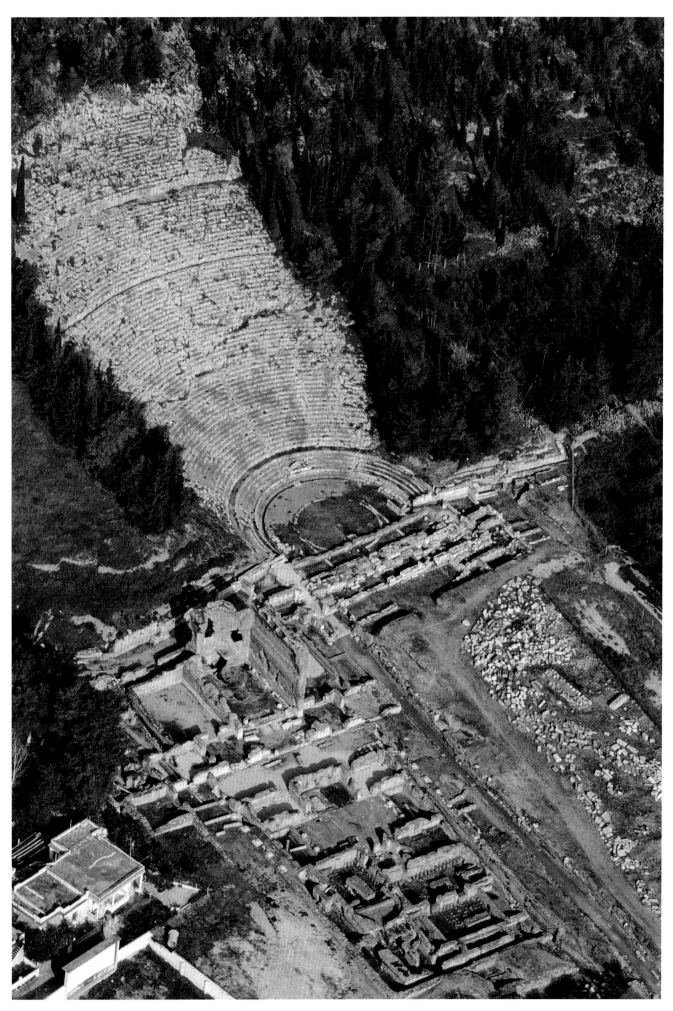

The caldera of the island of Thera, Cyclades

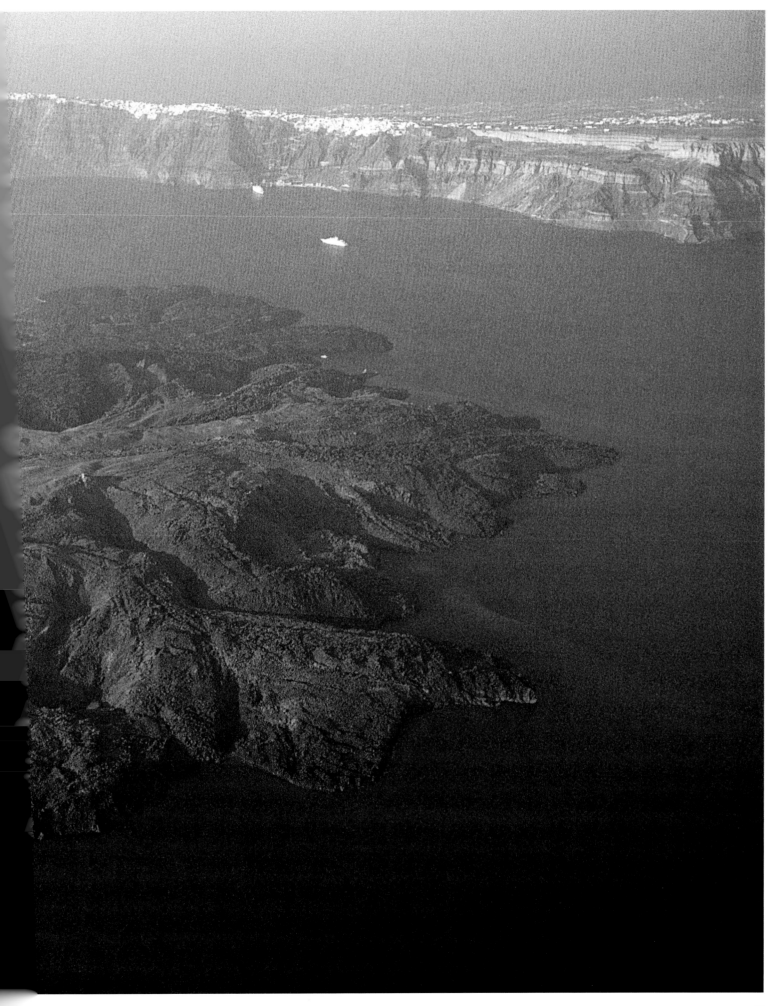

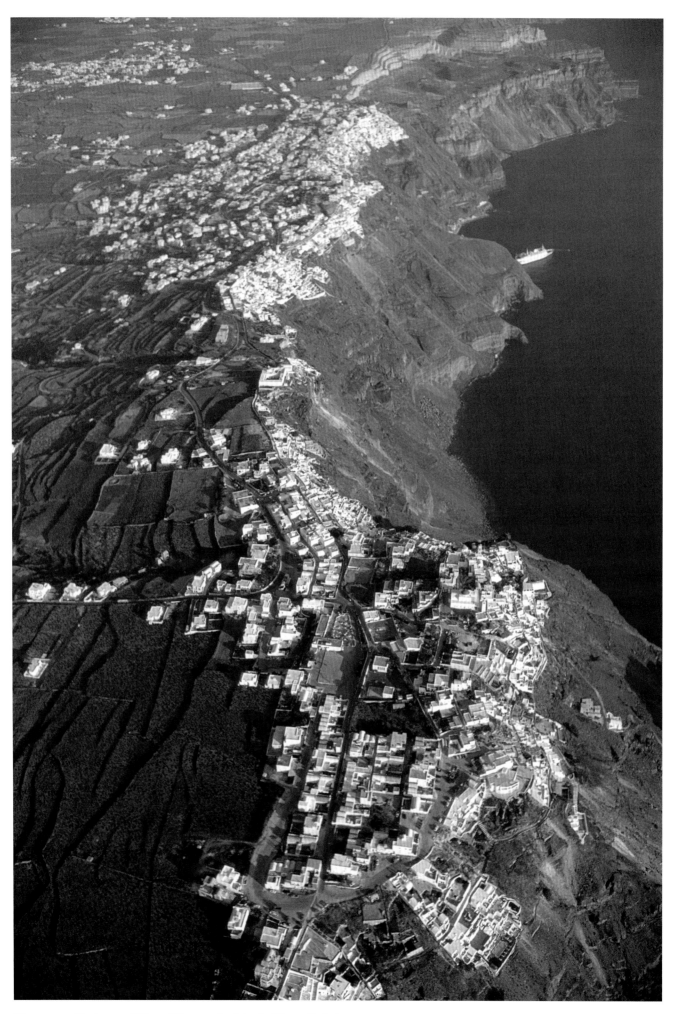

The towns of Oia and Thera on the island of Thera, Cyclades

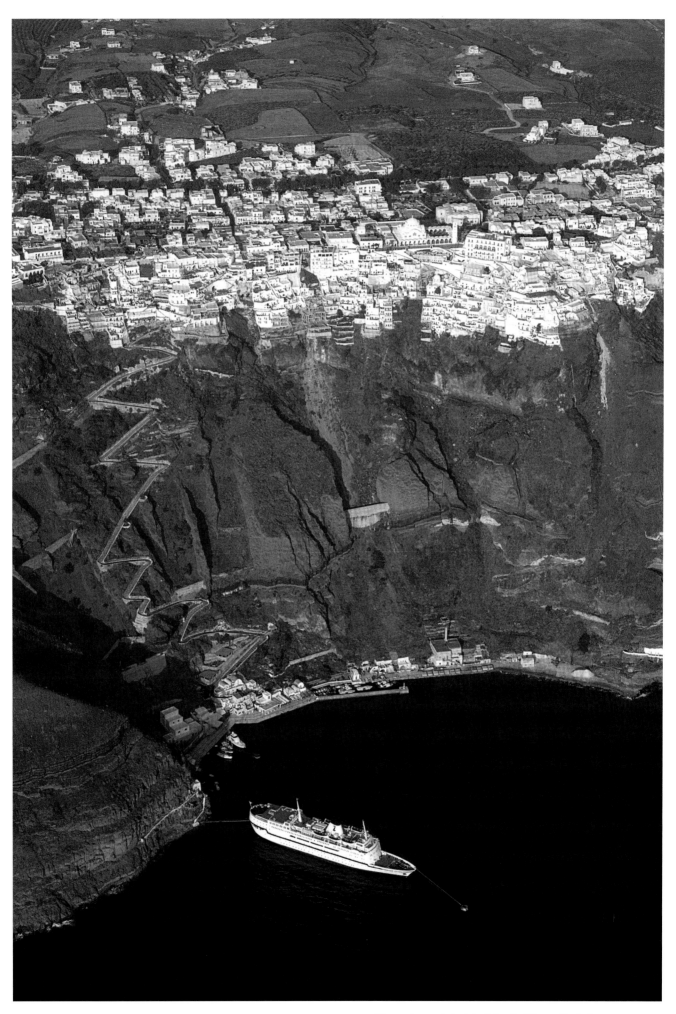

Thera, the capital of the island of Thera, Cyclades

page 68
The caldera of the island of Thera, Cyclades

Formerly known as Santorini, spectacular Thera is the result of one of the largest volcanic eruptions in recorded history. When the volcanic island's top blew off, the sea invaded the newly formed caldera. Today, villages cling to the crest of the precipitous cliff. The massive eruption occurred between 1700 BC and 1500 BC, but the precise date is fiercely disputed. Dating by tree rings favours the year 1628 BC, but this not only contradicts archaeological evidence but would also herald the end of a beloved theory: that the explosion-induced tsunami from Thera caused the collapse of the Minoan civilization on Crete. Over the last several hundred years, the Thera volcano awoke a number of times and grew some cones that pierced the surface of the central lagoon. In time these cones fused together to form the islands of Nea Kameni and Palea Kameni.

page 70
The towns of Oia and Thera on the island of Thera, Cyclades

The towns of Oia and Thera are adventurously situated on a cliff, up to 300 metres (1000 feet) above the level of the lagoon in the island's caldera. As if from an architect's dream, the towns with their white cubic houses have come to signify 'Greece' in much of the world.

page 71
Thera, the capital of the island of Thera, Cyclades

Perched right at the edge of a precipitous cliff, part of the island capital of Thera appears to be spilling over into the abyss. Cruise ships put ashore their passengers without dropping anchor, as the lagoon is far too deep. A path with 587 steps zigzags up the cliff face – a truly breathtaking experience.

page 73
The ruins of ancient Thera on the island of Thera, Cyclades

Ancient Thera, built on a promontory high above the sea, was inhabited from the ninth century BC until AD 726. The town was at its peak between 300 BC and 140 BC, when the Egypt-based Ptolemies maintained a naval base at Kamari, at the foot of the promontory. Archaeologists have recovered more than 700 cisterns on this site, indicating a sizable population.

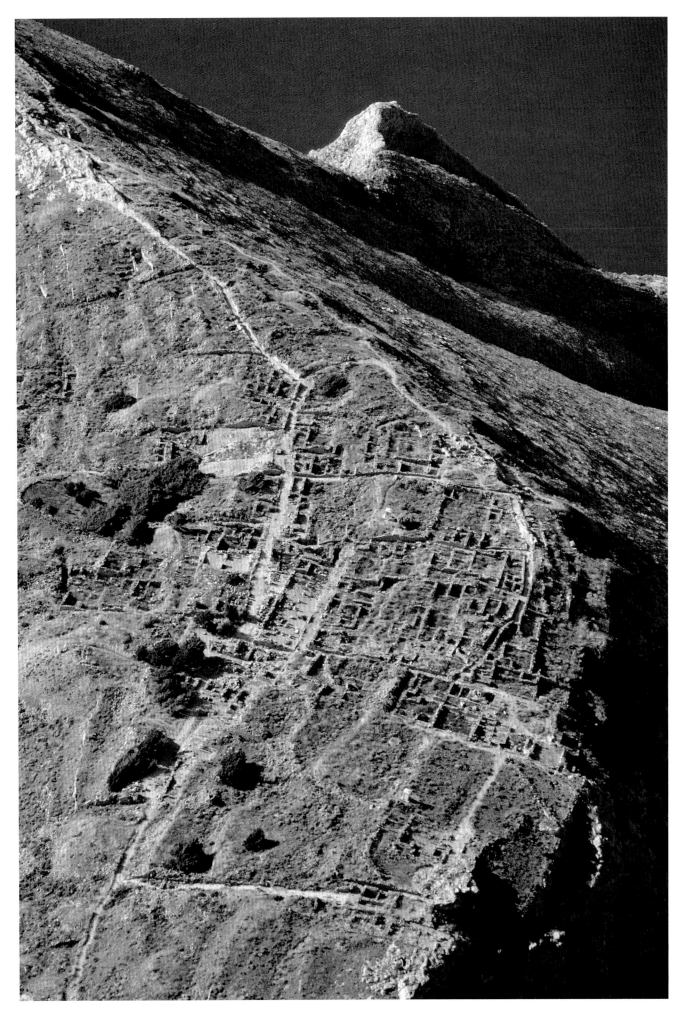

The ruins of ancient Thera on the island of Thera, Cyclades

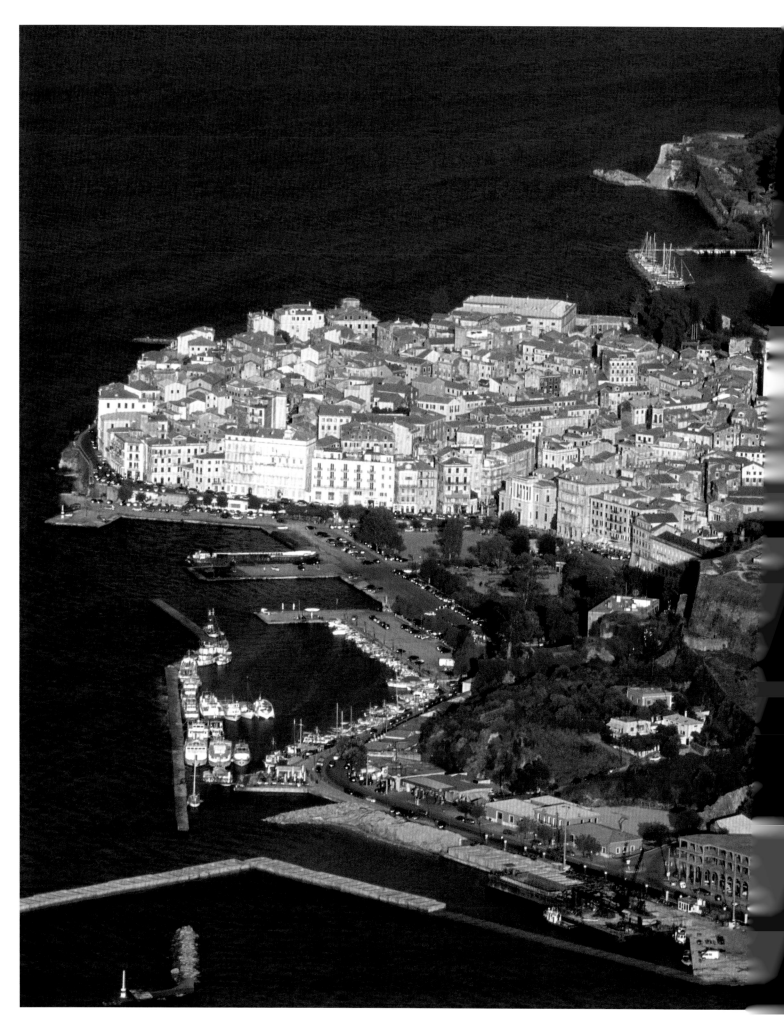

Corfu Town, Kerkyra, Ionian islands

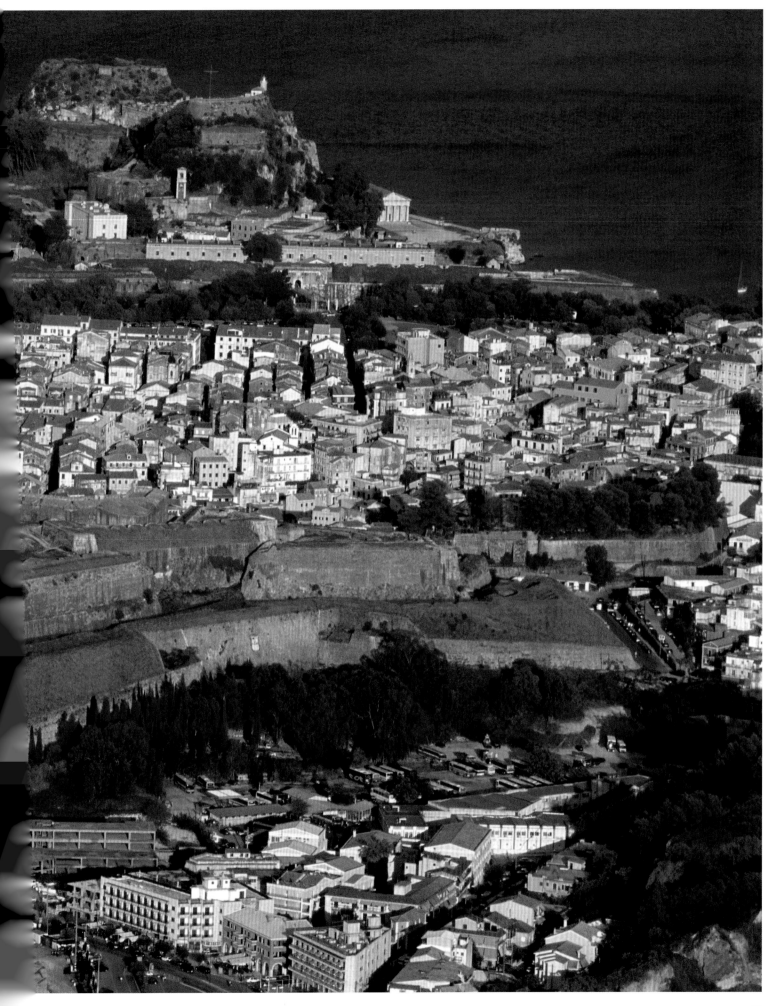

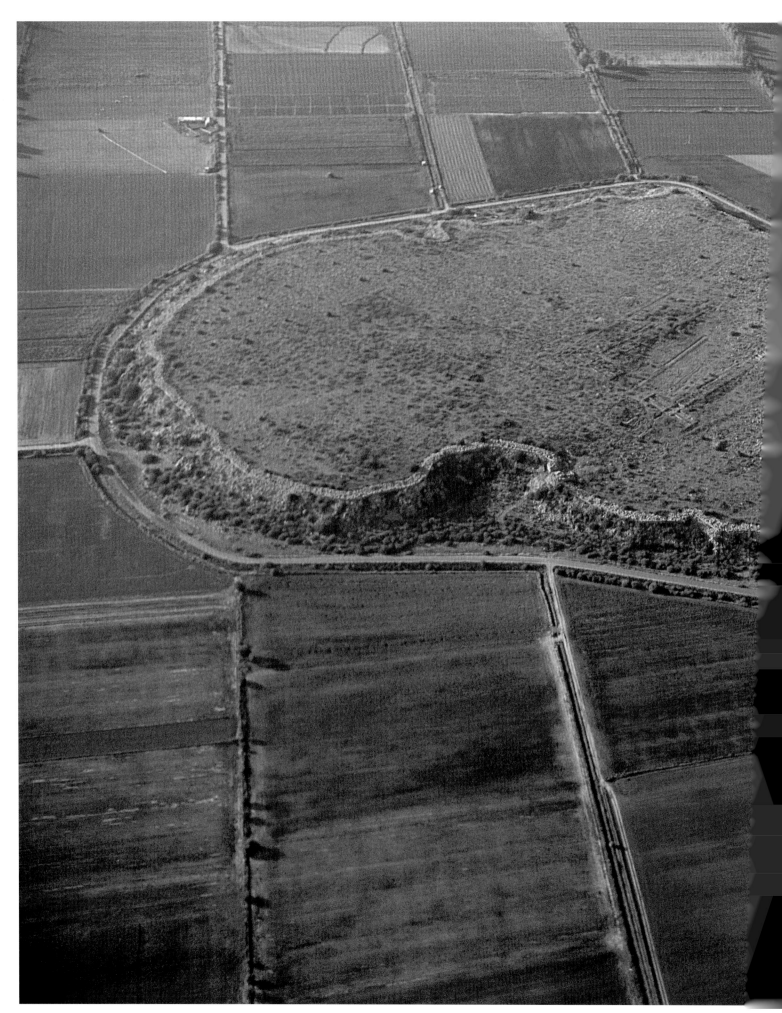

The fortress of Gla, Boeotia

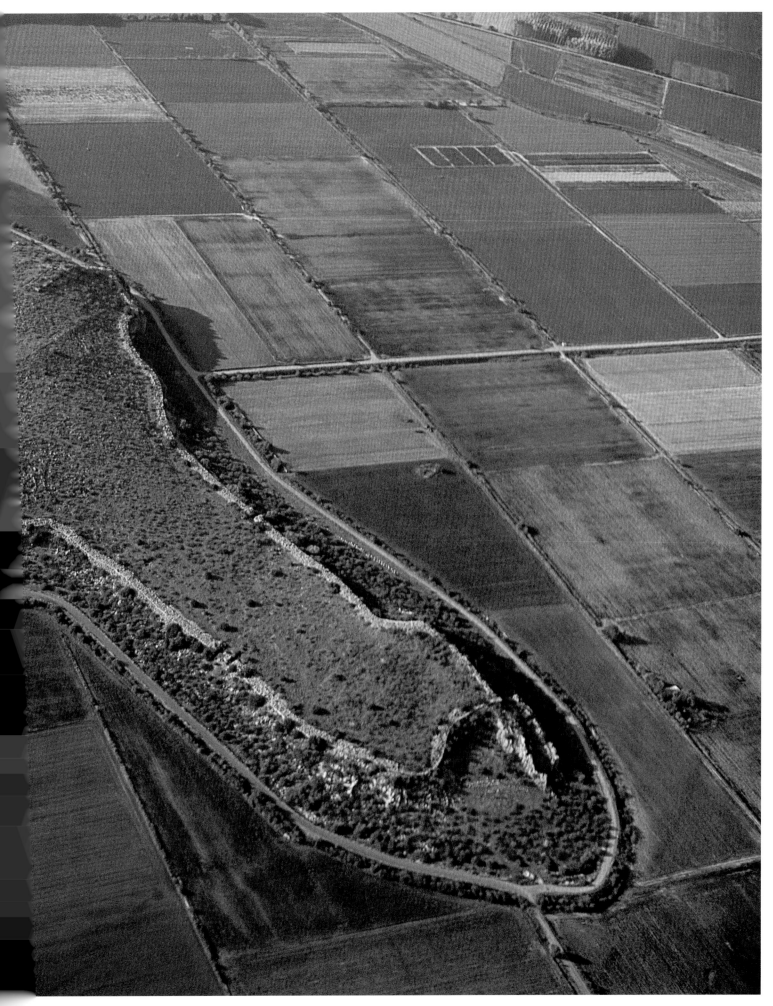

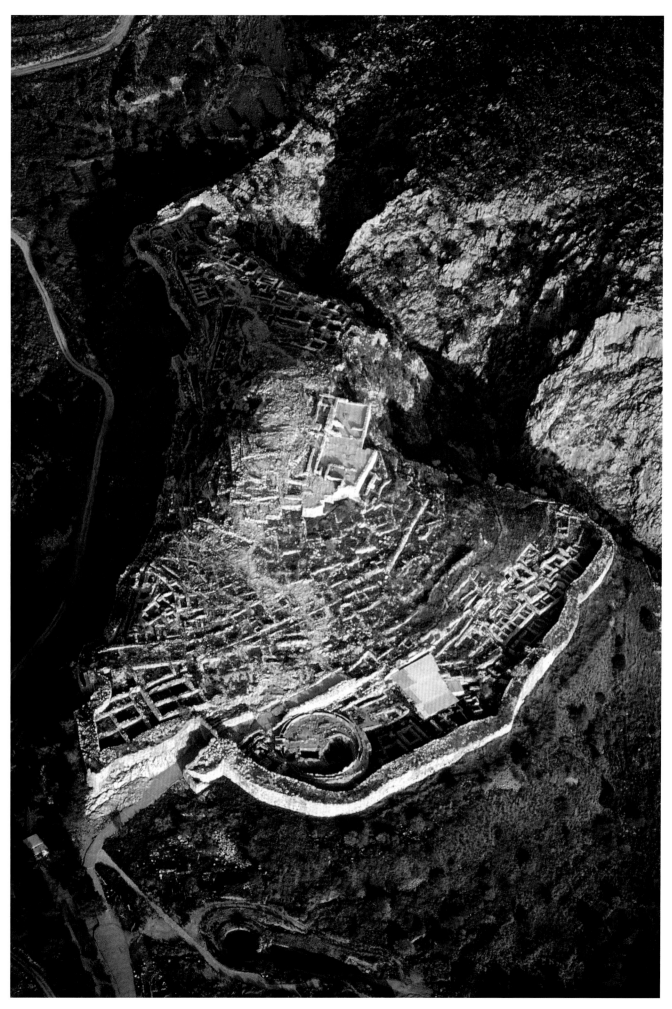

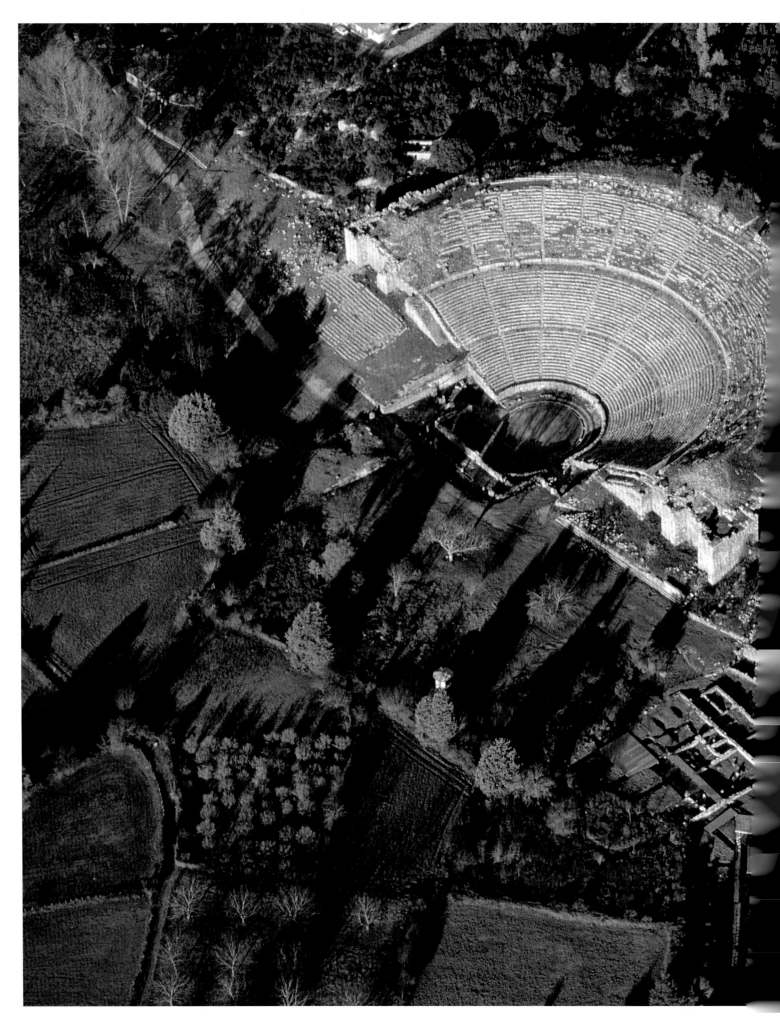

page 80
Dodona, Epirus

Second only to that at Delphi,
the oracle of Dodona made up in
religious significance what Epirus
lacked in political weight. Being in
the oracle business paid, and the
sanctuary of Zeus, with its theatre,
stadium and temples, prospered.
Zeus spoke through a sacred
oak tree, a whisper in the leaves
rustled by a breeze. The priests
who elucidated his messages were
forbidden to wash their feet and
slept on the ground to stay in tune
with Mother Earth; priestesses
based their prophecies on the flight
of sacred doves nesting in the
holy oak. Kings, states, cities and
citizens sought advice at Dodona
from the second millennium BC
through to the fourth century AD.

page 83
The ruins of Philippi, Macedonia

From the theatre to the forum
and the basilica across the road,
the ruins of Philippi, named after
Philip II, King of Macedonia, point
to the town's Roman and early
Christian heydey rather than its
Macedonian past. A battle like no
other in antiquity, involving almost
forty Roman legions, raged at
Philippi in the winter of 42 BC:
seeking to avenge Julius Caesar's
death, Octavian and Mark Antony
defeated his assassins, Brutus and
Cassius, who had fled Rome for the
eastern provinces. In AD 49, St Paul
preached in Philippi, sowing the
seeds for the first Christian
community on European soil. His
epistle to the Philippians irrevocably
put the town on the Christian map.

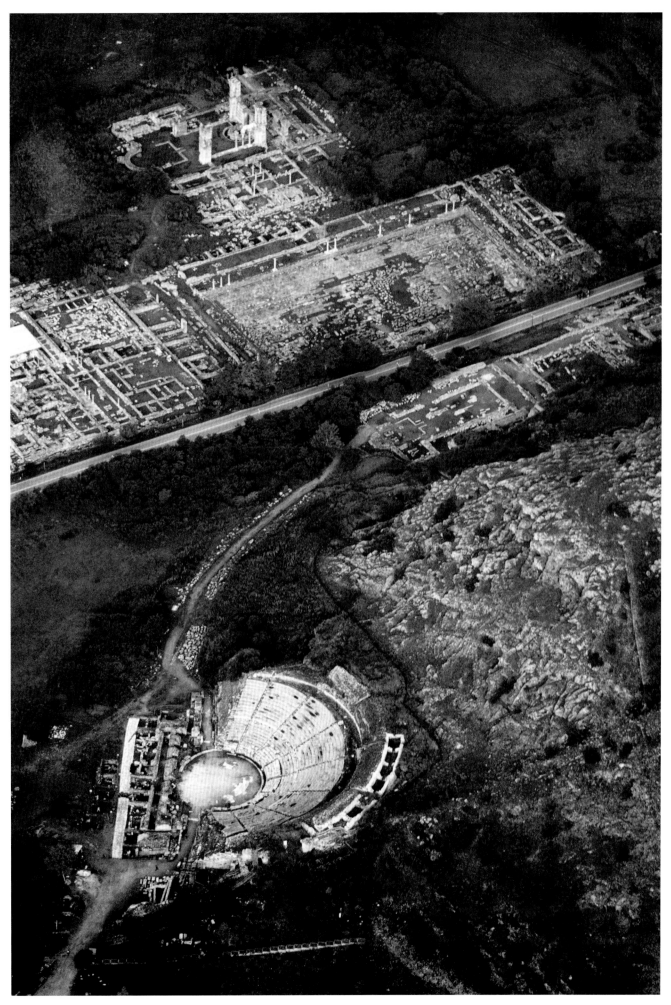

The ruins of Philippi, Macedonia

Hilly landscape in northern Chalcidice

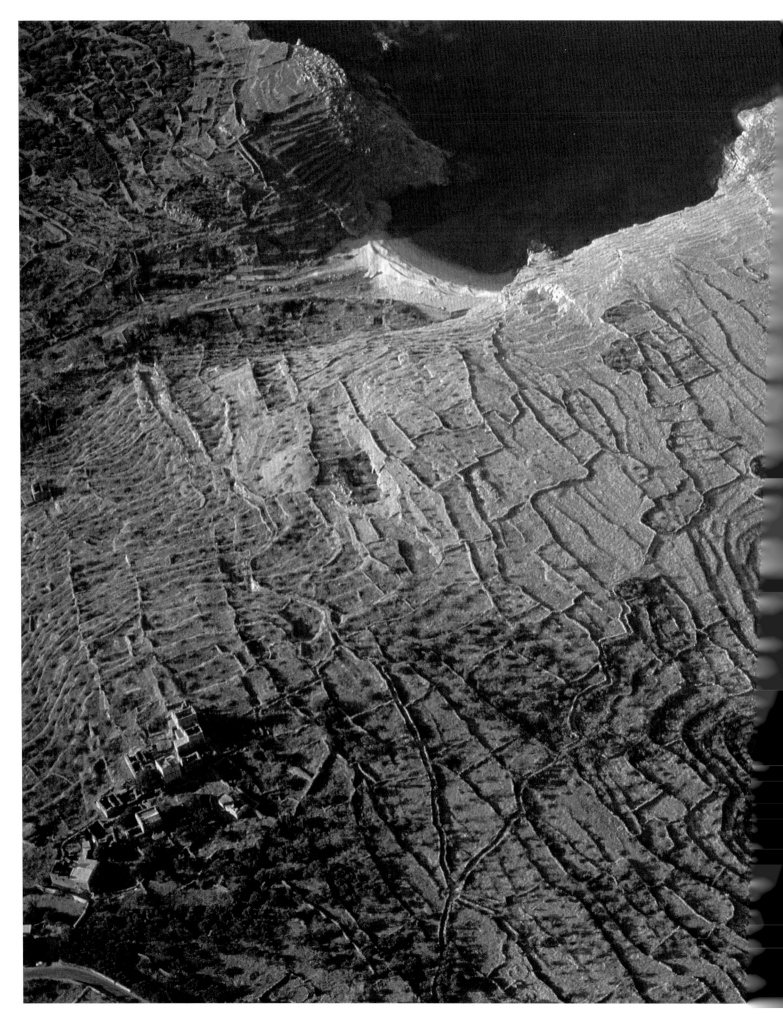

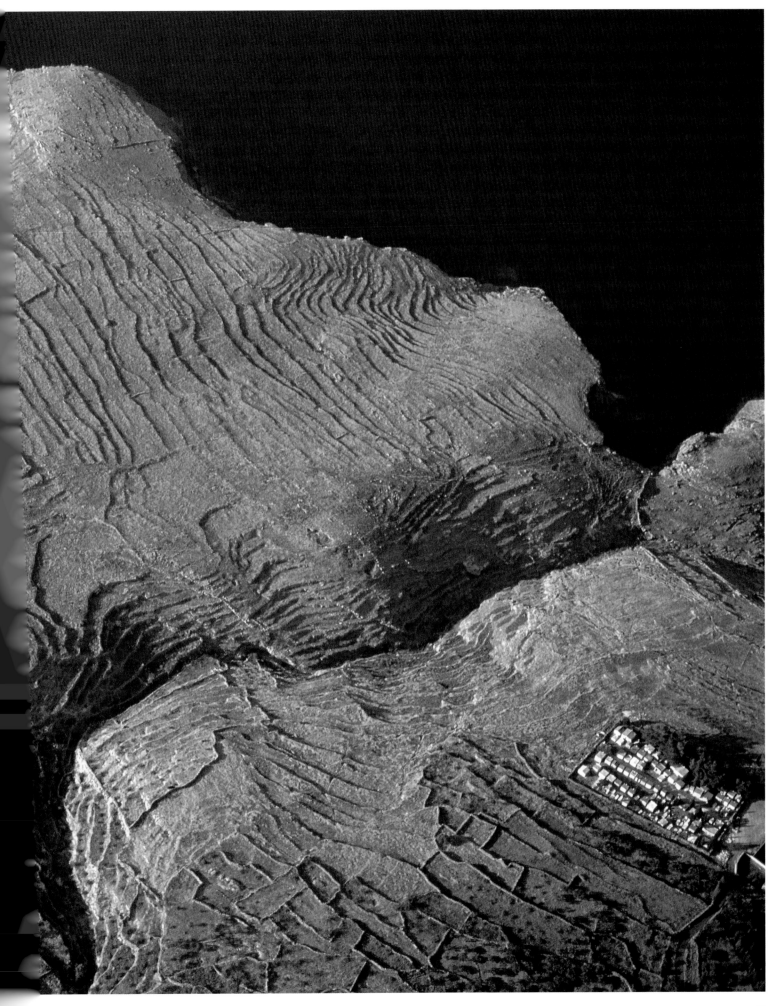

page 84
Hilly landscape in northern Chalcidice

The Chalcidice peninsula (Khalkidhiki in modern Greek) is best known for the three finger-like promontories that stretch into the sea, with Mount Athos – the 'Holy Mountain' – being the third and easternmost spur of land, rocky and heavily wooded. In contrast, the northern part of the peninsula is quite bucolic, with gently rolling hills and fields planted to grain.

page 86
Mani peninsula, Laconia

With its barren windswept hills, the Mani peninsula offers vistas that are unique in Europe. Although they live on – and are plagued by – tourism, the Maniots still try their hand at subsistence farming, eking a meagre living out of the earth by terracing and securing tiny plots with stone walls to protect them from gales and storms. A few centuries ago, the Maniots would have supplemented their income with piracy.

page 89
The plain of Marathon, Attica

In the late summer of 490 BC, a Greek army fought the decisive battle against the Persians during their first invasion of Greece on the plain of Marathon. The 192 fallen Athenians were buried in the barrow or grave mound visible in the lower right corner of the photograph. According to legend, a messenger in full armour ran the 42 kilometres (26 miles) to Athens to announce the victory, and then dropped dead from exhaustion. Today's marathon races commemorate this feat.

The historic centre of Naxos Town, Naxos, Cyclades

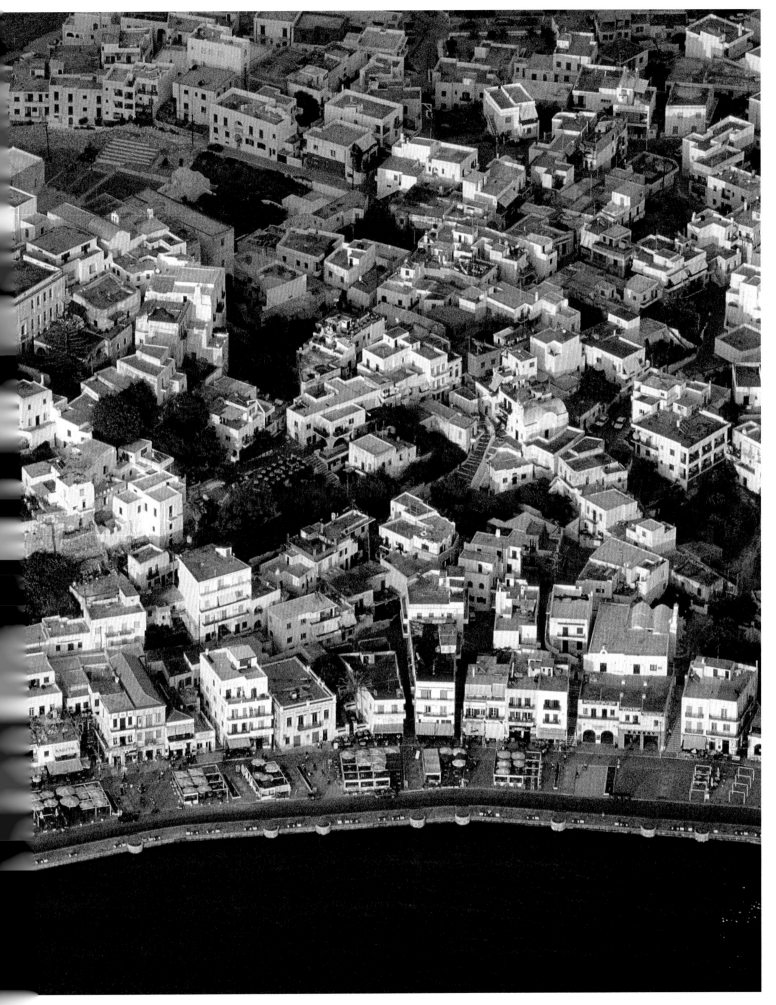

page 90
The historic centre of Naxos Town, Naxos, Cyclades

A Venetian citadel or 'kastro', built in the thirteenth century to ward off pirates, dominates the old part of Naxos Town. Within its defensive walls, Roman Catholic nobility of Venetian descent still maintain their mansions. Holding on to traditions, being true to one's word – these are still cherished values in this quiet residential oasis. It therefore might rile some Naxians that myth, poetry and opera have located the epitome of faithlessness on their island: the story of Ariadne, daughter of Cretan King Minos, spurned and left abandoned on Naxos by her perfidious lover Theseus.

page 93
St John's Monastery in Patmos Town, Patmos, Dodecanese

Self-exiled or banished to Patmos, St John the Theologian allegedly wrote the Book of Revelation on the island around AD 95, while residing in a cave. The monastery of St John was constructed to commemorate him in the eleventh century: a crenellated castle-fortress that could withstand frequent raids by pirates. Over the centuries it became a spiritual centre of the Orthodox Church, a holy place of pilgrimage, immensely rich in donations of land and manuscripts. The white houses of Patmos Town, which wrap around the monastery like strings of square beads, are believed to be the finest of their kind in the entire archipelago. Town and monastery are UNESCO World Heritage sites.

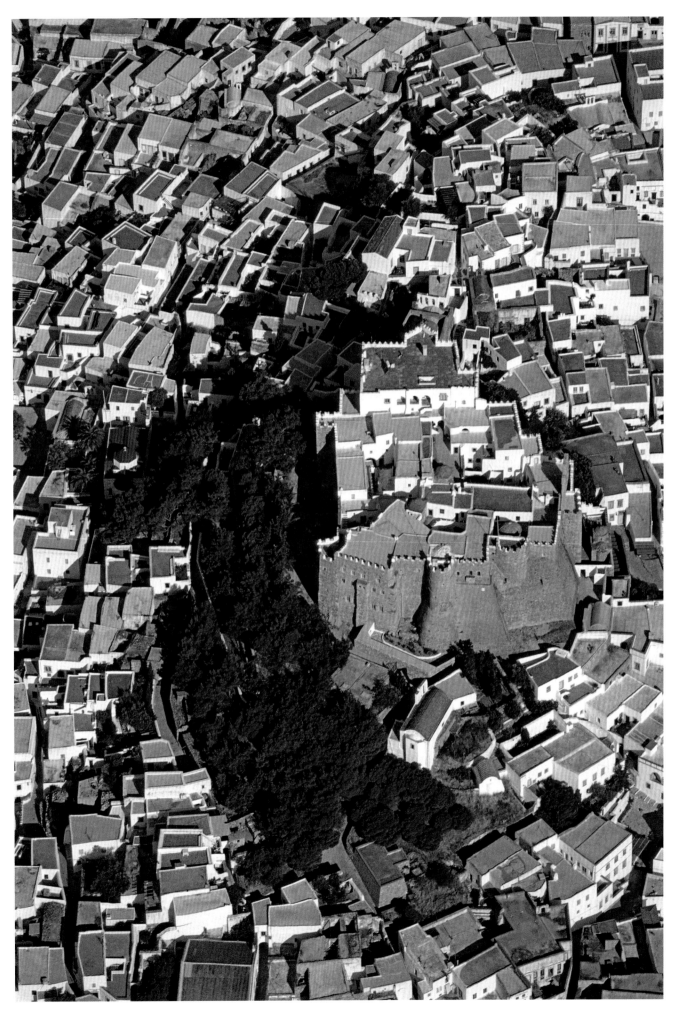

St John's monastery in Patmos Town, Patmos, Dodecanese

page 95

The Panagia Chozoviotissa monastery, Amorgos, Cyclades

No other monastery in Greece is more perilously placed: the Panagia Chozoviotissa monastery seems to cling desperately to the face of a cliff on the precipitous southeastern coast of the island of Amorgos. As its name implies, the monastery is dedicated to Mary, 'Panagia' (meaning 'All-Holy') being a title for the mother of Jesus, particularly in Orthodox Christianity. Thanks to generous donations of land, among them entire islands, the monastery grew to be one of the richest in Greece. It either dates back to the eighth century AD and was renovated in 1088, or it was founded by a Byzantine emperor in the eleventh century AD. Whichever version of the story is true, situating the building on a cliff high above the sea constitutes a challenging endeavour at any time.

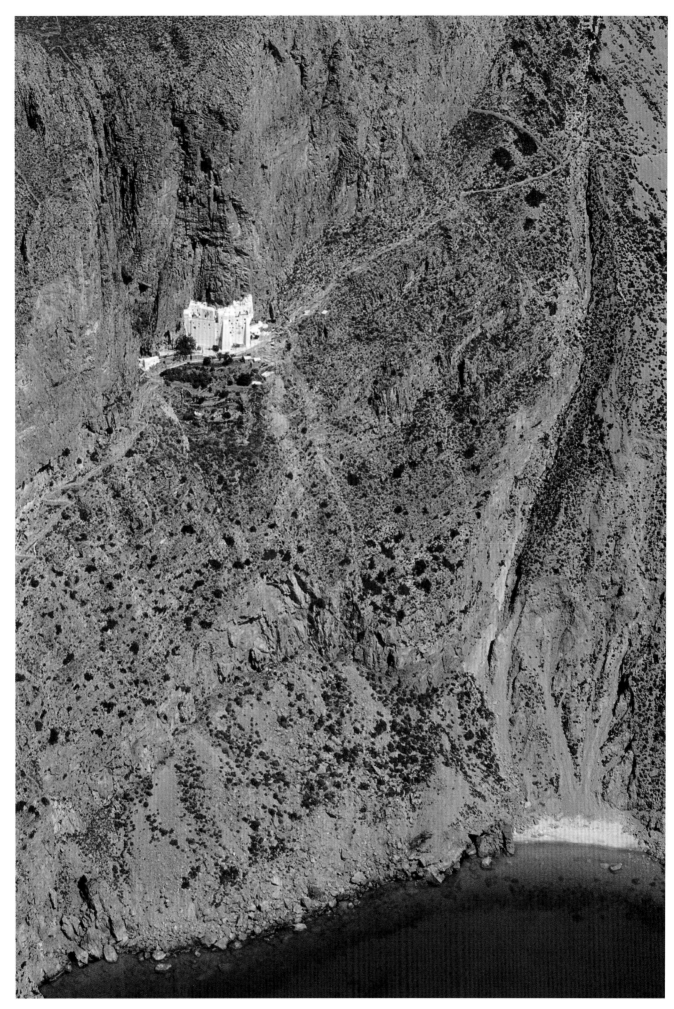

The Panagia Chozoviotissa monastery, Amorgos, Cyclades

So-called 'Homer's Tomb', Ios, Cyclades

page 96
So-called 'Homer's Tomb',
Ios, Cyclades
In antiquity, many places fought
over the honour of being Homer's
birthplace, but there was unanimity
about where he died: according to
a questionable biography of the
poet, he fell ill during a sea voyage
from Samos to Athens and died
on the island of Ios. The so-called
'Homer's Tomb' on the northern
flank of Mount Pirgos, accessible
from a car park via a paved footpath,
is however definitely of Hellenistic or
Roman manufacture. Uncontested
in its claim of being Homer's place
of death, Ios also tried to make a
link with his birth, but the claim
that Klymene, Homer's mother, was
from the island was never seriously
considered by competitors.

page 99
Ancient Messene, Messenia
Thanks to the Theban victory at
the battle of Leuctra in 371 BC,
the Messenians were freed from
350 years of Spartan oppression:
with independence, the new
capital city of Messene was born.
Conspicuous among the ruins of the
Hellenistic town are the stadium
with its tiered seats constructed of
stone and the sanctuary dedicated
to Asclepios, god of medicine and
healing. His temple stood in the
centre of a portico.

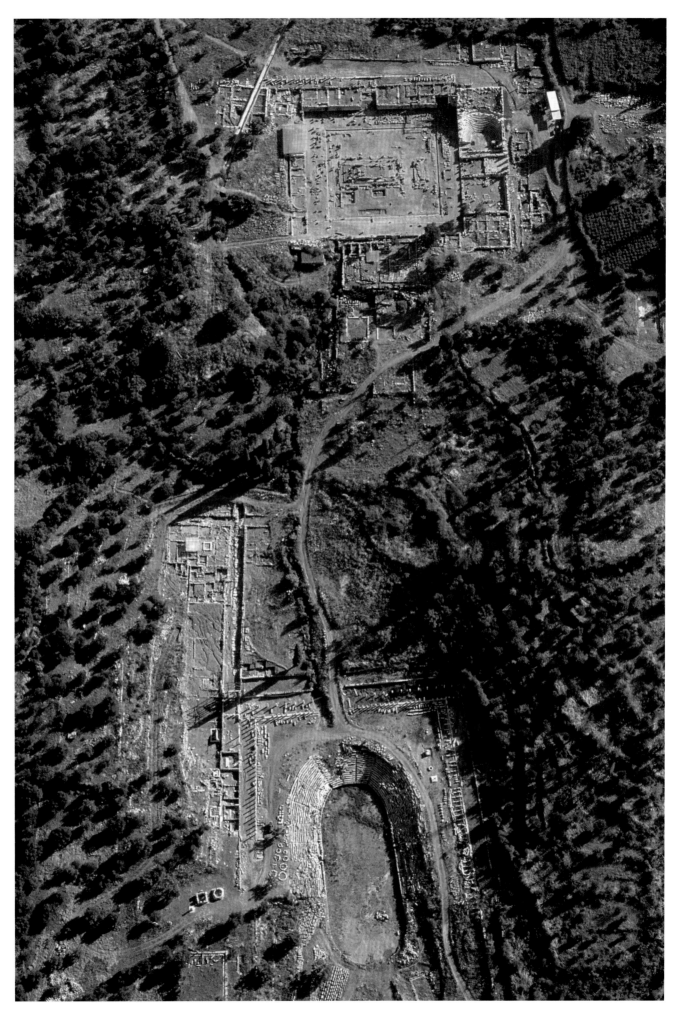

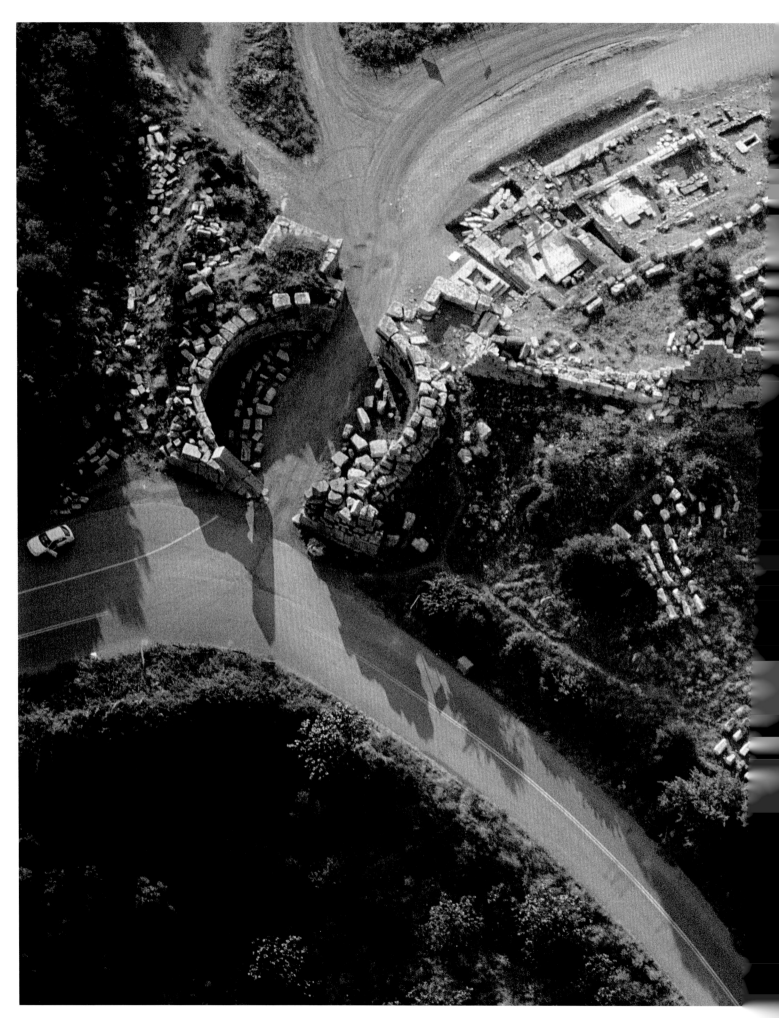

The Arcadian Gate at Messene, Messenia

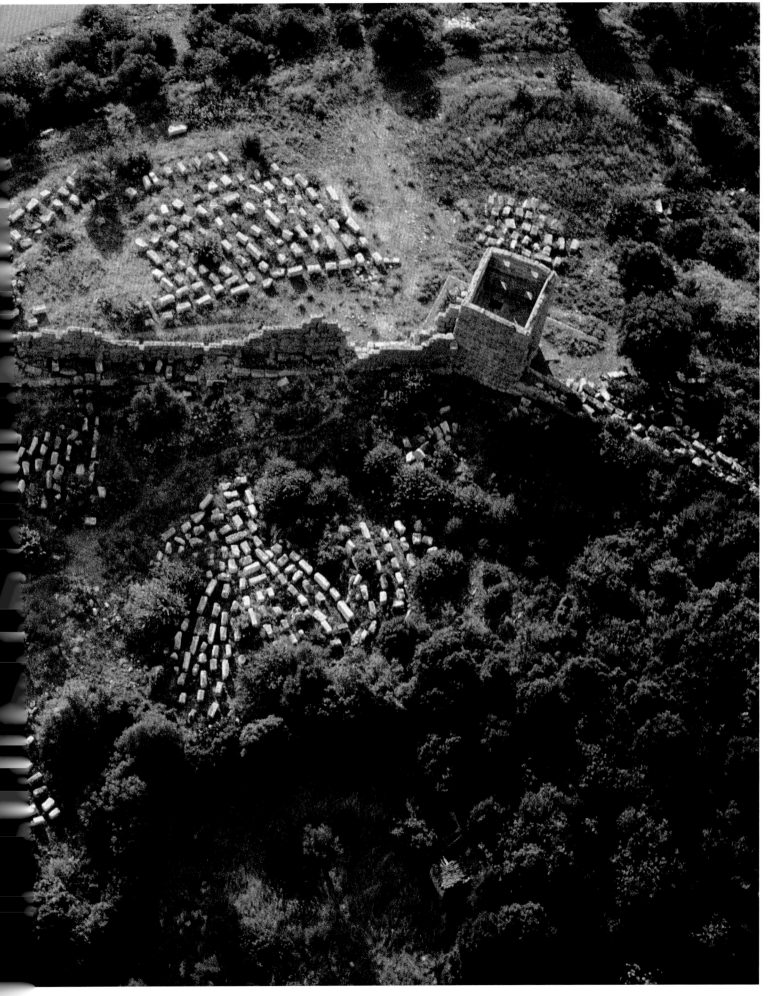

page 100
**The Arcadian Gate
at Messene, Messenia**
The wall encircling New Messene,
9 kilometres (5.5 miles) long and
fortified with square towers, was
already much admired in antiquity,
the gateways in particular arousing
interest. The Arcadian Gate seen in
this photograph consisted of two
gates enclosing a circular space.
Two towers projecting outwards
flanked the outer gate, and
aggressors caught in the round trap
had to reckon with a volley of arrows
and javelins from on high.

page 103
**The village of Vathia on
the Mani peninsula, Laconia**
Clan towers dominate this typical
(and deserted) Maniot village. The
people of the Mani peninsula, a
mix of descendants of Sparta and
Frankish, Byzantine and Turkish
refugees, were notorious squabblers
– endless feuds and vendettas
prompted them to build defensive
towers protecting their families from
cantankerous neighbours. However,
they united against any outside
aggressor, and fiercely defended
their autonomy. With their uprising
against the Ottoman Empire in 1821,
the Maniots instigated the Greek
War of Independence.

The village of Vathia on the Mani peninsula, Laconia

Ermoupoli on the island of Syros, Cyclades

page 104
Ermoupoli on the island of Syros, Cyclades

Aptly named in 1926 after Hermes, the god of commerce to the ancient Greeks, Ermoupoli is a hub for shipping and maritime trade, and the administrative and legal capital of the Cyclades. Although Syros has been inhabited since the third millennium BC, Ermoupoli is a young city: it grew from a refugee town after the Greek War of Independence. By the end of the nineteenth century, it was the foremost port of Greece, with a healthy industrial base in shipbuilding and textile manufacturing. For a while, its rise and success even made it a candidate for the capital of the new kingdom of Greece. The opening of the canal of Corinth, which put the port of Piraeus at an advantage over Ermoupoli, prompted a decline.

page 107
The harbour town of Kommos, Crete

From prehistoric right through to Roman times, the Bay of Kommos functioned as Crete's gateway to Egypt, Asia Minor and the Near East. At first the ancient harbour town of Kommos served as the port to the Minoan palace of Phaistos, but after that city's demise it grew to become a harbour for all of Crete as well as a sizable town, with traces from Minoan times (at the bottom and the centre of the photograph) and the remains of two Greek sanctuaries (at the top). Maritime trade was already common in the era of the old Minoan palaces, and meant bartering overseas for metals and the tusks of Syrian elephants. The Minoans offered luxury goods, exquisite ceramic vessels and jewellery. Caravans of donkeys delivered the cargo inland.

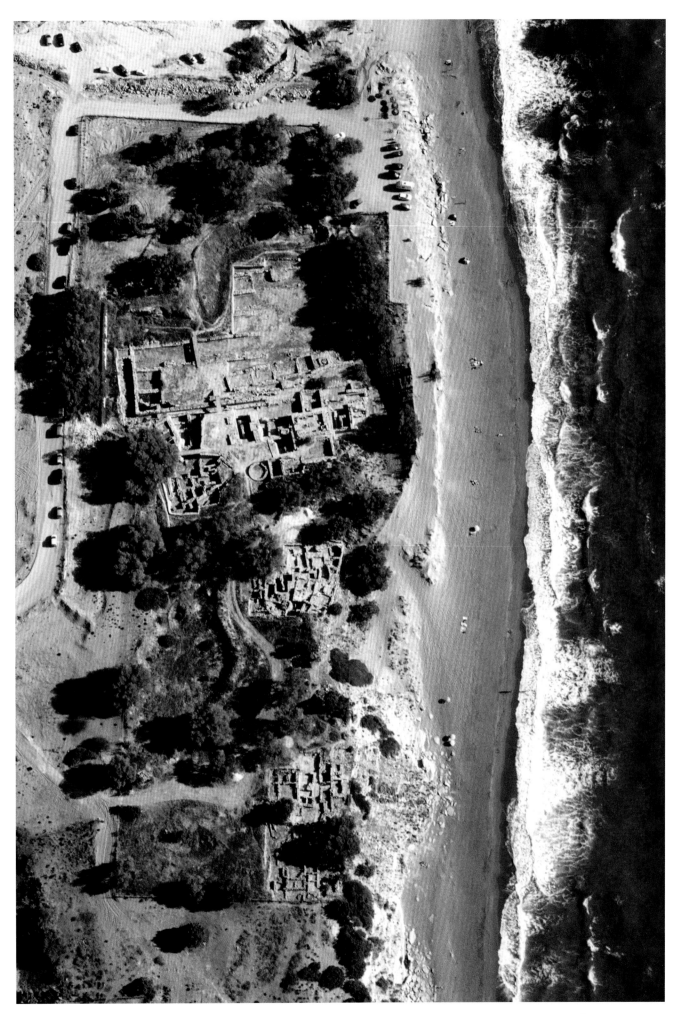

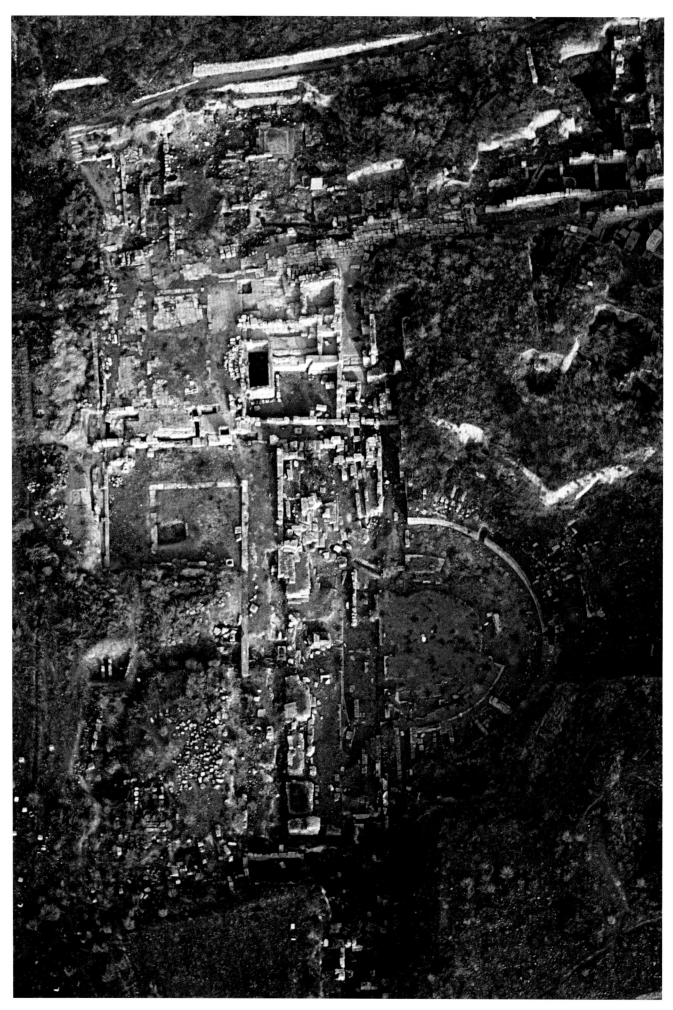

Ancient Corinth, Corinthia

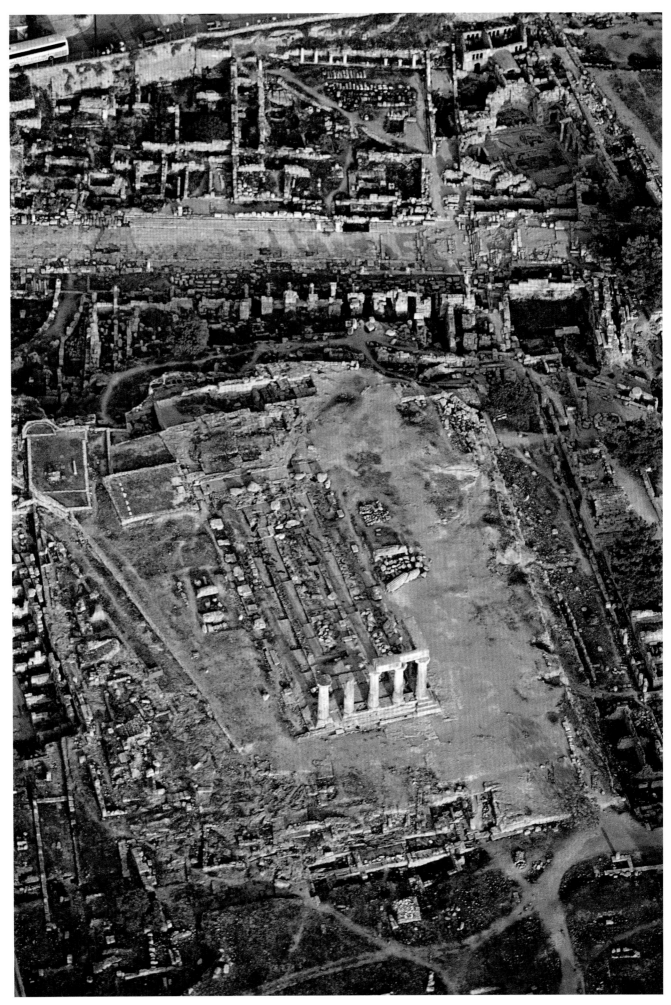

The temple of Apollo in ancient Corinth, Corinthia 109

page 108
Ancient Corinth, Corinthia

Remarkably innovative, the people of the ancient city of Corinth made the most of their geographical position: they controlled traffic across the Corinthian isthmus and access to the Peloponnese. The city became affluent, but the Corinthians were prone to luxury and of rather loose morals. The philosopher Diogenes (died c.320 BC) was Corinth's famous spoilsport, urging extreme poverty and living in a clay storage jar. Today, the city's ruins echo the ups and downs of a long history. Built in the sixth century BC, the central sanctuary of Apollo dates back to Corinth's first heyday, when it established colonies in Sicily and on Kerkyra. Most of the remains, however, are Roman: smaller shrines, a theatre, an odeum or concert hall, meeting and market places, the infrastructure of daily life such as shops, springs and fountains, baths and latrines. Under the Romans, who had sacked and then rebuilt the city, Corinth reached a second peak, but an earthquake in AD 521 toppled it for good.

page 109
The Temple of Apollo in ancient Corinth, Corinthia

With captivating views of the Gulf of Corinth, the Apollo sanctuary occupies the highest point of the ancient city's terrain. Made of tufa, a type of limestone, the columns were originally covered with white stucco to make them look like marble.

page 111
Ancient Olympia, Elis

No other site of ancient Greece still reverberates as strongly in our time and world as Olympia: every four years, the Olympic flame is reignited here. From 776 BC, games were held quadrennially for more than a millennium in Olympia's lush and leafy surroundings. During this time, the site was continuously expanded, with the addition of shrines for worship, treasuries for storing votive offerings, sports halls and places for training and exercise, and living quarters. On either side of the five days' duration of the games, a sacred truce of a month or more was declared for all of Greece, making them a guaranteed Panhellenic success. Olympia is a UNESCO World Heritage site.

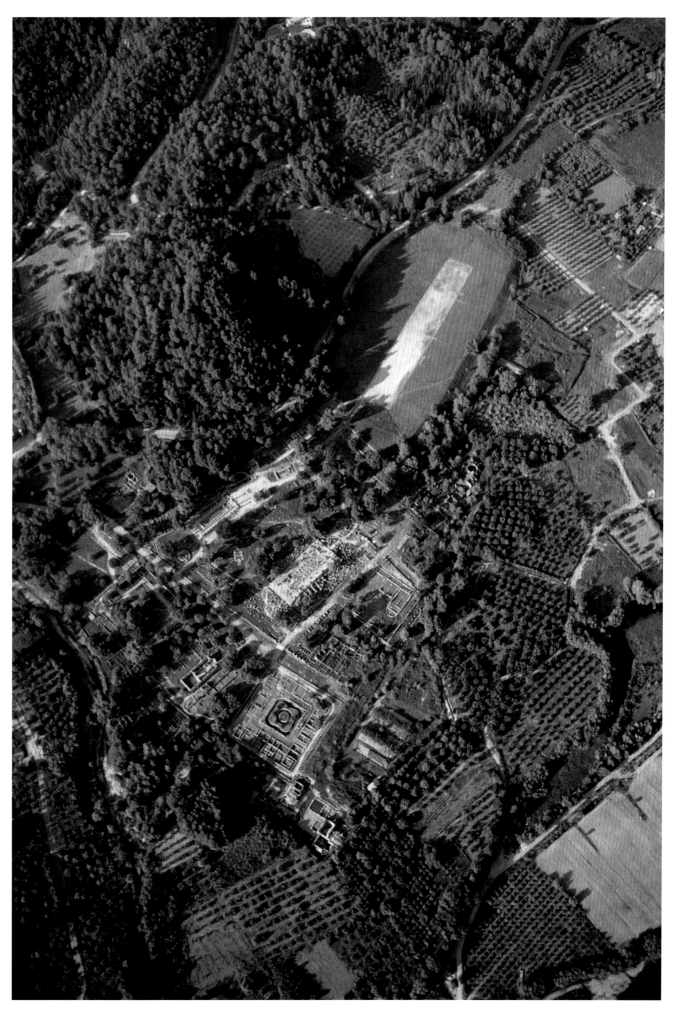

Ancient Olympia, Elis

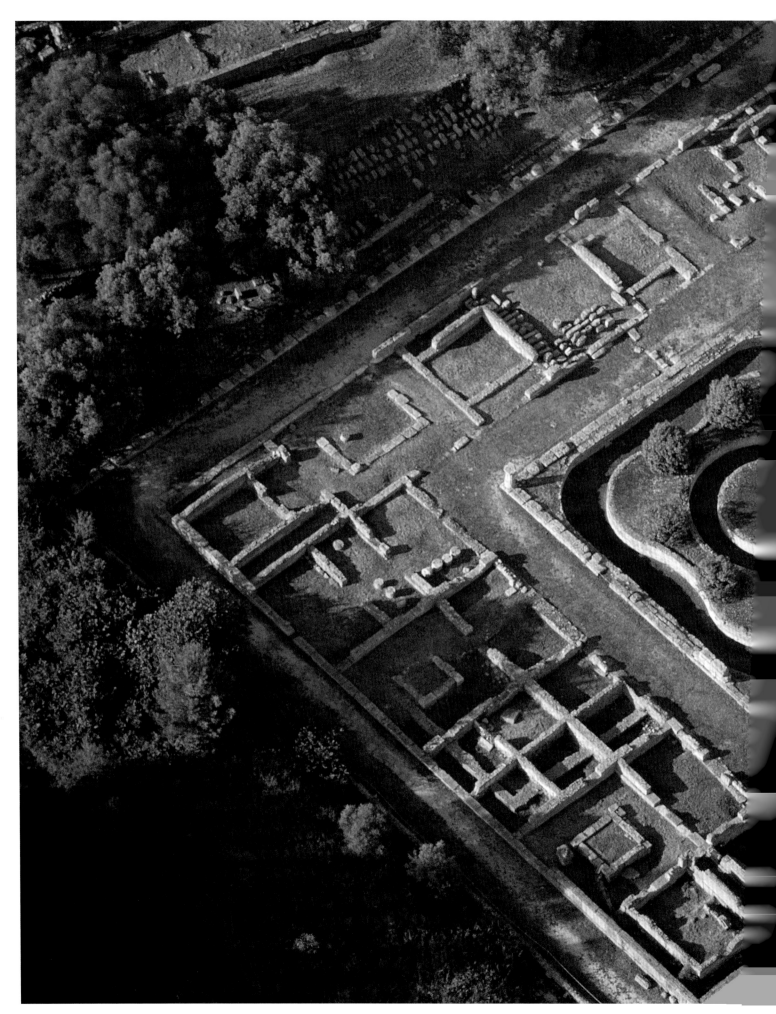

The Leonidaion hotel in Olympia, Elis

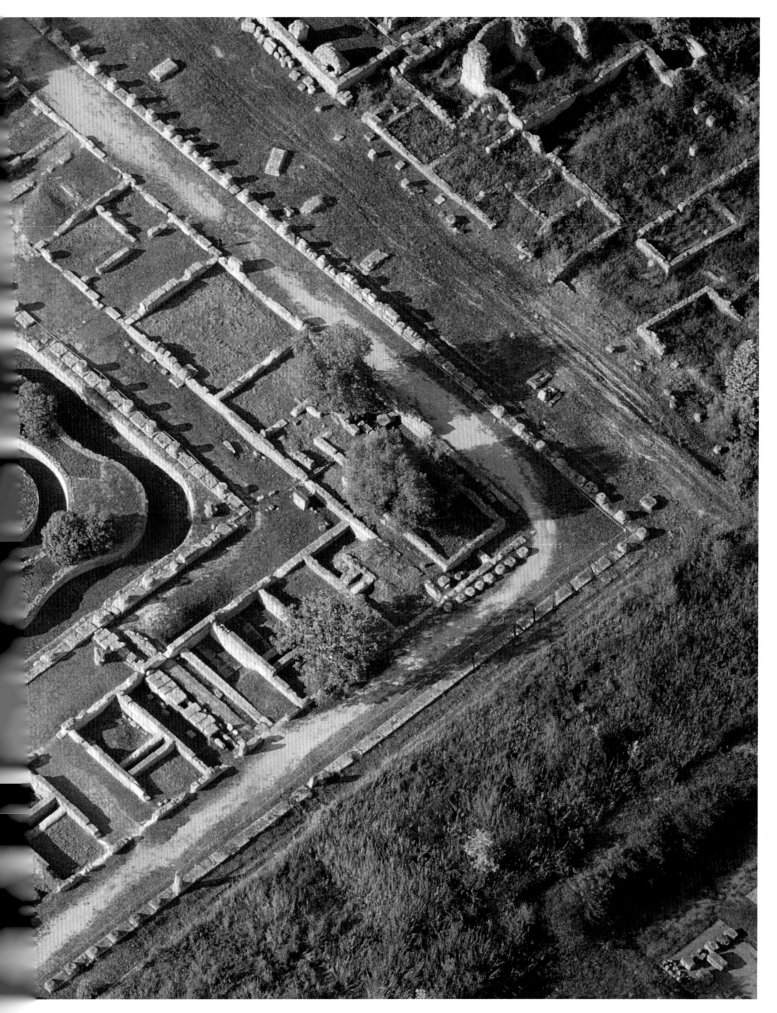

page 112
The Leonidaion hotel in Olympia, Elis

The Olympic games were an immense success: visitors from the entire Greek world, from the Black Sea and Asia Minor, from Sicily and North Africa, flooded the site. With accommodation rare and expensive, squalid camps mushroomed along a nearby river, drowning in refuse and plagued by flies. It is perhaps with good reason that the Olympian Zeus was also described as Apomuyios – 'he who drives away flies'. To make the Olympic experience more pleasant, at least for dignitaries, a man called Leonidas from the island of Naxos built a hotel around 330 BC, which grew to become the biggest building in Olympia. In the second century AD, it was remodelled to its present shape, perhaps prior to the visit of Emperor Hadrian. The Roman designers adorned the central courtyard with an artful garden and waterworks, in line with the latest fashions.

page 115
The temple of Zeus in Olympia, Elis

The sacred precinct of Olympia was dedicated to Zeus of Mount Olympus, the god of gods. In the fifth century he was honoured with a temple almost as large as the later Parthenon, built from local shell limestone whitened with stucco and roofed with marble tiles. A colossal seated statue of Zeus erected in the temple was regarded as one of the Seven Wonders of the World in antiquity. This effigy was crafted in gold and ivory by the Athenian sculptor Phidias, the ruins of whose studio next to the temple can still be visited today. After the Byzantine emperor Theodosius I ordered all pagan temples to be demolished in AD 391, the chryselephantine statue ended up in Constantinople, where it was later destroyed in a fire.

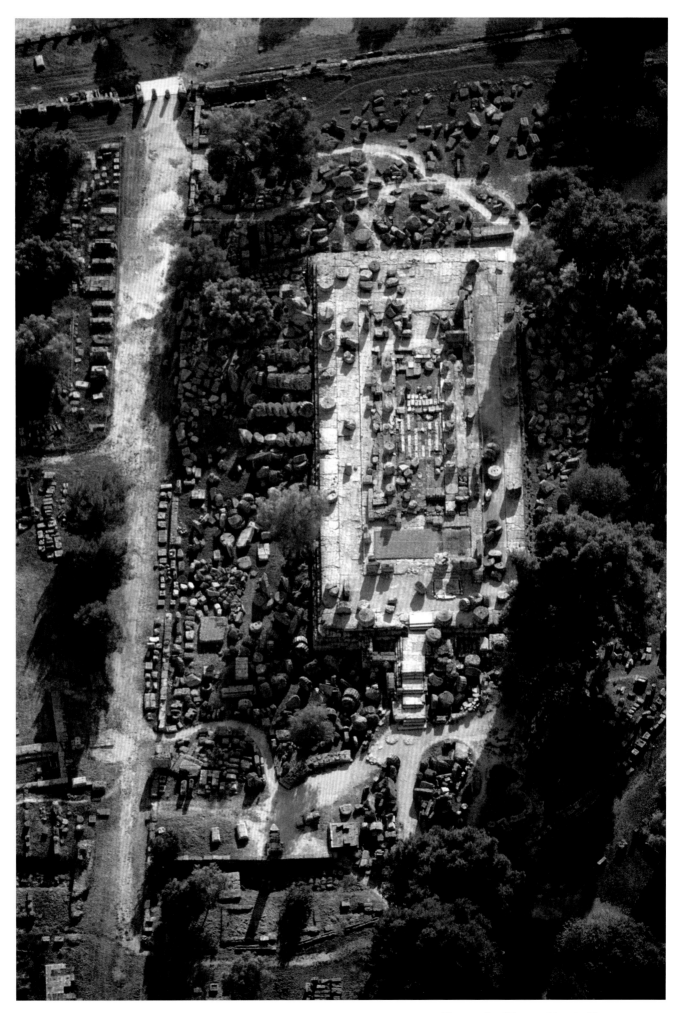

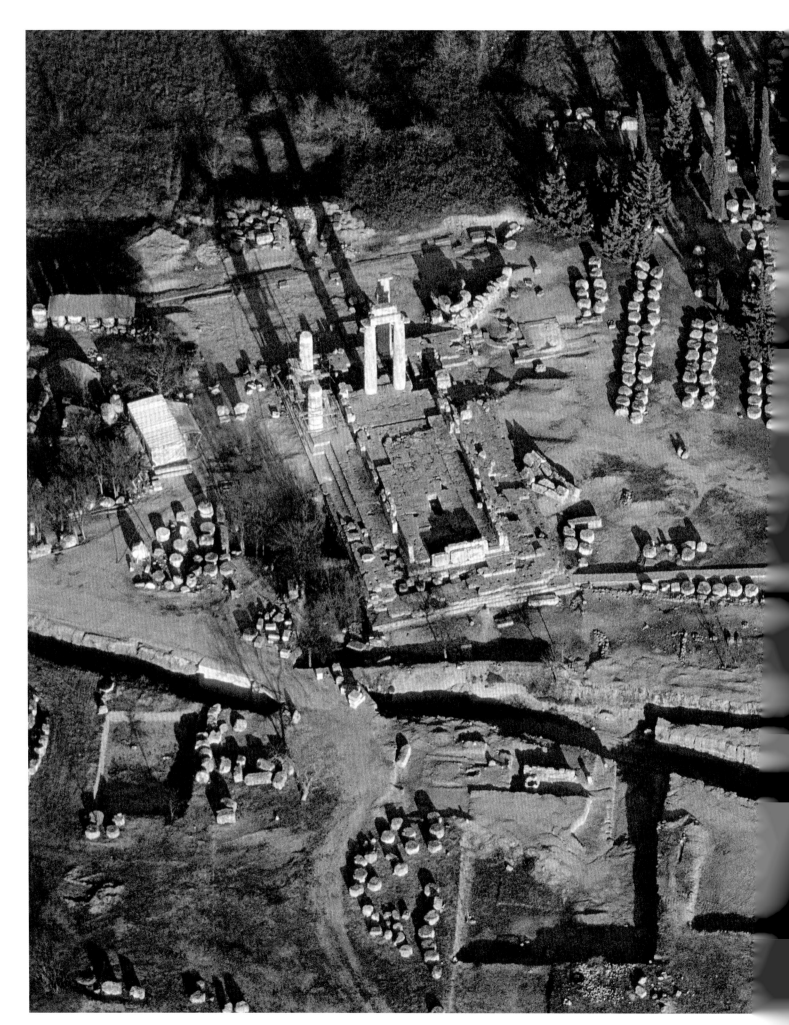

The temple of Zeus in ancient Nemea, Corinthia

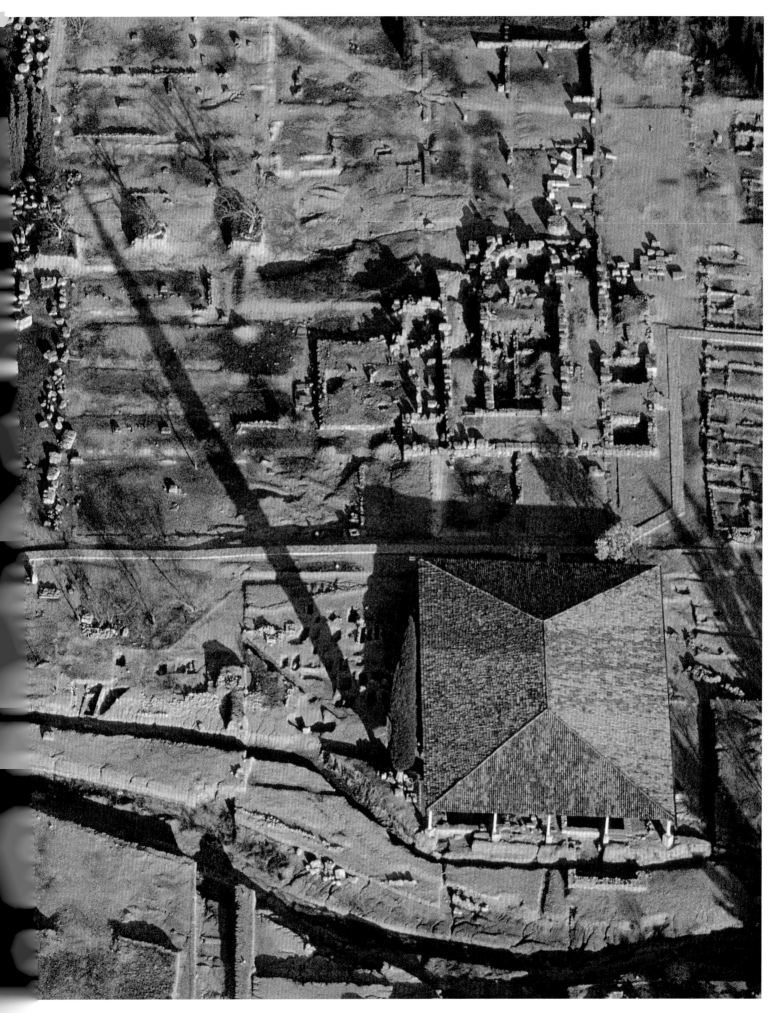

page 116

The temple of Zeus in ancient Nemea, Corinthia

This photograph shows the sanctuary dedicated to Zeus in ancient Nemea. The still-upright columns of the temple date from the fourth century BC. Nemea became the venue of biennial games that ranked with the other Panhellenic events at Olympia, Delphi and Isthmia. According to Greek mythology, Heracles performed the first of his twelve labours in the city, strangling the fierce Nemean lion. Today, the vintners of modern Nemea call their red wine 'the blood of Heracles'.

page 119

The acropolis of Lindos, Rhodes, Dodecanese

In Greek myth, Lindos is a very special place: this is where the goddess Athena sprang from the head of Zeus, making her father so happy that he let gold rain down on the island of Rhodes. There was a sanctuary dedicated to Athena on top of the rock from the tenth century BC. The Knights of St John transformed the acropolis into a mighty fortress that was successfully defended against Turkish naval forces twice.

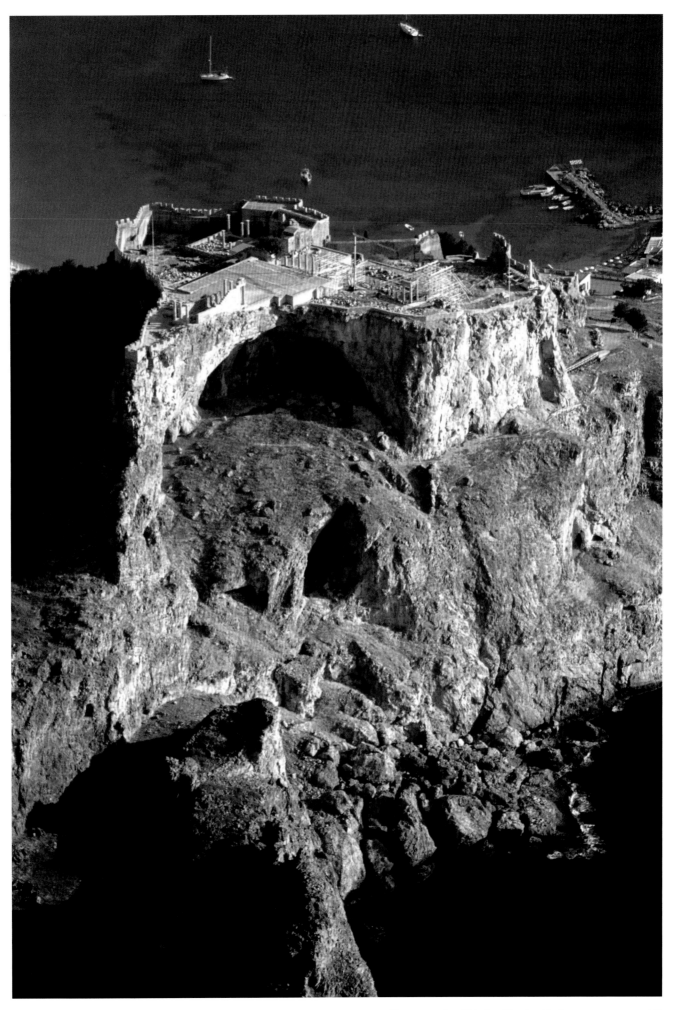

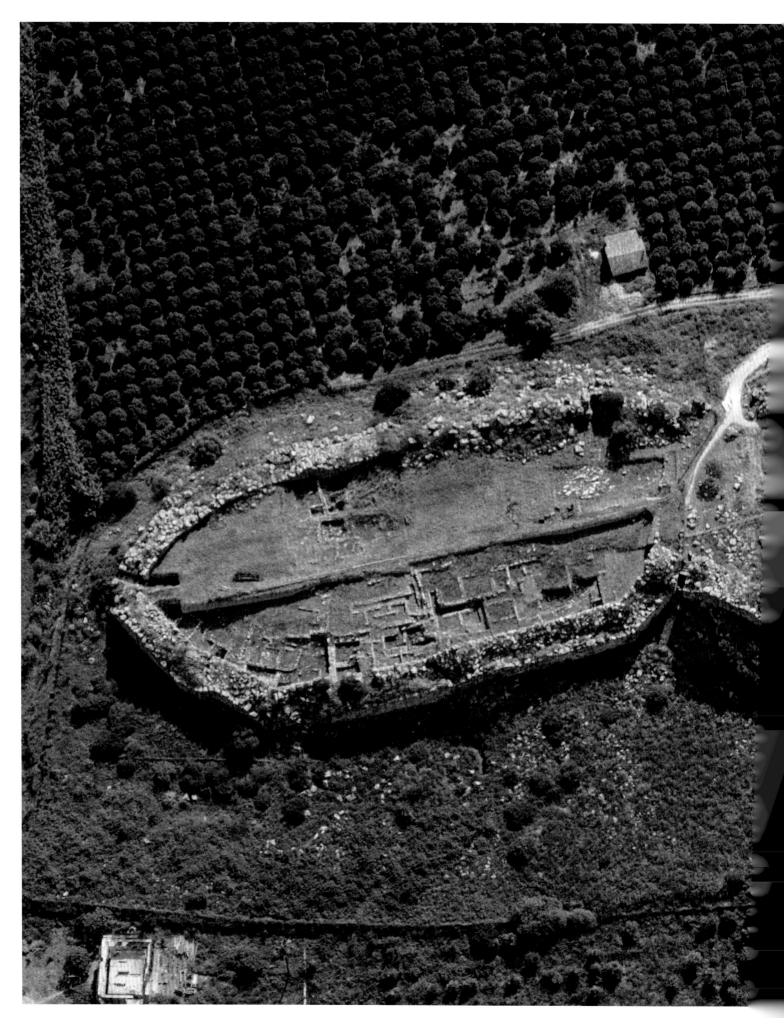

The citadel of Tiryns, Argolis

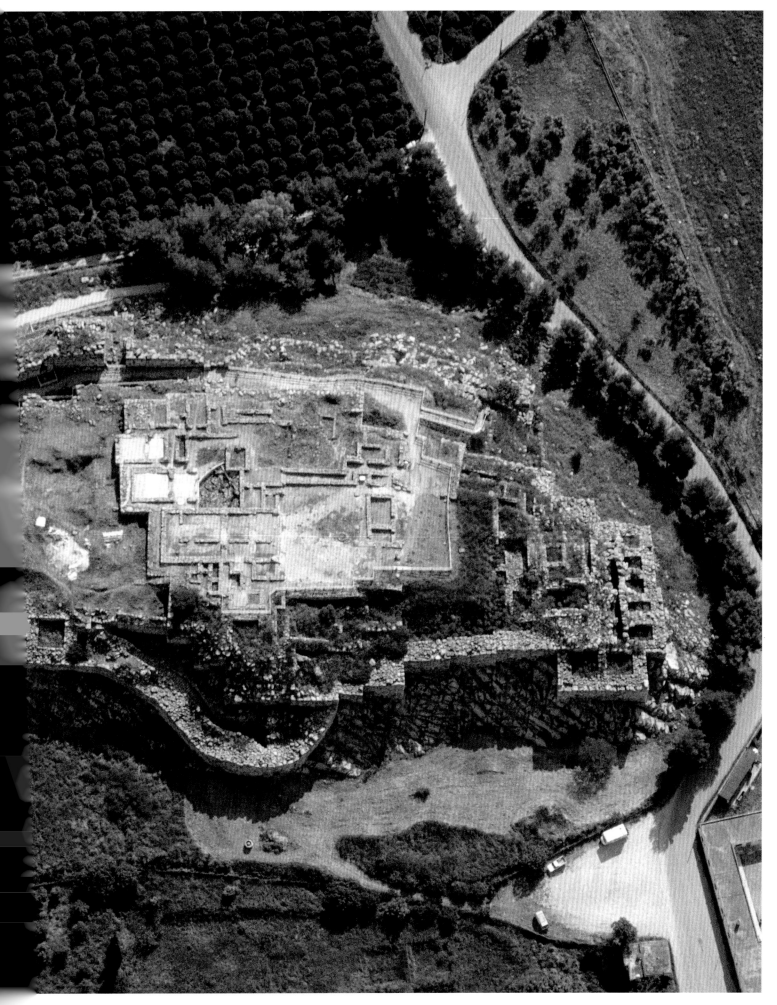

page 120
The citadel of Tiryns, Argolis
Built on a long, narrow rocky bluff
and now surrounded by citrus
orchards, the acropolis of Tiryns
was once a harbour town on the
Argolic Gulf and possibly the port
of Mycenae – the upper town with
the ruler's palace, the lower town
with service quarters and utility
buildings. It was no doubt only a
satellite to mighty Mycenae, but the
citadel's casemates and ramparts,
dating mostly from the thirteenth
century BC, are the apogee of
Mycenaean military architecture.
The Cyclopean masonry work
already impressed in antiquity:
Homer wrote of 'wall-girt Tiryns' and
in the second century AD, the travel
writer Pausanias even compared the
ramparts to the pyramids. Tiryns is
a UNESCO World Heritage site.

page 123
The ruins of Kamiros,
Rhodes, Dodecanese
In antiquity one of the three largest
cities of Rhodes, today Kamiros
is nothing but a field of ruins from
Hellenistic times. Kamiros had
profited from the immensely fertile
surrounding lands and became
wealthy trading and exporting its
crops. Kamiros figs were famous
in the Aegean and beyond; the
city's coins depicted a fig leaf. The
settlements of Rhodes were plagued
by tsunamis and earthquakes: after
the massive earthquake of 227 BC,
Kamiros was rebuilt once more, but
deserted for good when another
quake struck in AD 142.

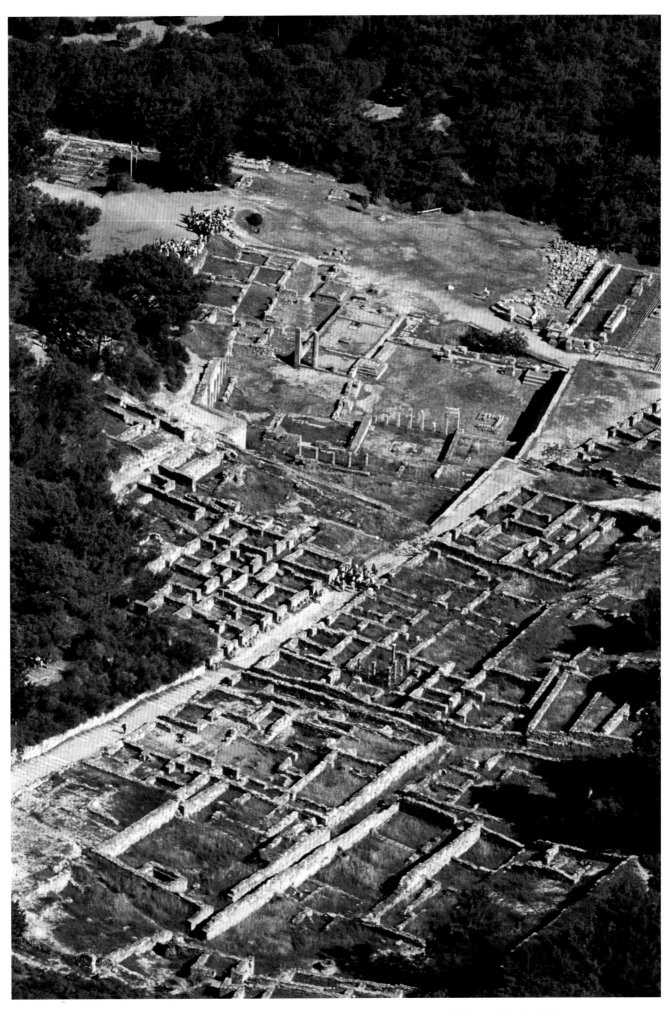

The ruins of Kamiros, Rhodes, Dodecanese

page 125

Cape Zagora on the island
of Andros, Cyclades

Andros, the second-largest island
of the Cyclades, is also its most
fertile, being rich in water resources,
arable soil and forest. In antiquity
its capital and main port were on
the craggy west coast. While only
faint traces of them remain, the
ground plan of a fortified settlement
from the eighth century BC on
Cape Zagora, a nearby precipitous
headland, is still readable with
astonishing clarity – an aggregation
of one-room houses constructed
from slate surrounding a sanctuary.
The settlement was abandoned by
700 BC, but the sanctuary remained
in use. In just one of the many
riddles posed to archaeologists by
this enigmatic settlement, the shrine
on Zagora was dedicated to Athena,
although the island's patron god
was Dionysos.

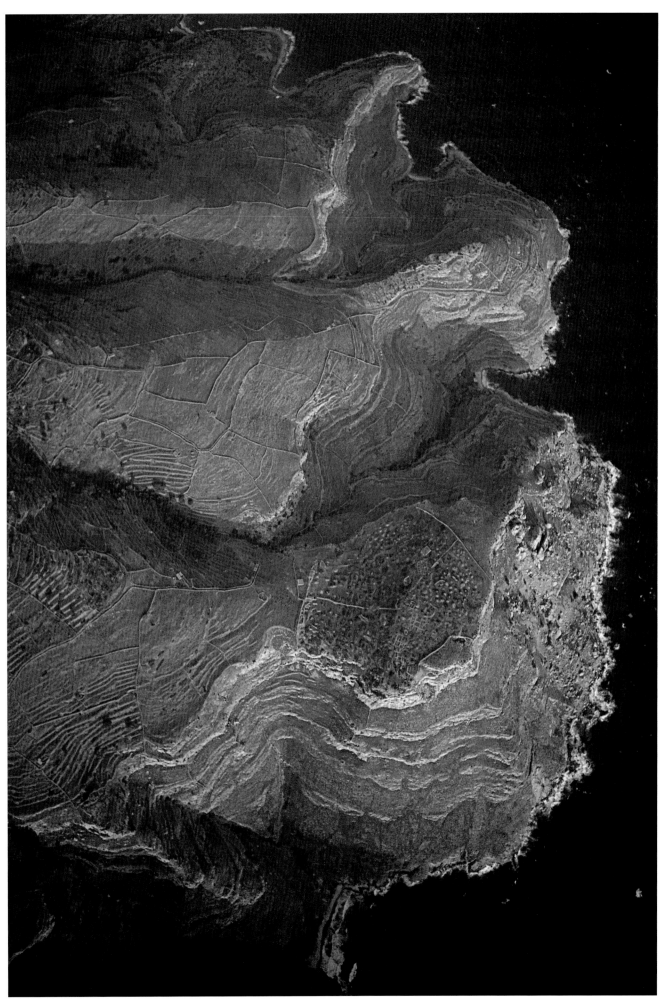

Cape Zagora on the island of Andros, Cyclades

Orchards on the island of Naxos, Cyclades

The temple of Athena Alea in Tegea, Arcadia

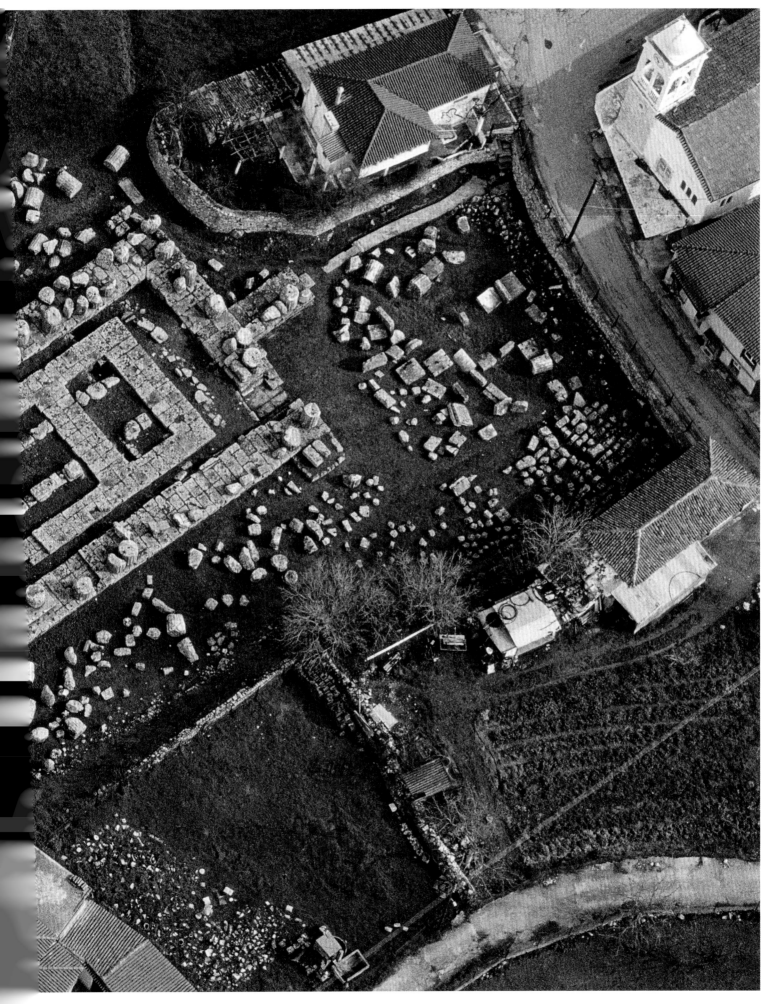

The ancient town of Mantineia, Arcadia

page 126

Orchards on the island of Naxos, Cyclades

Naxos is an island of marble, famed in antiquity. The largest of the Cycladic islands, it is also the most fertile. Mount Zas, at 1001 metres (3300 feet) the highest peak in the Cyclades, functions as the island's rainmaker, trapping the clouds. Thanks to adequate precipitation over its many mountain valleys and large coastal plains, Naxos, quite exceptionally in the archipelago, could comfortably sustain itself on the yield of its cropland. Shelterbelts protect olive groves, orchards and fields of cereals and vegetables. In addition, the island possesses a fair amount of pasture for grazing and breeding cattle.

page 128

The temple of Athena Alea in Tegea, Arcadia

The first temple on the Peloponnese to be built entirely of marble, the temple of Athena Alea in Tegea replaced an older structure that had burnt down in 395 BC. Sculptures in one of the pediments depicted the Calydonian Hunt, in which Atalanta, a local huntress, had successfully taken part, bringing back trophies and donating them to the temple: the hide of Artemis' ferocious boar was still displayed there in Roman times. The temple enjoyed the right of granting asylum; among documented asylum seekers were Spartan kings and an elderly high-priestess who had accidentally let the temple of Hera near Argos go up in flames and feared reprisals.

page 130

The ancient town of Mantineia, Arcadia

On a swampy plain ringed by the mountains of Arcadia, Mantineia sprang from the fusion of five villages around 500 BC. In 371 BC, when the town was rebuilt using locally available sun-dried mudbricks after a conflict, the town planners adopted the grid system reflected in today's ruins. They surrounded the town with a wall 4 kilometres (2.5 miles) long, accessible via ten gates and fortified with 126 square towers that projected outwards. From a political and military standpoint, however, Mantineia never lived up to its somewhat grandiose appearance: fatally, in times of war it tended to ally itself with the losing side. Now, in more peaceful times, the ruins are threatened by the ploughs that headlessly level the adobe structures. Many towers and gates have been lost to intensive agriculture in recent years.

page 133

The ruins of Gortyn, Central Crete

Gortyn has a very modest Minoan past, but the village later took over from Phaistos as the capital of the Mesara region, and grew further to become a metropolis. Under the Roman emperors, its population reached 200,000, and Gortyn was made capital of a Roman province comprising Crete and much of North Africa. Among the ruins hidden in a profusion of olive trees, the Governor's sumptuous palace, visible at the bottom of the photograph, stands out. But Gortyn owes its fame to stone tablets on which the laws of this city-state were inscribed in the local Doric dialect around 450 BC. The tablets were inserted into the wall of an odeum or little theatre (top right corner), and deal with individual liberty, property, inheritance, adultery, rape, violence and almost every other imaginable offence.

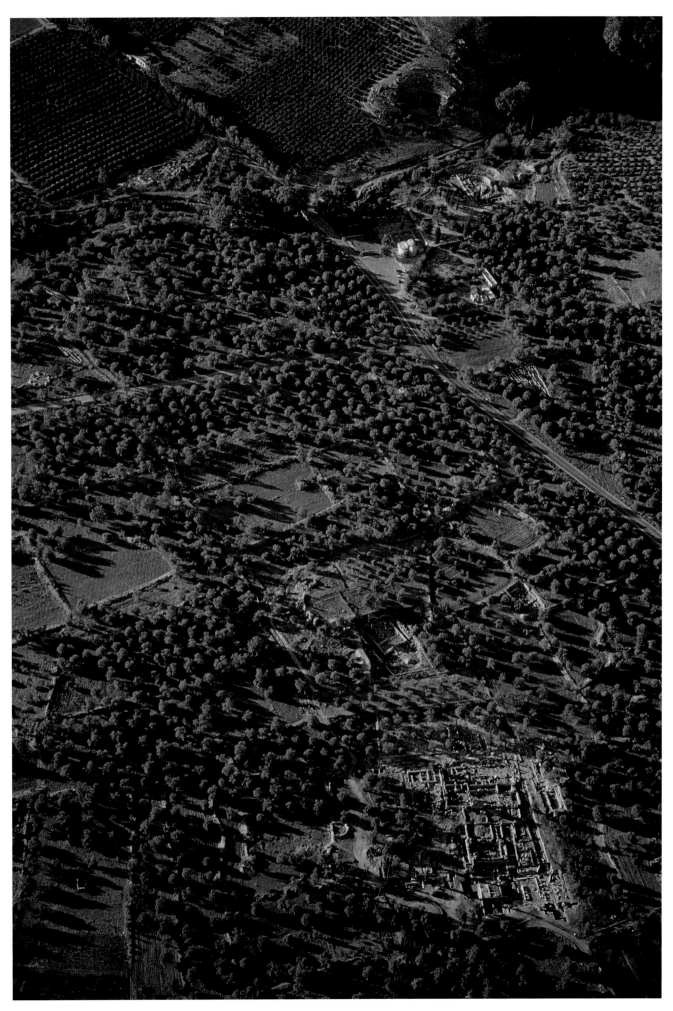

The ruins of Gortyn, Central Crete

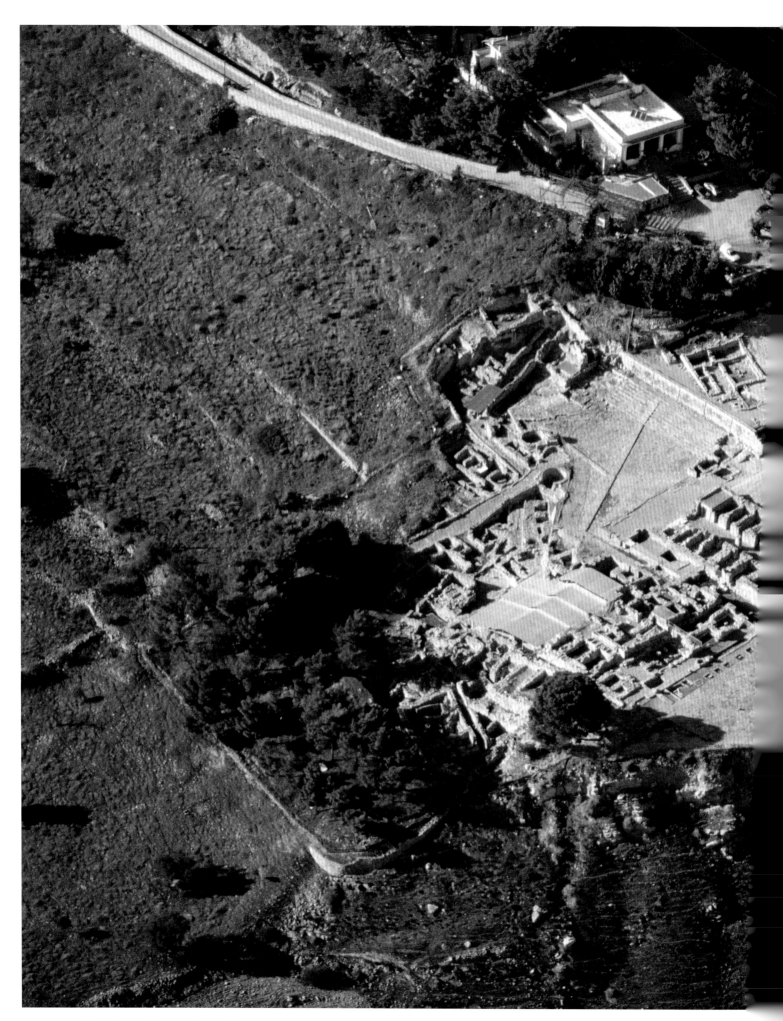

The palace of Phaistos, Central Crete

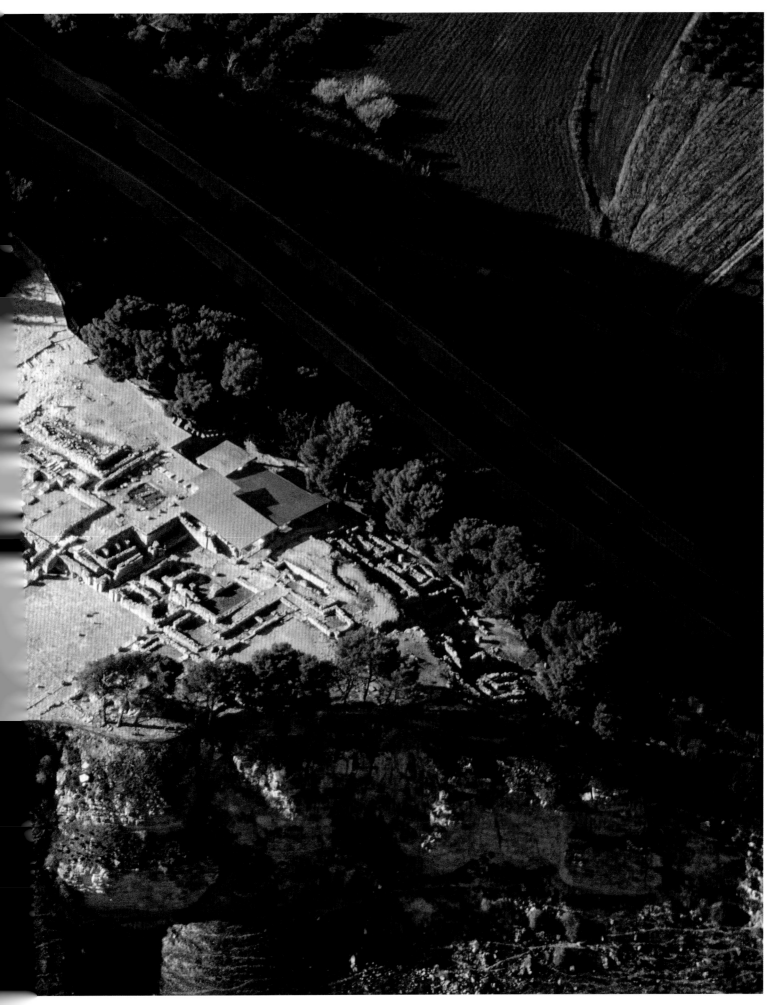

The palace of Phaistos, Central Crete

If the Minoans had an eye for a spectacular view, each ruler of Phaistos must have felt that his residence ranked first among all the Minoan palaces. In size second only to Knossos, the palace of Phaistos sits on a hill overlooking the Mesara Plain. Like Knossos, it actually consists of two superimposed palaces built and rebuilt between 2000 BC and 1400 BC, in a complex dance of construction and destruction caused by fire and earthquakes. In 1908, the excavation of the old palace yielded the famous Phaistos Disc: a clay disc stamped on both sides with a spiral of symbols, assumed to be a script. Resisting many attempts at decipherment, the disc remains one of the great mysteries of archaeology – or, as some scholars fear, a successful hoax.

The Minoan town of Gournia, Eastern Crete

The ruins of a small Minoan town on a gently sloping hill above Mirabello Bay on the north coast of Crete are well worth the detour. Gournia was not ostentatious: its largest structure was a manor house rather than a palace, a religious and administrative centre as well as the residence of some overlord. The town is made up of simple buildings inhabited by fishermen, farmers, traders and artisans. People first settled the site in the third millennium BC, but what is visible of Gournia now was built after 1650 BC. The end came around 1450 BC with a cataclysmic earthquake. When excavating the houses, archaeologists discovered floors strewn with domestic and agricultural implements.

The Minoan palace of Knossos, Central Crete

According to myth, Daedalus built the palace of Knossos for the legendary King Minos as a labyrinth to house the half-human, half-bull Minotaur. The palace was constructed around 2000 BC and rebuilt several times after earthquakes, each time aggrandizing a lucid enough ground plan: royal domestic quarters, shrines, public reception halls, offices, workshops, treasuries and storerooms surrounding a paved courtyard. Ultimately the giant palace numbered 1300 rooms, some of them stacked five storeys high. No wonder the royal complex appeared maze-like to vistors. The palace, the nerve centre and capital of Minoan Crete, was not fortified. It was deserted shortly after 1400 BC, probably following an earthquake-induced fire. By that time the site on the island had been occupied by Mycenaean Greeks. Knossos is a UNESCO World Heritage site.

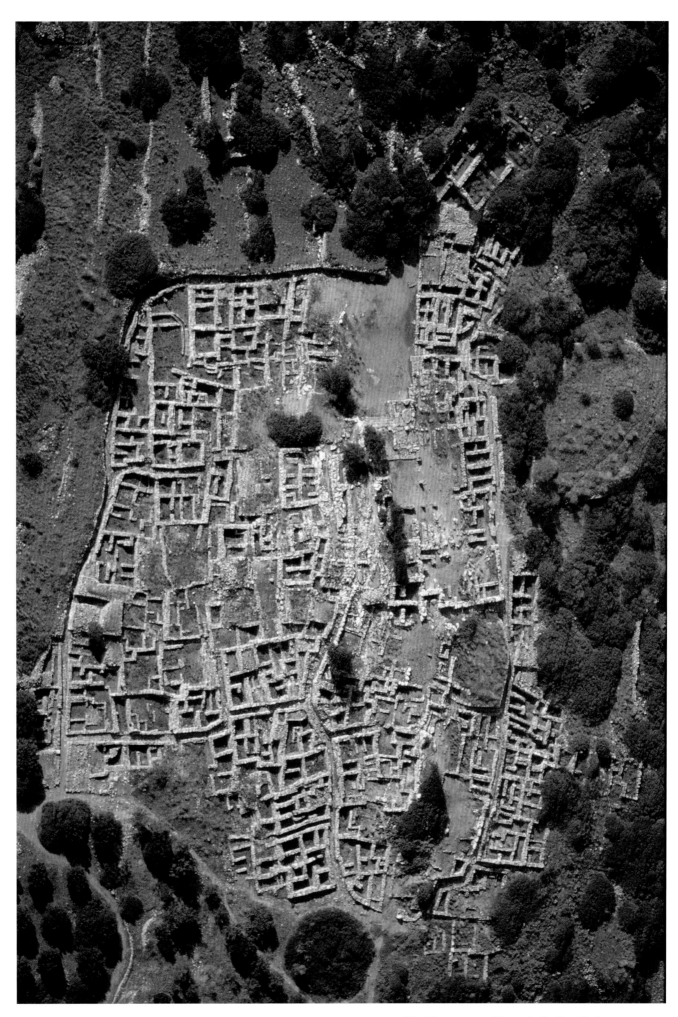

The Minoan town of Gournia, Eastern Crete

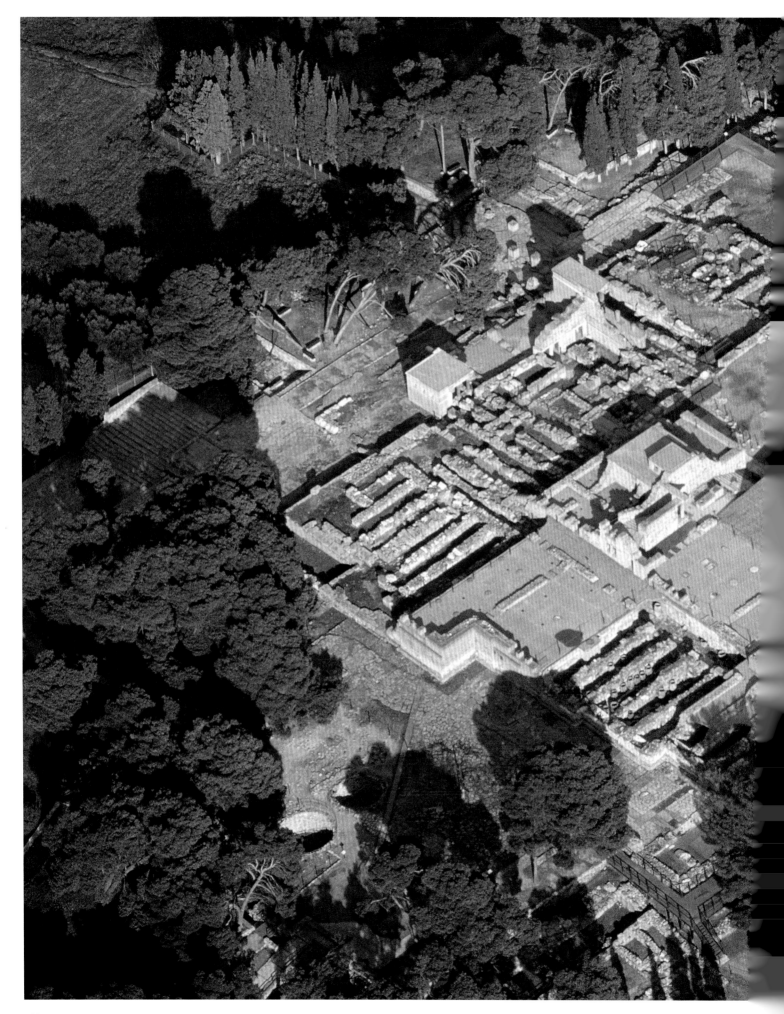

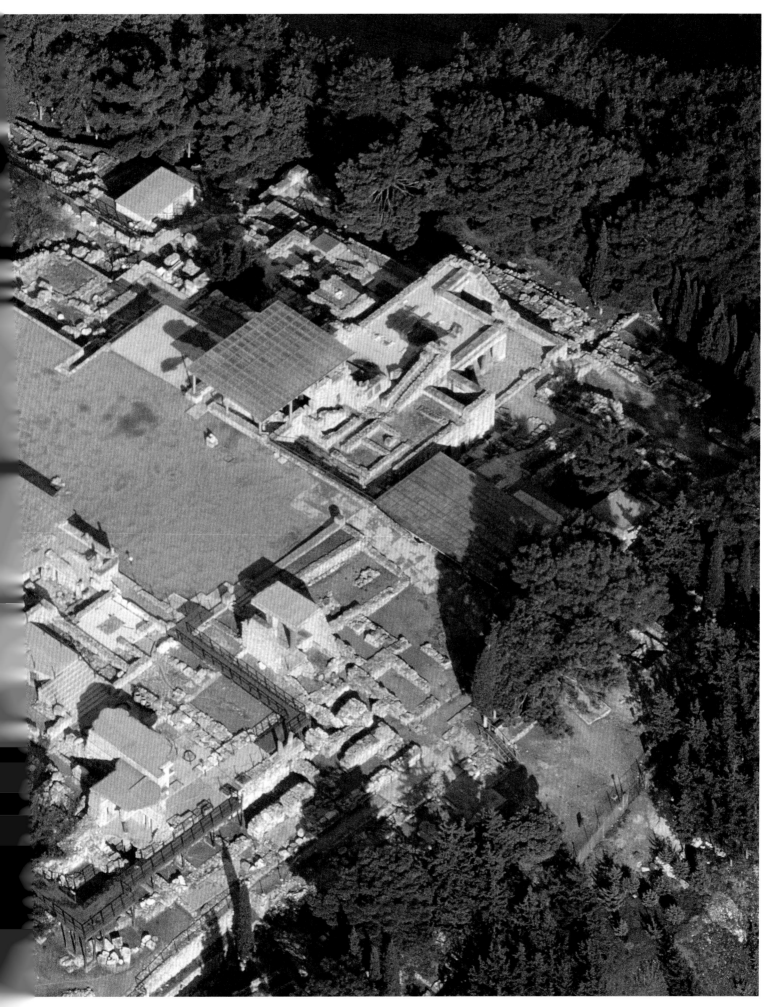

ILLUSTRATED TIMELINE

The illustrated timeline starting on page 142 provides an abridged history of prehistoric and historical/Classical Greek art and archaeology, from the start of the Bronze Age down well into the era of Roman imperial domination. Photographs of key sites within the defined area of 'Greece' are accompanied by a selection of key artefacts, both scientifically excavated and casual finds.

There follows a glossary of basic terms comprising places, periods, and terms of art, as well as a Who's Who of figures historical, mythical and divine.

3000 BC

2000 BC

1600 BC

Historical events

c.3000 BC
Emergence in Crete of the Minoan civilization, named for Minos, a legendary ruler of the island.

2000 BC
Knossos founded in Central Crete.

1600 BC
Minoan civilization at its peak. The Minoans traded with the Levant and Egypt, and their culture began to influence otherAegean islands, as well as the Mycenaean civilization of mainland Greece.

c.1530 BC
Eruption of the Theran volcano. Ash and pumice from this devastating eruption, which some scholars believe occurred earlier, around 1620 BC, were found as far away as Egypt and Israel. Plato (c.428 –c.348 BC) may have drawn on this event for his account of the legendary island of Atlantis, which sank into the ocean. It may also be the basis for stories in the Old Testament book of Exodus.

Archeological sites

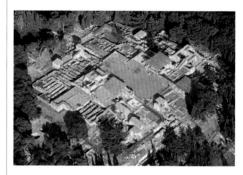

Fourni Necropolis, Central Crete
The Fourni Necropolis was in continuous use from the Early Minoan period (around 2400 BC) until the Mycenaean Greeks arrived in Minoan Crete in 1500 BC. Archaeologists have explored two dozen large tombs, covering more than a thousand years of changing burial rites and tomb-building styles, among them circular beehive tombs, some of them untouched since the time of burial.

Palace of Knossos, Central Crete
The maze-like Minoan palace was built between 2000 BC and 1400 BC.

c.3200–1100 BC
The Bronze Age

Art and Cultural events

2000–1400 BC
Construction of Minoan palaces at Knossos and Phaistos.

1800–1450 BC
Linear A script in use in Crete and some Aegean Islands, for a pre-Hellenic language of Minoan Crete that remains unknown.

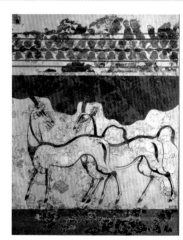

c.2600 BC
Cycladic Figurine
Marble figurines were produced throughout the Cycladic Islands during the Early Bronze Age.

c.1750–1650 BC
Cult Scene Ring
This ring was found at Mycenae on the mainland, but it is believed to be a Minoan work.

1600 BC
Shaft graves at Mycenae.

1600–1200 BC
Construction of Mycenaean citadels on Greek mainland.

Legends attributed to this time: The Voyage of the Argo, Oedipus, The Labours of Heracles.

c.1550 BC
Antelope Fresco
Many Late Cycladic (c.1600–1050 BC) frescoes have been preserved at Akrotiri, a Bronze Age town on Thera, as they were buried under ash as a result of the volcanic eruption that destroyed the site during the sixteenth century.

1500 BC

1400 BC

1300 BC

1450–1200 BC
Minoan civilization in decline.

1400 BC
Mycenaean civilization, centred on Mycenae, c. 90 km (55 miles) southwest of Athens, at its height.

1250 BC
The legendary Trojan War is generally dated to this time. According to the many accounts, such as Homer's *Iliad* and *Odyssey*, Paris, son of the Trojan king, stole Helen away from her husband, Menelaus of Sparta, whose brother Agamemnon, King of Mycenae, then led the Greeks against the people of Troy in western Anatolia in a ten-year war.

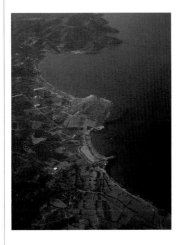

Palaikastro, Crete
The plain of Roussolakkos on the east coast of Crete, shown in the lower half of this photograph, was the site of a Minoan town second in size only to Knossos. Its inhabitants prospered by breeding sheep, cultivating olives and engaging in maritime trade. Only parts of this town have been excavated; a white-roofed shed signals the excavation site of Palaikastro amid orchards.

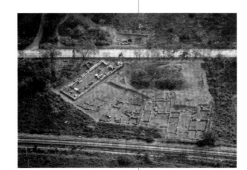

The Temple of Artemis at Aulis, Boeotia
According to legend, it was in the Bay of Aulis that the Greek fleet, poised to attack Troy, was frustrated by a dead calm: Agamemnon had offended Artemis. In order to appease the goddess and gain fair wind for his ships, he agreed to sacrifice his daughter, Iphigenia. At the last moment, Artemis prevented this infamy by spiriting the girl away to one of her shrines on the Black Sea.

1450–1180 BC
Linear B script, an adapted form of Linear A, used by the Mycenaean Greeks.

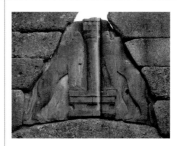

c.1300 BC
Construction of the Lion Gate, the main entrance to the citadel of Mycenae.

Treasury of Atreus, an impressive *tholos* or tomb, built at Mycenae.

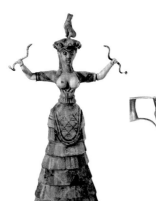

1400 BC
Destruction of Minoan palace at Knossos.

c.1500 BC
Snake Goddess
Faience statuette found in the Temple Repositories at the Minoan palace of Knossos, Crete. May have been used in ritual performances.

c.1475 BC
Vapheio Cups
Although found in the *tholos* tomb of Vapheio, near Sparta on the Greek mainland, these early Mycenaean gold cups, decorated with huntsmen and bulls, were probably made in Crete.

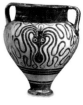

c.1300 BC
Mycenaean Clay Krater
Excavated from a Mycenaean tomb on the island of Rhodes. The octopus design is based on earlier Minoan Marine Style imagery.

1200 BC

1000 BC

800 BC

Historical events

1150 BC
Mycenaean civilization begins to collapse.
Destruction and abandonment of many Mycenaean palaces, including the palace at Thebes, a city that had once rivalled Mycenae as a centre of Mycenaean power.

1100 BC
Dorian incursions: legendary events possibly based on real arrival of new culture in southern Greece.

1100–900 BC
The Dark Age: The population of Greece shrinks and goes into decline, no longer using script. Trade with other nations is greatly reduced.

1000 BC
End of Minoan (Cretan) civilization.

776 BC
First Olympic Games are held at Ancient Olympia.

Archeological sites

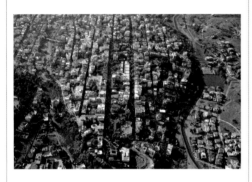

The city of Thebes, Boeotia
Rebuilt in the nineteenth century after an earthquake, Thebes, the capital of modern Boeotia (and home to Oedipus and Antigone), occupies the hill that was the large acropolis of the ancient city. Today, it is hard to imagine the powerhouse that Thebes was during the Mycenaean civilization.

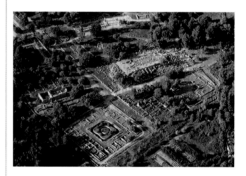

Ancient Olympia, site of the first Olympic Games

c.1050–900 BC
The Proto-Geometric Period

900–700 BC
The Geometric Period

Art and Cultural events

900–700 BC
Geometric style is developed in Athens. Pottery is decorated with zigzags, meanders and other geometric patterns.

800 BC
Simple depictions of humans and animals first appear on pottery.

c.1150 BC
Psi Figurine
Painted simple terracotta figurines such as this one were mass-produced by Mycenaean potters. This late example dates from the century after the destructions that devastated the palaces on the Mycenaean mainland.

c.1050 BC
Proto-Geometric Amphora
Pottery of this period is decorated with zigzags, meanders and other geometric patterns. This funerary amphora is from the Kerameikos cemetary in Athens.

c.875–850 BC
Early Geometric Amphora
Decorated with a meander pattern, this amphora is from the Kerameikos cemetery in Athens.

750 BC

700 BC

650 BC

750 BC
Early Greek colonies established in southern Italy: Euboeans settle Ischia and Cumae.

c.735–715 BC
Sparta conquers Messenia, and the Spartans enslave the Messenians.

700–600 BC
Sparta becomes a military state following the uprising of the Messenian slaves, or Helots. All Spartan boys and young men complete rigorous military training.

669 BC
Battle of Hysiae: Argos defeats Sparta.

c.660 BC
Pheidon, one of the first tyrants in Greece, seizes power in Argos.

650 BC
Greeks in Egypt.

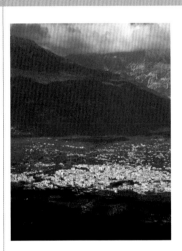

Sparti, capital of Laconia

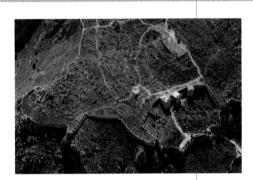

700–480 BC
The Archaic Period

Acrocorinth, Corinthia
This rocky outcrop on the Corinthian plain served as Corinth's acropolis. There was a temple dedicated to Aphrodite, the goddess of love, lust and beauty, on its summit. The ritual prostitution associated with the cult of Aphrodite may have proved contagious: St Paul sternly admonished his flock against consorting with harlots in his first epistle to the Corinthians, written around AD 55.

750 BC
Invention of Greek alphabet, based on the Phoenician writing system.

c.750–700 BC
Homeric epics and poems recorded in writing and circulated.

c.750 BC
Dipylon Krater
This monumental vessel served as a grave marker at the Kerameikos cemetary, Athens. Covered with a series of figured friezes, it represents the Geometric painting style at its most developed.

c.725 BC
Proto-Corinthian pottery begins to emerge in Corinth with new shapes and decorations. Wares are exported throughout the Greek world and beyond from c.720 BC to 650 BC.

700 BC
Construction of early peripteral temples (with exterior columns supporting the roof).

c 690 BC
Loutrophoros
The work of the Analatos Painter marks the transition from the Geometric to the Proto-Attic style of vase painting, when eastern influences such as fantastic animals, floral ornament and curvilinear patterns began replacing the more rigorous geometric visual vocabulary.

c.650 BC
Macmillan Aryballos
Small unguent flask from Thebes. The miniature size, friezes of painted decoration and combination of outline and black-figure technique are typical of the Protocorinthian style.

650 BC
'Daedalic' statues –figurative sculptures displaying Orientalizing influences, attributed to legendary artist Daedalus.

Sphinxes, griffins and other images from the East appear in seventh-century Greek arts and crafts.

625 BC 600 BC 575 BC

621–620 BC
The legislator Draco
issues the first written
law code in Athens.
Enforced by a court, it
replaces the system of
oral law and blood feud.

594 BC
Athenian statesman
Solon (c.630–c.560 BC)
introduces a new and
more humane law code.

582 BC
First Pythian Games held
in Delphi, in honour of the
god Apollo.

c.560–546 BC
Reign of the proverbially
wealthy Croesus, king of
Lydia and ruler of Greek
cities in Asia Minor such
as Ephesus.

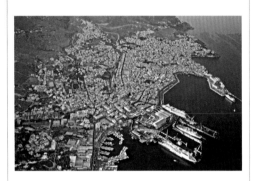

Mytilene, Lesbos
From 600 BC until 550 BC,
Mytilene, the capital of
Lesbos, Greece's third-
largest island, was one
of the cultural centres
of the ancient world,
thanks to the poet Sappho
(c.610–c.570 BC). The lyric
poet Alcaeus was her
contemporary, and some
of the surviving fragments
of his work describe the
political and social life
of the city, including a
beauty contest in search
of 'Miss Lesbos'.

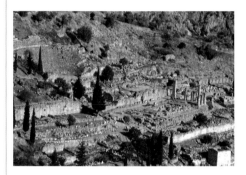

The sacred precinct of Delphi, Phocis

625 BC
Corinthian pottery,
decorated with small
geometric and floral
patterns as well as
pictures of gods and
heroes, is at the height
of its popularity and
exported around the
Mediterranean.

600 BC
Establishment of the
Doric order, one of
the three canonical
organizational systems
of ancient Greek
architecture

Early examples of
Athenian black-figure
pottery appear.

c.560–480 BC
Life of the mathematician and
philosopher Pythagoras.

c.610–c.570 BC
Life of the poet Sappho.
Born on Lesbos from an
aristocratic family, she
wrote highly admired
lyric poetry.

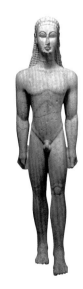

c.585 BC
New York Kouros
This *kouros* ('youth')
exemplifies the standard
stance of the marble
statues produced in
Greece since the end of
the seventh century BC:
left leg forward, arms by
the sides. He is made of
marble from Naxos.

c.560–546 BC
Stater of Lydia
According to the Greek
historian Herodotus,
coinage was invented by
the people of Lydia in
western Turkey, and their
king, Croesus, was the
first to issue gold and
silver coins.

550 BC

525 BC

500 BC

550 BC
Achaemenid Persian
Empire founded.

546/545 BC
The Persian Empire
conquers the Ionian
Greeks: Cyrus II 'The
Great' defeats Croesus
of Lydia.

545 BC
Peisistratos becomes
tyrant of Athens;
tyrannies elsewhere in
Greece.

510 BC
Expulsion of Hippias,
the son of Peisistratos:
Athens is freed from
tyranny by the Spartans
and the Alcmaeonidae,
a powerful and noble
Athenian family.

508/7 BC
Cleisthenes introduces
democracy in Athens.

505 BC
Sparta's Peloponnesian
League formed.

499–494 BC
Ionian Revolt: Ionian
Greeks rebel against the
Persian Empire.

490 BC
Battle of Marathon:
Athens and Plataea
defeat Darius I and his
invading Persian army.

**Sanctuary to Hera on
the island of Samos,
Eastern Aegean**

The plain of Marathon, Attica

c.550 BC
'Caeretan hydriai',
vases decorated with
mythological scenes,
produced by Greek-born
artists in Etruria.

540 BC
Polycrates, tyrant
of Samos, orders
construction of new
Sanctuary to Hera.

Limestone pediments
on Acropolis; Ionic order
established, e.g. temple
of Artemis at Ephesus.

c.540 BC
*Ajax and Achilles
Playing Dice*
This amphora, decorated
using the black-figure
technique, was signed by
the Athenian potter and
painter Exekias.

534 BC
The first tragedy is
performed in Athens, at
a festival dedicated to
Dionysos.

525 BC
Siphnian treasury, the
first religious structure
made entirely of marble,
built to store votive
offerings at Delphi;
beginnings of red-figure
pottery in Athens.

515 BC
Euphronios Krater
Produced near the
beginning of the red-
figure tradition, this
calyx krater is the only
surviving complete vessel
painted by Euphronios
(c.520–470 BC).

c.500 BC
Kore 674
This late example of a
kore ('maiden') figure was
found on the Athenian
acropolis, where she had
been buried after the
Persian sack of Athens in
480/479 BC.

480 BC　　　460 BC　　　440 BC

Historical events

480 BC
Second Persian invasion:
Xerxes, son of Darius,
marches on Greece.

Battle of Thermopylae;
Persians burn down the
Acropolis of Athens.

Battle of Salamis: Athens
and alliance of Greek city-
states overcome Persian
fleet, despite being
heavily outnumbered by
the Persian fleet.

479 BC
Battle of Plataea: Greeks
defeat Persian army.

478–404 BC
Athens founds anti-
Persian Delian league.

c.460 BC
Start of the 'Golden
Age' of the Athenian
Empire, a period of
political hegemony,
economic growth and
the production of some
of the most influential
and enduring cultural
artefacts of the Western
tradition.

462 BC
Further Democratic
reforms at Athens:
Ephialtes and Pericles.

460–446 BC
'First' Peloponnesian War
fought by Sparta and her
allies against Athens and
her allies.

450 BC
Peace of Callias between
Persia and the Delian
League led by Athens
(authenticity disputed).

Pericles (c.496–429 BC) is
General of Athens.

447 BC
Thebes defeats Athens,
establishes Oligarchic
federal state.

446 BC
Thirty Years' Truce
between Athens and
Sparta (broken 431 BC).

431–404 BC
Atheno–Peloponnesian
War between Athens and
Sparta and their allies.

430–426 BC
Almost a third of the
population of Athens,
including Pericles, dies in
an outbreak of plague.

Archeological sites

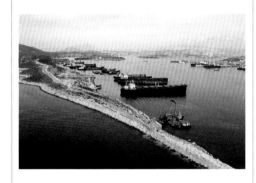

Salamis, Attica
A spit of land protruding
from the island of Salamis
– known as Kynosoura,
meaning dog's tail –
helped the Greeks win
the battle of Salamis.
Themistocles, the Greek
commander, lured the
Persian ships into the
narrows between Salamis
and the mainland, where
they hardly had room to
manoeuvre. The Persian
king Xerxes watched the
demise of his fleet from
the shore.

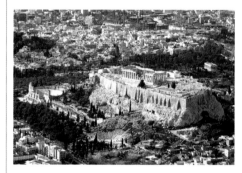

The Acropolis of Athens, Attica

480–323 BC
The Classical Period

Art and Cultural events

c.496–405 BC
Life of Sophocles, one of
classical Athens' three
great tragic playwrights.
Author of the Theban
plays: *Antigone*, *Oedipus
Rex*, *Oedipus at Colonus*.

486 BC
The first comedy is
performed in Athens.

c.485–425 BC
Life of the historian
Herodotus.

c.480–407 BC
Life of the playwright
Euripides.

c.480 BC
Wounded Warrior
This sculpture comes
from the east pediment
of the Doric temple of
Aphaia on Aigina.

c.460 BC
Achilles and Penthesilea
On this large cup or
kylix, the standard red-
figure technique has
been enhanced with the
addition of red, yellow,
blue, white and gold.

458 BC
The *Oresteia*, a trilogy of
tragedies by Aeschylus –
Agamemnon, *Choephoroi*
(*The Libation Bearers*),
The Eumenides – is first
performed in Athens.

460 BC
Temple of Zeus, Olympia;
Stoa Poikile, Athens.

c. 450 BC
Discobolos of Myron
The original bronze
Discobolos (c.470–440 BC)
is lost, but the sculpture
is known from Roman
marble copies such as
this one.

440 BC
*Horsemen from the
Parthenon Frieze*
The Parthenon's
decorative programme
was said to have been
designed by Phidias
(c.490–430 BC). These
blocks come from the
frieze that encircled the
main rooms.

447 BC
Construction of
Parthenon begins.

420 BC

400 BC

380 BC

421 BC (to 414 BC)
Peace of Nicias.

418 BC
Battle of Mantineia:
Spartan victory.

415–413 BC
Athenian expedition to
Sicily: Syracusan victory.

404 BC
Aided by Persia,
Sparta wins Atheno-
Peloponnesian War.

Start of Spartan
hegemony, which lasts
until 371 BC.

401–400 BC
Expedition of the '10,000'
to Mesopotamia and back.

399 BC
Trial of Socrates. Found
guilty of impiety and
corrupting the youth of
Athens, he is sentenced
to death by drinking
hemlock.

395–386 BC
Corinthian War: Sparta
defeats alliance of
Athens, Boeotia, Argos
and Corinth.

386 BC
King's Peace: treaty
between the Spartans
and the Persian Great
King Artaxerxes II. Persia
and Sparta carve up the
Aegean Greek world
between them.

378 BC
Athens founds anti-
Sparta Second Sea-
League, of which Thebes
is a founder member.

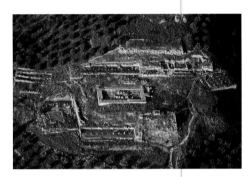

Heraion, Argolis

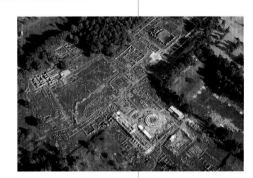

Epidauros, Argolis
For close to 1000 years,
starting in the fourth
century BC, the sick
visited Epidauros in
search of a cure. At the
temple of Asclepios
they made offerings
to the god of medicine
and underwent ritual
purification. They spent
the night in the holy
dormitory, and Asclepios
healed them in their
sleep or spoke to them in
their dreams, dispensing
dietary advice, prescribing
herbal medicine and
also urging them to take
physical exercise.

420 BC
Temple of Apollo at
Bassae.

410 BC
Erechtheum on the
Acropolis at Athens
completed.

400 BC
Construction of the
Heraion, Argolis.

385 BC
Plato founds his school at
the Academy in Athens.

380 BC
Construction of the
Temple of Asclepios,
Epidauros.

432 BC
Parthenon completed.

c.420–410 BC
Warrior Seated at his Tomb
Vases decorated in the
white-ground style such
as this one date almost
exclusively from the 5th
century BC.

c.400 BC
Grave Stele of Hegeso
This grave marker from
the Dipylon cemetery in
Athens is one of the most
beautiful and harmonious
funerary reliefs of the
Classical period.

375 BC

350 BC

325 BC

Historical events

371 BC
Sparta is defeated by Thebes at the battle of Leuctra. The Messenians are freed from 350 years of Spartan oppression.

362 BC
Second Battle of Mantineia: Theban alliance, led by Epaminondas, defeats Athens and Sparta.

359 BC
Philip II becomes King of Macedonia.

356 BC
Birth of Alexander the Great.

338 BC
Macedonian conquest of Greece.

336 BC
Murder of Philip II, Alexander ascends to the throne.

336–323 BC
Reign of Alexander the Great, who extends the empire to India.

335 BC
Alexander orders destruction of Thebes.

334 BC
Alexander invades Persian empire.

330 BC
End of Achaemenid Persian empire.

323 BC
Death of Alexander the Great in Babylon.

Failed revolt of Greeks against Macedon.

322 BC
Termination of Athenian Democracy.

301 BC
Battle of Ipsus, death of Antigonus I Monophthalmus ('Antigonus the One-Eyed'), founder of Antigonid dynasty of Greece.

Archeological sites

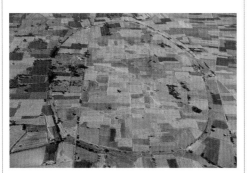

Mantineia, Arcadia

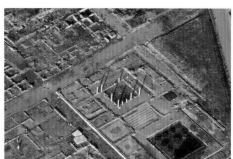

Pella, Macedonia
Alexander the Great was born and raised in Pella, where he was groomed for office by no less a teacher than the philosopher Aristotle. The kings of Macedon first took up residence in the city around 410 BC. Today, a main road cuts through the residential quarter of the ancient town, whose houses featured luxurious elements such as columned courtyards and floor mosaics composed of coloured pebbles.

323–31 BC
The Hellenistic Period

Art and Cultural events

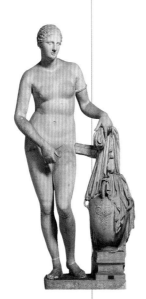

c.345 BC
Colonna Venus
One of many copies of the Aphrodite of Knidos, the first female nude sculpture in ancient Greece. The original by by Praxiteles (c.400–330 BC) was destroyed in a fire in Constantinople in AD 476.

335 BC
Aristotle sets up his school at the Lyceum in Athens.

c.325–300 BC
Marathon Boy
Rare example of a surviving bronze sculpture from ancient Greece, found in a shipwreck off Marathon.

c.330–300 BC
Myrtle Wreath
This gold wreath with 120 delicate blossoms was found in the antechamber of a royal Macedonian grave at Vergina.

300 BC

275 BC

250 BC

300 BC
Establishment of
Hellenistic kingdoms.
Greek art and ideas
spread throughout
the former empire of
Alexander the Great.

283 BC
Death of Ptolemy I,
founder of Ptolemaic
dynasty of Egypt and of
the Library at the new
capital of Alexandria.

281 BC
Seleucus I, founder of
Seleucid dynasty of Asia,
assassinated.

280 BC
Achean League
refounded.

263 BC
Eumenes I succeeds
Philetaerus as ruler of
Pergamum kingdom in
Asia Minor.

c.250 BC
Gauls in Asia Minor
Celtic tribes invade
Greece, reaching Delphi.

244–241 BC
Agis IV king at Sparta.

238–227 BC
War of Attalus I Soter of
Pergamum for control of
Asia Minor.

235–222 BC
Cleomenes III king at
Sparta.

224-222 BC
Antigonus III invades
Peloponnese and founds
Hellenic League.

223–187 BC
Antiochus III succeeds
Seleucus III.

222 BC
Battle of Sellasia:
Antigonus III defeats
Sparta.

221–179 BC
Philip V, successor of
Antigonus III, alliance with
Hannibal of Carthage.

211 BC
Alliance between
Aetolia and Rome: First
Macedonian War.

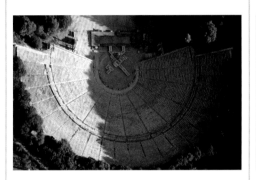

Theatre of Epidauros, Argolis

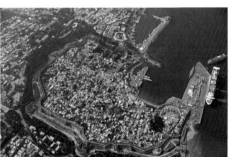

Rhodes Old Town, Rhodes, Dodecanese
Rhodes Old Town was
once home to the
Colossus of Rhodes, a
statue of the Greek God
Helios that stood over
30 metres (100 feet) high.
Erected around 280 BC, it
was considered one of the
Seven Wonders of the
Ancient World. One of
the tallest statues of the
time, it marked the
island's victory over
Demetrius 'the Besieger',
the son of Antigonus I
Monophthalmus, the ruler
of Cyprus, in 304 BC, after
the year-long siege of
Rhodes.

300 BC
Construction of the
theatre of Epidauros,
Argolis.

'Alexander Mosaic': made
up of more than a million
tesserae, the most famous
example of Hellenistic
mosaic technique depicts
Alexander the Great
defeat of Darius III of
Persia at Issus.

Euclid founds a school of
mathematics in Athens.
Zeno founds Stoic school.

280 BC
Construction of the
Colossus of Rhodes
completed.

290 BC
Foundation of the Royal
Library of Alexandria, holding
the greatest collection of
works of Greek literature in
the ancient world.

287–212 BC
Life of mathematician and
philosopher Archimedes of
Syracuse.

280/279 BC
Demosthenes
This statue of the orator
Demosthenes (a marble
copy after Polydeuktos),
made c.40 years after
his death, is far from
the Classicizing ideal
of earlier portraits. The
sculptor sought to convey
his character as well as
physical features.

c.270 BC
Astronomer Aristarchus
of Samos develops the
first known model of the
solar system with the
Sun, not the Earth, at
the centre of the known
universe. This theory
was formulated in the
sixteenth century by
Copernicus.

**Late third century BC
(original)**
Dying Gaul
This statue of a wounded
soldier is thought to be
a second century AD
marble copy of a bronze
erected in the late third
century BC to celebrate
the victory of Pergamum
over invading Celts.

200 BC

150 BC

100 BC

Historical events

200–197 BC
Second Macedonian War.

196 BC
Rome declares Greece 'Free'.

194 BC
Rome abandons Greece.

192–188 BC
Syrian War of Rome against Antiochius III.

171–168 BC
Third Macedonian War.

168 BC
Rome defeats the Macedonians at Pydna, end of Antigonid dynasty.

148 BC
Macedonia becomes a Roman province.

147–146 BC
Achaean League rises against Rome.

146 BC
Roman sack of Corinth. Achaea (the Greek mainland south of Macedonia) becomes a Roman protectorate.

133 BC
Attalus III of Pergamon dies without an heir, leaving the kingdom to Rome. Pergamum become Roman province of Asia.

86 BC
Sack of Athens by Roman general Sulla.

64 BC
Roman general Pompey the Great conquers Seleucid empire.

48 BC
Julius Caesar defeats Pompey the Great in Greece and becomes Dictator of Rome.

31 BC
Battle of Actium: Cleopatra and Mark Antony are defeated by Octavian, Ptolemaic dynasty in Egypt ends. Rome conquers the last remaining Greek territories. The Hellenistic period comes to an end.

27 BC–AD14
Octavian reigns as First Roman Emperor.

Archeological sites

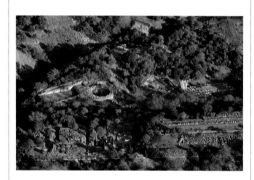

The Sanctuary of the Great Gods, Samothrace
This sanctuary's cult was secret: the shrine operated for more than a millennium, but we know hardly anything about the mysteries celebrated here. Its venerated divinities, the Kabeiroi, were pre-Olympian gods, but the lips of the initiated remained sealed on penalty of death. Initiated or not, mariners in distress implored the Great Gods for help and protection. The statue of the winged Victory was recovered here in 100 pieces in 1863.

Plaka, the capital of Melos
The island's modern capital, Plaka, occupies the site of the ancient city of Melos. In 1820, a farmer unearthed a statue of Aphrodite made of gleaming white marble near the ancient theatre. It was to become the island's most famous export – a masterpiece of Hellenistic art now known as the Venus de Milo. The farmer sold it to the French Ambassador in Constantinople, who in turn presented it to King Louis XVIII.

Art and Cultural events

c.200 BC
Victory of Samothrace
The winged goddess Nike (Victory) formed part of a monument constructed when the sanctuary of the Great Gods on Samothrace was at its most prosperous.

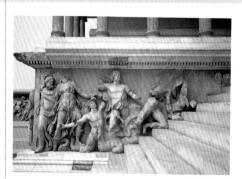

165 BC
Great Altar of Zeus at Pergamum is built possibly in celebration of Pergamum's victory over the Celts.

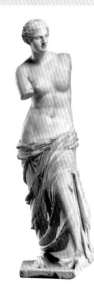

c.100 BC
Venus de Milo
This statue, discovered in 1820 on the Cycladic island of Melos, was long thought to be by Phidias and date from the fifth century BC, but stylistic considerations (such as the dramatic drapery) now place the work between 150 BC and 50 BC.

After AD1

After 1800

AD 66–67
Roman Emperor Nero tours Greece, 'wins' at Olympics.

AD 117–38
Reign of Emperor Hadrian.

AD 391
Emperor Theodosius I orders termination of all non-Christian worship, including the Olympic Games.

AD 529
Emperor Justinian orders closure of Greek philosophical schools.

Parthenon and Hephaisteion turned into Christian churches.

1456
Turks occupy Attica.

1506
Excavation of *Laocoön* in Rome.

1733
Foundation of Society of Dilettanti in London, which sponsors the study of ancient Greek and Roman art.

1804–11
Transfer of Parthenon sculptures to Britain by Lord Elgin.

1821–32
Greek War of Independence from Ottoman rule, during which the theatre of Argos served as the meeting place for the National Assembly twice, in 1821 and 1829.

1870–90
Excavations at Troy by Heinrich Schliemann.

1876
German excavations at Olympia begin.

1896
French explorations at Delphi begin.

1900
Sir Arthur Evans starts excavation of Knossos.

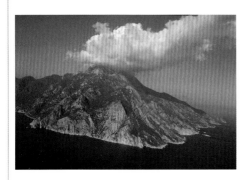

Mount Athos, Chalcidice
The easternmost of the three prongs of the Chalcidice peninsula ends in Mount Athos, 2003 metres (6700 feet) high, which since the ninth century AD has turned into the 'Holy Mountain'. Studded with Orthodox monasteries, it is an autonomous entity of Greece. The monks strictly control access to their republic-within-a-republic, keeping out females of any kind – even animals.

The theatre of Argos, Argolis

First century AD
Laocoön
A Roman copy of a Greek original dating from the the third or second century BC, this sculptural group was discovered in Rome in 1506. It shows the Trojan priest Laocoön and his sons being attacked by serpents sent (according to Virgil's *Aeneid*) by Athena as punishment for having warned the Trojans against bringing the wooden horse into their city.

160 AD
Travels of Pausanias of Magnesia, author of a ten-volume *Description of Greece*, a proto-touristic guide preserving much lore and fact about Classical Greece.

GLOSSARY

Agora Market place, the central civic area of a Greek city.

Acropolis 'High citadel'; in most Greek cities, an elevated area reserved for temples.

Amphora Form of ancient vessel with two handles and a narrow neck, used as a storage jar for liquids such as oil or wine.

Antique Term often considered interchangeable with **Classical**, although it has a slightly different meaning: 'The Antique' generally refers to the physical remains of the Greek and Roman world, such as architecture and sculpture, rather than these civilizations' influence on the arts.

Archaic Literally, 'old'; strictly, the period from c.650 BC to 480 BC. In Greek sculpture and painting of the Archaic period, an early formulaic approach possibly based on Egyptian models engendered an increasing interest in anatomy that resulted by the end of the period in bold experimentation and mastery of form. Sophisticated metalworking and painting techniques developed, and themes and subject matter expanded, though any direct form of historical representation is rare.

Architrave Beams above columns; lowest part of the **entablature** on a Greek building.

Attic Relating to the city and territory of Athens; the region of Attica.

Black-figure Style Ancient Greek vase-painting technique in which figures and designs are painted in black silhouette, with details incised to reveal the colour of the background slip. *See also* **Red-figure style**

Bronze Age The period from c.3000 BC to 1000 BC, characterized by the use of bronze as the major metal for tools and weapons. In most cultures the Bronze Age followed the Neolithic period, when stone tools were prevalent, and was succeeded by the Iron Age, when techniques for smelting iron ore for use in weapons and tools were developed.

Caryatid Female figure (**kore**) taking the place of a column in supporting an **entablature**.

Chryselephantine Greek term combining the words for gold and ivory, used to describe sculpture incorporating those materials on a wooden core. Chryselephantine works were created in Greece from the Archaic period, in particular colossal sculptures of cult figures in major sanctuaries such as Olympia and on the Athenian acropolis.

Classical In Greek art, the period from c.480 BC to 320 BC, starting with the Greek victory over the Persians and ending with the death of Alexander the Great, but otherwise the term is used generally to describe the art and culture of ancient Greece and Rome. Classical Greek artists achieved an elegance of form and perfection of technique that have been emulated but seldom surpassed in Western art. The period is divided variously into the Early Classical (c.480–450 BC), High Classical (c.450–375 BC) and Late Classical (c.375–323 BC) periods.

Classical Orders In classical architecture, the five classes of columns and their associated features: **Doric**, **Ionic**, **Corinthian**, Tuscan (similar to the Doric order, but with a simpler base and frieze) and Composite (combines characteristics of both Ionic and Corinthian orders).

Colossus Originally meaning a 'double' of a person or being; eventually denotes a statue of over life-size scale, such as the Colossus of Rhodes.

Corinthian One of the five **Classical Orders**. Characterized by an ornate capital carved with stylized acanthus leaves.

Cornice The upper, horizontal member of the **entablature**.

Cycladic culture Culture that flourished on the Cycladic islands of Greece during the Bronze Age. The culture is best known for its elegantly schematic marble figurines dating to the early Bronze Age (third millennium BC). Although the Cyclades fell within the cultural orbit of Minoan Crete and Mycenaean Greece, they retained their own distinctive art and architecture.

Dark Age The period from c.1100 BC to 800 BC that followed the collapse of the **Minoan** and **Mycenaean** civilizations around the twelfth century BC. Literacy and the arts declined and the greatly reduced population reverted to a more primitive way of life.

Delian League Alliance of Greek states dominated by Athens, with its headquarters at Delos. Founded in 478 BC during the Greco-Persian Wars, the Delian League was disbanded in 404 BC after Sparta defeated the Athenians at Aegospotamoi.

Diazoma The ambulatory or horizontal passage separating the several ranges of seats in a theatre or stadium.

Doric One of the five **Classical Orders**. Massive in style, with simple capital and column. Greek columns are fluted without a base, while Roman versions can be either fluted or unfluted and have a base.

Egypt, Ancient Civilization that flourished for three millennia along the Nile, from around 3000 BC until the Roman period. The country was ruled by a Hellenistic dynasty, the Ptolemies, from 304 BC to 30 BC, after which it was annexed by Rome.

Entablature Includes all parts of an architectural order above the columns, consisting of **architrave**, **frieze** and **cornice**.

Etruscan Civilization Civilization that flourished in central Italy and Tuscany from the ninth to the third century BC. Etruria carried on extensive trade with Greece during the Archaic and Classical periods (seventh to fourth centuries BC), and many of the most well-known Greek vases came from Etruscan tombs at Cerveteri, Tarquinia and elsewhere. Etruscan tomb paintings also reveal much of what is known of ancient Greek wall painting styles.

Frieze In Greek and Roman Classical architecture, the central section of an **entablature**, which can be decorated with bas-reliefs; any horizontal band decorated with mouldings, relief sculpture or painting.

Geometric The period c.900 to 750 BC, so called because the decoration of pottery at this time was distinctly geometric, made up of lines, triangles, circles and meanders, and largely non-narrative. Where figures do appear, they too are created of geometric shapes; three-dimensional sculpture is also schematic. An evolution of the **Proto-Geometric** style.

Gymnasium Literally, place where one goes naked. As today, a place set aside for physical exercise and training.

Helladic Used of the **Bronze Age** period as it occurs on the Greek mainland. *See also* **Mycenaean Civilization**

Hellenistic Using Greek modes of style, expression or language; in art-historical chronology, conventionally covers the period of 323 BC to 31 BC. Beginning with the death of Alexander the Great and ending with the defeat of Cleopatra and Marcus Antonius by Octavian (later Augustus), the Hellenistic period was a time when Greek art and culture expanded throughout the eastern Mediterranean and Near East. Alexander's generals divided up between them the conquered regions and established Greek political institutions, culture and art in lands from Egypt to Persia. The painting and sculpture of the period is charcterized by increasing realism and exaggerated drama.

Helot Native Greek serf-like subject of Sparta, both in Laconia and Messenia.

Heraion Temple of Hera.

Heroön Shrine for worship of a hero.

Ionic One of the five **Classical Orders**. The capitals have volutes and the columns have bases.

Iron Age The period from c.1000 BC to 1 BC. In the traditional categorization of the human past, the Iron Age succeeded the **Bronze Age** and was characterized by the use of iron as the main metal used for weapons and tools.

Kerameikos Potters' quarter in Athens, northwest of the Acropolis. The name is the source of the word 'ceramic'.

Kouros/Kore Terms for freestanding statues from the Greek **Archaic** and early **Classical** period, denoting nude male youths and clothed maidens (such as those found on the Athenian Acropolis), respectively. The sculptures stand upright with one foot in front of the other, their weight distributed evenly on both legs. Kouroi have been found in the sanctuaries of male deities and were used as grave markers for aristocratic burials.

Krater Large, wide-mouthed metal or pottery vessel used for mixing wine with water, often with handles. Large examples hold around 45 litres (10 gallons). Volute kraters are egg-shaped, with scroll-shaped handles attached at the vessel's shoulder, calyx and bell shapes are subdivisions, while calyx kraters spread out like the cup or calyx of a flower. Examples of bell-shaped kraters are found in **Red-figure** pottery.

Linear B Syllabic (non-alphabetic) writing system used for the Mycenaean language, an early form of ancient Greek.

Meander Decorative border constructed from a continuous line shaped into a repeated motif.

Megaron The principal hall in a Mycenaean house, with an open porch and a vestibule. Found in all Mycenaean palace complexes, where it contained a central hearth and a throne.

Minoan Crete-based **Bronze Age** 'palatial' civilization named after legendary King Minos, which flourished from c.3000 BC to 1100 BC. Minoan art and culture heavily influenced that of mainland Greece before being absorbed, probably militarily, by the **Mycenaeans**. The Minoans are renowned for their naturalistic wall paintings, exquisite metal- and stonework, and fine painted pottery.

Mosaic Decorative art using pebbles or small pieces of coloured glass, stone or other materials. Pebble mosaics were used to create decorated floors in ancient Greek buildings.

Mycenaean Civilization overlapping with, then overtaking, **Minoan**, which flourished during the late **Bronze Age** in central and southern mainland Greece, from c.1600 BC until 1050 BC; also called Late **Helladic**. Taking its name from city of Mycenae, the culture was culturally and artistically influenced by the Minoan and **Cycladic** civilizations. By around 1450 BC, the Mycenaeans dominated the whole of the Aegean. Examples of Mycenaean art and, by extension, culture, have been found as far away as **Egypt**, the shores of Anatolia and the Black Sea region.

Necropolis From the Greek for 'city of the dead', a large cemetery or burial ground, usually including structural tombs.

Odeum Roofed building used mostly for musical performances.

Oracle Message or instructions understood to come from divine authority.

Orientalizing Showing Near Eastern influence; chronologically, the period of c.750 to c.650 BC Examples of Orienalizing style include animal friezes on early Archaic Greek pottery or the influence of Phoenician silver on Etruscan ceramics.

Orchestra Circular 'dancing space' in the Greek theatre, below the stage.

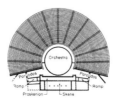

Panhellenic Open to, or involving, the Greek-speaking world

Pediment Triangular gable at the end of a building, formed by the pitch of the roof. Includes the wall at the back (tympanon), the raking **cornice** above, and the horizontal cornice below. In ancient Greece and Rome (and in Classical revival architecture since then), the pediment was often, but not necessarily, filled with sculpted decoration.

Polychromy Use of many colours in decorating architecture and sculptures.

Proto-Corinthian style An **orientalizing** style of Greek vase-painting, centred on the city of Corinth from c.720 BC to 640 BC. It is characterized by miniature vessels and complex animal and figural friezes.

Proto-Geometric The period from c.1050 BC to 900 BC, the pottery of which indicates the end of the **Dark Age**. Only basic pottery exists from the Dark Age, but around 1050 BC better-made vessels reappear, decorated with horizontal bands featuring circles, triangles and wavy lines. The Proto-Geometric style evolved to become the **Geometric** style.

Ptolemies *see* **Egypt**

Red-figure style Ancient Greek vase-painting technique in which figures and designs are left reserved (without paint), the resulting blank silhouettes then completed with painted details. *See also* **Black-figure style**

Relief From the Italian *relivare* ('to raise'), term used in sculpture and architecture to describe a design or image that protrudes from a flat surface. The terms 'high relief' or 'low relief' are used to describe the amount of projection.

Stele Upright stone or bronze slab used to record an event or mark a grave, common in many cultures throughout the world. Stelae are often inscribed or decorated with carvings.

Tholos Round-shaped building or tomb.

Tumulus (pl. tumuli) Burial mound, usually with raised earth.

HISTORICAL FIGURES

Achaemenids Greek version of the dynastic name of the Persian royals, from the seventh to fourth centuries BC.

Aeschylus Athenian tragedian (c.525–456 BC), said to have written 90 plays, only seven of which survive. His life witnessed key events in the city: the fall of the tyrants, the rise of democracy and the Persian wars (he fought at the Battle of Marathon).

Alcmaeonidae Powerful Athenian family, exiled by **Peisistratos**, and instrumental in the reforms which led to a democratic constitution at Athens. **Cleisthenes** was the Alcmaeonid who set up the Athenian democracy in 508/7 BC. A later member of the family was **Pericles**.

Alexander the Great The name universally given to Alexander III of Macedon (356–323 BC), son of **Philip II**. He was a pupil of Aristotle c.343 BC, and succeeded his father in 336 BC, completing his planned conquest of the Persian empire. His early death at Babylon prevented the consolidation of a new imperial system.

Archimedes Inventor and astronomer (c.287–212 BC), died fighting Romans in defence of his native Syracuse.

Aristophanes Author (c.450–385 BC) of over 40 comedies, 11 extant. Lyrical and bawdy, Aristophanes is the acknowledged master of political 'Old Comedy' at Athens, such as his play *Birds* of 414 BC. He introduced the 'Middle Comedy' of manners with plays such as *Wealth* in 388 BC.

Aristotle Philosopher, literary critic, natural scientist and teacher of **Alexander the Great**, Aristotle (384–322 BC) was at first the pupil of **Plato**, then set up his own school (ultimately known as the Lyceum). Thirty of his 500 treatises are extant, including *Politics*.

Attalids Dynastic name of the rulers of Pergamum, beginning with Attalus I as the first official 'king' in 241 BC.

Cleisthenes of Athens Athenian aristocrat (c.570–c.508 BC) and the presumed 'founder' of democracy at Athens, due to a series of political reforms enacted during his magistracy of the city in 508 BC.

Cleopatra Cleopatra VII (69–30 BC) was the last of the Graeco-Macedonian Ptolemies to rule Egypt following **Alexander**'s conquest. Defeated with Antony by Octavian/Augustus at Actium in 31 BC, she committed suicide.

Cyrus the Great Cyrus II, Great King of Persia (c.580–530 BC), founded the **Achaemenid** empire and liberated the Jews from Babylon.

Darius I Great King of Persia (c.520–486 BC), he quelled the Ionian Revolt (499–494 BC) but was defeated at the battle of Marathon in 490 BC.

Demosthenes Athenian politician and orator of genius (384–322 BC). He led Athenian and Greek resistance to **Philip** and **Alexander** of Macedon, ultimately without success.

Draco Author of earliest Athenian laws (c.620 BC), later – unfairly – believed to have been 'written in blood', i.e. to stipulate capital punishment for all or most defined crimes.

Epaminondas Theban general and philosopher, most famous for defeating Sparta in 371 and 362 BC and enabling foundation of Messene and Megalopolis.

Euripides Tragedian (c.485–406 BC), 19 of whose c.80 attributed plays survive. Much ridiculed by comic poets in his lifetime, he was the most popular of the classic Athenian tragedians after his death, and is now thought the most 'modern'.

Herodotus Historian (c.484–425 BC), whose *Histories* remain an engaging account of his travels and a pioneer history of the Greco-Persian Wars.

Hippias Elder son of **Peisistratos**. After banishment from Athens in 510 BC, he sought exile with the Persians and was with them at the battle of Marathon in 490 BC.

Hippocrates of Kos The founder of a medical school (c.460–380 BC).

Homer Claimed as a native son by many Ionian cities, 'Blind Homer' may or may not have flourished in the eighth century BC and been responsible for combining and developing long oral traditions into the two great Greek epics that bear his name, the *Iliad* and the *Odyssey*. His works conjure up a heroic age vaguely located in what we would call the **Mycenaean** past, but they were not written down until the sixth century BC.

Menander Principal author (c.342–292 BC) in Athens of 'New Comedy', famed for its realism and interest in character; it is less political and less fantastic than the 'Old Comedy' as written by **Aristophanes**.

Miltiades Athenian statesman and general (c.550–489 BC). Though his political career was chequered (he was a tyrant in the Thracian Chersonese and vassal of Persia), his strategic role at the battle of Marathon in 490 BC earned him eventual heroization.

Nicias Wealthy slave-owning Athenian statesman and general (c.470–413 BC). He reluctantly took charge of the ambitious Athenian expedition to invade Syracuse in 415–413 BC; he was defeated and killed.

Peisistratos Three times tyrant of Athens, the longest from from 545 BC to his death in 527 BC, he promoted lavish public works and Athenocentric cultural and religious programmes. It is argued that he saw himself as a second **Heracles** – which would account for the prevalence of Heraclean images in sixth-century BC Athenian art.

Pericles Athenian democratic statesman, financial expert and commander (c.495–429 BC). Hugely influential c.450–430 BC, he is linked with the monumental development of the Acropolis and said to have been a close friend of **Phidias**.

Phidias Athenian sculptor (c.490–430 BC) in bronze and marble, as well as **chryselephantine**. Creator of cult-statues of **Zeus** at Olympia and **Athena** in the Parthenon at Athens. Probably the most gifted and industrious artist of the fifth century BC, he was perhaps responsible for entire sculptural programme of the Parthenon.

Philip II King of Macedon (359–356 BC), and father of **Alexander the Great**. He laid down the effective strategy and foundation of the Macedonian empire, conquered most of Greece and planned the invasion of Persia later completed by his son, but was assassinated during his daughter's wedding.

Plato Pupil and disciple of **Socrates** at the end of the fifth century BC; master of his own school at Athens, the Academy, until his death in 347 BC. His range of philosophic interests was dominated by the quest for moral knowledge, but nevertheless astonishingly broad. All his known dialogues have survived.

Plutarch Greek-born writer (c.AD 46–120) of over 200 works, of which the 78 *Moral Essays* and 46 biographies survive. He is a principal source for biographical information on, for example, **Pericles**.

Ptolemy I (c.357/6–283/2 BC) Founder of Ptolemaic kingdom and dynasty of Egypt as 'successor' of **Alexander**. Believed to have founded the Museum and Library at the kingdom's capital of Alexandria.

Sappho Late seventh-century poet and perhaps pedagogue of Lesbos. The theme of her work is invariably personal rather than political; her homoerotic lyrics have give us 'Lesbian'.

Socrates Cult philosopher of Athens (469–399 BC), of unorthodox ethical and religious views and antidemocratic political outlook. He was satirized by **Aristophanes** yet revered by **Plato** and others. Socrates was tried and condemned to death on a charge of religious subversion and corrupting the young.

Sophocles Athenian playwright (c.496–406 BC), most famous for his Theban plays.

Themistocles Commander of the successful Athenian fleet at the battle of Salamis in 480 BC; later exiled to Asia Minor.

Thucydides Historian and general (c.455–400BC), exiled for failing to preserve Amphipolis, the key Athenian base of power in Chalcidice, from the Spartans.

MYTHICAL AND DIVINE FIGURES

Achilles The outstanding warrior of Greek legend, whose temperamental behaviour during the Greek siege of Troy is the principal theme of **Homer**'s *Iliad*.

Adonis An eternally beautiful youth whose cult was associated with that of **Aphrodite**.

Agamemnon King of Mycenae. In **Homer**'s *Iliad*, the commander-in-chief of the Greek expedition against Troy. His murder on his return from Troy is the subject of the first play in the *Oresteia* trilogy of **Aeschylus**. *See also* **Iphigenia**

Ajax Second only to **Achilles** in the Greek contingent at Troy, the stalwart Ajax was the local hero of the island of Salamis.

Amazons Tribe of female warriors, vaguely located in the East, who appear frequently in Greek art and mythology. Amazons mythically denied the 'traditional' feminine roles of child-rearing and keeping house. Various Greek heroes tangled with them (including **Achilles, Heracles** and **Theseus**).

Aphrodite Goddess of love, sex, beauty and fertility in the Greek world and beyond, whose cult centred on her supposed birthplace (Cyprus), but pervaded maritime places throughout the Aegean, such as Knidos, where a statue of her by Praxiteles earned notoriety for showing (perhaps for the first time) the goddess nude.

Apollo Twin of **Artemis** and patron of music and other arts; divine patron of colonization. His cult at Delphi centred round an oracle, where two mottoes ('Know thyself' and 'Nothing too much') reminded visitors of an essentially civilizing concept of the god. Archaic statues of young men (*kouroi*) mimic Apollo's appearance.

Ares The god of war.

Ariadne Daughter of King **Minos** of Crete, who assisted **Theseus** in his struggle with the Minotaur, but was subsequently abandoned by him on the island of Naxos, where **Dionysos** found her.

Artemis Twin of **Apollo**. Goddess of hunting and wild nature, and associated with the transition from girlhood to womanhood, her cult was often bloody, yet in certain places (such as Ephesus) deeply rooted.

Asclepios Hero-god of healing and medicine. His cult flourished and expanded in the fourth century BC.

Athena Olympian goddess daughter of **Zeus**, she emerged fully grown from his cranium. Patron deity of both Athens and Sparta, though she was worshipped throughout Greece. Associated with war as well as women's work and crafts.

Atreus Son of Pelops, Atreus inherited a curse which haunted him and his own descendants at Mycenae, including **Agamemnon** and others.

Clytemnestra Wife and murderer of **Agamemnon**

Daedalus Archetypal inventor, artist and technician of Greek mythology, he was said to have created the first 'living' statues.

Demeter Goddess of agricultural fertility, especially grain, and 'bringer of treasures', Demeter is invariably maternal in her image. The most powerful story connected with her cult (especially at Eleusis) was that of her daughter **Persephone**, whose redemption from the Underworld was invested with the symbolism of rebirth and renewal.

Dionysos God of illusion and ecstasy, especially through wine and drama, who is also known as Bacchus. Mythically, the satyrs and maenads were his sensual enthusiasts, but his cult had its serious side too. Himself reborn after mutilation at the hands of the **Titans**, Dionysos promised immortality.

Hades Both the presiding deity of the Greek Underworld, and the name of the Underworld itself.

Helen 'The face that launched a thousand ships': beautiful offspring of **Zeus** and **Leda**, she was the wife of **Menelaus** when abducted by **Paris**, and thus the cause of the Trojan War.

Hephaistos The god of fire, volcanoes (after his Latin name, Vulcan) and metalworking.

Hera Wife of **Zeus**; associated with human married life and patron deity of Argos. Much mythology is generated by her jealousy or anger at her husband's frequent infidelity.

Heracles The most ubiquitous of Greek heroes, Heracles was a bastard son of **Zeus**, and began his life with mortal status. Later, with the support of **Athena**, he was received on Olympus as one of the divines. The choice of twelve of his heroic deeds ('Labours') to decorate the temple of Zeus at Olympia ensured their canonical status.

Hermes The messenger of the gods, usually shown with winged feet. As escort of souls, he had connections with the Underworld.

Icarus Son of **Daedalus**. He plunged to his death while escaping Crete with his father, who had equipped him with wings. Icarus flew too high and the sun melted the wax which held his wings.

Iphigenia Daughter of **Agamemnon**, condemned to be sacrificed by him; versions of her story say that she was saved by **Artemis**, who substituted a deer or a boar.

Laocoön Aristocratic priest of Troy, who protested at the acceptance of the Wooden Horse as a 'gift' from the besieging Greeks. Two serpents were despatched by either **Apollo** or **Athena** to attack him and his sons for this protest (or, as it seems, insight).

Menelaus Younger brother of **Agamemnon**. The abduction of his wife **Helen** by **Paris** of Troy was the cause of the Trojan War.

Minos Legendary king of Crete, who kept the hybrid bull-man, known as the Minotaur, in a labyrinth constructed by **Daedalus**. **Theseus** dispatched the beast, to which Minos had been sacrificing Athenian youths. No historical Minos is implied by creating the term 'Minoan' to define the prehistoric Cretan palace culture, though elements of his mythology seem to reflect certain features of the palace of Knossos.

Nike Goddess or personification of Victory, usually shown as winged.

Odysseus (in Latin, Ulixes or Ulysses) The hero whose adventures are described chiefly in **Homer**'s *Odyssey*, though he appears prominently in the *Iliad* too. A quick and inventive intelligence is his hallmark.

Oedipus Abandoned in his infancy by father King Laius of Thebes, Oedipus eventually fulfills a prophecy which declared that he would kill his father and marry his mother. Incidentally, he rids Thebes of the **Sphinx** which is plaguing the city – by defeating her in a contest of riddles.

Paris One of the sons of Priam of Troy. His abduction of **Helen** caused the Trojan War, in which he plays little part; however, it is his arrow which ultimately slays **Achilles**.

Pegasus Winged horse, born from the decapitated Gorgon Medusa, particularly associated in mythology with the city of Corinth.

Persephone Daughter of **Demeter** (she is also known as 'maiden', or *kore*), she was abducted by the god of the Underworld, **Hades**. Demeter protested by causing a crop failure, and negotiated an agreement whereby her daughter would return for eight months a year, every year. (The story is rationalized as the onset of spring).

Poseidon God of water generally, and sea in particular, he was also deemed responsible for earthquakes. In the mythical prehistory of Athens, he contested with **Athena** for possession of Attica – as shown on the west pediment of the Parthenon.

Sphinx Monster with human head (usually female in Greek art) and lion's body, of Egyptian origin; connected with transporting souls, hence often found in funerary imagery.

Theseus The special hero of Athens, credited with many adventures, and the unification of Attica as a region. The shrine (Theseion) erected in his honour at Athens has yet to be located.

Titans Primordial gods or forces of nature, the wayward offspring of Heaven and Earth, prior to the Olympians.

Zeus In the works of **Homer**, 'father of gods and men' and 'cloud-gatherer': the supreme Olympian, guardian of law and justice. In art he is usually bearded and half-clad. His most celebrated image was at Olympia, the colossal throned figure made in the 430s BC by Athenian sculptor **Phidias**.

INDEX

Phaidon Press Limited
Regent's Wharf
All Saints Street
London N1 9PA

Phaidon Press Inc.
180 Varick Street
New York NY 10014

www.phaidon.com

First published 2012
© 2012 Phaidon Press Limited

ISBN 978 0 7148 6084 8

Production Manager Paul McGuinness
Project Editor Alex Stetter

Designed by Struktur Design

Printed in China